500 YEARS
OF
Illustration

500 YEARS
OF
Illustration

FROM ALBRECHT DÜRER
TO ROCKWELL KENT

HOWARD SIMON

DOVER PUBLICATIONS, INC.
MINEOLA, NEW YORK

Bibliographical Note

This Dover edition, first published in 2011, is an unabridged republication of the work originally published by The World Publishing Company, Cleveland and New York, in 1942 under the title *500 Years of Art & Illustration*. The original foldout plates from the 1942 edition, located between pages 36 and 37, appear here as an eight-page section in its original position in the book.

Library of Congress Cataloging-in-Publication Data

Simon, Howard, 1903–1979.
 [500 years of art & illustration]
 500 years of illustration : from Albrecht Dürer to Rockwell Kent / Howard Simon. — Dover ed.
 p. cm.
 Originally published: 500 years of art & illustration. Cleveland [Ohio] : World Pub. Co., 1942.
 Includes index.
 ISBN-13: 978-0-486-48465-5
 ISBN-10: 0-486-48465-3
 1. Illustration of books. 2. Illustrators. I. Title. II. Title: Five hundred years of illustration : from Albrecht Dürer to Rockwell Kent.

NC960.S5 2011
741.6'4—dc23

 2011022648

Manufactured in the United States by Courier Corporation
48465301
www.doverpublications.com

To Mina

A NOTE OF ACKNOWLEDGMENT

I AM GRATEFUL to artists, authors and publishers who have graciously and generously cooperated in the making of this book. Special acknowledgment is made here to The Macmillan Company of New York and London for permission to reproduce the illustrations of Boris Artzybasheff from *Behind Moroccan Walls* by Henriette Celaire; for permission to reproduce the illustrations of Wilfred Jones from *The Rise of American Civilization* by Charles A. and Mary R. Beard; for permission to reproduce the illustrations of Agnes Miller Parker from *Through the Woods* by H. E. Bates and for permission to use the illustrations of Gwen Raverat from *The Runaway*. Special acknowledgment is likewise made to Dodd, Mead and Company, New York, for permission to use illustrations by John Farleigh from *Adventures of the Black Girl in Her Search for God* by George Bernard Shaw. To Harcourt, Brace and Company, New York, acknowledgment is made for permission to use the illustrations of Henry C. Pitz from *Lumberjack* by Stephen C. Meador and for permission to use the illustrations of James Reid from *The Lapp Mystery* by S. S. Smith.

Acknowledgment is made to Longmans Green and Company, for permission to use the illustrations of James H. Daugherty from *Courageous Companions* by Charles J. Finger and illustrations from *The Farmer's Year*, written and engraved by Clare Leighton. Acknowledgment is also made to Harper and Brothers, New York, for permission to use the work of Howard Pyle from *Howard Pyle's Book of Pirates;* and to Henry Holt and Company of New York for permission to use the illustrations of J. J.

vii

Lankes from *A Woodcut Manual;* to The Viking Press, New York, for permission to use the illustrations of Ilse Bischoff from *In Calico and Crinoline* by Eleanor Sickels; to Covici-Friede, for permission to use the work of Leopoldo Mendez and José Guadalupe Posada from *Contemporary Mexican Artists* by Agustín Velázquez Chávez; to Faber and Faber of London for permission to use Rex Whistler's illustrations from *The Lord Fish* by Walter de la Mare; and to William Jackson (Books) Ltd., London, for permission to reproduce the decorations of Shakespeare's *As You Like It.* Acknowledgment is also made to Random House, New York, for permission to reproduce the work of Lynd Ward from *Vertigo, A Novel in Woodcuts* and for permission to use the illustrations from *N by E,* written and illustrated by Rockwell Kent; to Frederick A. Stokes Company, New York, for permission to use the illustrations of Gordon Grant from his book *Sail Ho!*

Acknowledgment is likewise made to Constable and Company, London, for the use of Arthur Rackham's illustrations from *Little Brother and Little Sister and Other Tales* by the Brothers Grimm; to Coward McCann, Inc., New York, for the use of illustrations from *Millions of Cats,* written and illustrated by Wanda Gág; to Oxford University Press, New York and London, for permission to use the illustrations of Helen Sewell from *A First Bible;* to the John C. Winston Company of Philadelphia for permission to use the illustrations of Kurt Wiese from *Young Fu of the Upper Yangtze* by Elizabeth Foreman Lewis. Acknowledgment is also made to Tosspo, Warsaw, for illustrations by St. O. Chrostowski, T. Cieslewski, T. Kulisiewcs, W. Skoczylas, L. Tyrowicz from *Polish Art* by Mieczyslaw Treter; to Blue Ribbon Books, New York, for permission to use the illustrations of John Austen from *Don Juan* by Lord Byron; to Rarity Press, New York, for permission to use the illustrations of Robert Gibbings from Gustave Flaubert's *Salammbo;* to the magazine *Story Parade,* New York, for permission to use the illustrations of Grace Paull from *Mr. Bumps* in Volume II, Nos. 3, 4, and 5 and of Boris Artzybasheff from *The Seven Simeons,* Vol-

viii

ume II, Nos. 3, 4 and 5; to E. P. Dutton & Co., Inc. for the use of Eric Gill's decorations from *The Temple Shakespeare;* to Modern Age Books, Inc., New York, for permission to use illustrations by Howard Simon from *Old Hell* by Emmett Gowan. Acknowledgment is also due to The American Russian Institute for permission to use the illustrations on pages 292-297.

Reproductions of *De Claris Mulieribus,* Hans Holbein's *The Dance of Death* and the "Portrait of Erasmus"; the works of William Hogarth, Goya, Thomas Rowlandson, Thomas Bewick, John Leech, William Morris, Auguste le Père, and Kathe Köllwitz, were made by courtesy of The New York Public Library from originals in the Print Room of the Library, and the author gratefully acknowledges the friendly cooperation of Dr. Frank Weitenkampf, Director, and Henry Meier, his assistant. He also wishes to thank Herbert Williams, Orrick Johns, who gave his time generously to the preparation of the manuscripts, and finally the great debt he owes to his wife, Mina Lewiton, who edited and revised the entire manuscript.

H. S.

The valuable recommendations and suggestions of Mr. Jerome Darwin Engel, in connection with the preparation and organization of this book, are cordially acknowledged.

THE PUBLISHERS.

CONTENTS

Part Two: THE PRESENT

INTRODUCTION

ONE OF the distinguishing marks of a great book is the persistence with which it is illustrated. The Bible, Cervantes' *Don Quixote,* the works of Shakespeare and Rabelais, *Pilgrim's Progress,* Aesop's *Fables*—are all among the much illustrated books. Almost every generation demands the classics in modern dress, set forth pictorially by a favorite modern hand. There scarcely has been a generation without its interpreter of the world's great books.

On the subject of fine bookmaking there have always been two different schools of thought. There are those who would decorate a book with clear, beautiful type, print it on good paper and allow, at most, a printer's flower to decorate the page. And there are the others to whom an illustrated book is an enriched one. This present work is intended primarily for those of the second group. Its purpose is to treat of illustration apart from its type surroundings, not forgetting, however, the limitations that type imposes upon it.

An exhaustive work on the subject of book illustration would, of necessity, run to many volumes and include many more illustrators than are represented in the following chapters. If this book, however, will serve as an introduction and as an impetus to further study in the fascinating field of book illustration, then at least, the main purpose of the author will have been accomplished.

The problem of fitting the illustration in style and conception to type is one that is ever present. Many artists have made good drawings and

engravings for books, but because of a predominance of black have failed to achieve a harmonious effect with the type page. This lack of harmony in the completed book becomes more evident as we approach the early stages of mass production and observe the cheap books of the 1900's.

In reaction against the badly made product of the machine—subsequently made still more ugly by the invention of photogravure, we find William Morris leading a movement that in its typographic medievalism stemmed from the works of Dürer, master wood engraver, and Koberger, master printer of Nuremburg.

Everything about the justly-famous Kelmscott *Chaucer*, printed by William Morris was hand-made; the paper, the elaborate woodcut borders, the reed-pen drawings by Edward Burne-Jones, carefully engraved on wood, and the binding, beautifully tooled by skilled craftsmen. This work was inspired by the magnificently decorated and illuminated Renaissance manuscripts, which had reached perfection before the invention of printing. The harking backward, incidentally, is characteristic of most of the so-called private presses, even to the present time.

The decoration of the printed page both in design and typographic arrangement is a subject that merits separate and special attention in a book devoted to that subject alone. Here it can only be touched upon. Great strides have already been made since the first high-speed presses spewed forth their ill-favored offspring. And the books of the future will be those that utilize the high-speed presses, making possible quantity production and its manifest benefits, without sacrificing the quality of design or craftsmanship. Already, progressive publishers are proving that it lies within the realm of possibility.

It is the purpose here to trace the development of the modern book artist through the men who influenced his growth. For this purpose, it is necessary to know a little of their lives and the periods in which they flourished. All of the progenitors of modern illustration did not illustrate books. They were rather forerunners who blazed the trails.

The term "illustrator" has often been used as a kind of epithet to hurl at the modern artist who dares to embody an idea in the medium of print. It is a partial purpose of this book to point out that the greatest of artists have not neglected illustration. With them it was another form of pure creative expression. Their drawings for books contain all of the abstract qualities of esthetic design that distinguish their other works.

In order to make clear the progress of illustration as an independent art, we must consider the base as being the *Incunabula,* or the earliest of books illustrated with crude woodcuts. A step above these, and far above them esthetically, are the superbly beautiful books of the Renaissance. Dürer, one of the greatest of all book illustrators, worked in this period, to the greater glory of the printed book. In Italy, at the same time, Aldus was creating his splendid work, *The Dream of Poliphilius.* The illustrations for it have been attributed, at one time or another, to almost all the Renaissance masters, Raphael and Mantegna among them. After these come the realists of the Eighteenth Century: Hogarth, the moralist and the mordant, romantic Goya who was not a book illustrator but whose influence in illustration still is felt strongly. In the Nineteenth Century appeared Cruikshank, interpreter extraordinary of Dickens; Toulouse-Lautrec, biting satirist, and Aubrey Beardsley, fantastic, simple and complicated by turn. These are only a few who have built the solid structure that the art of illustration rests upon.

Thus we come to the modern book artists. Examples of their work are presented with the intention of showing modern book illustration in direct relation to its precedents. For convenience, grouping among the moderns has been made by nationality, although such a grouping, it is easily seen, has its limitations, for national boundary lines often are not barriers against current prevailing thought. It frequently happens that two artists working far apart geographically are nevertheless bound together in a kinship of style and genre and even medium.

Since the early books, the techniques of illustration have varied little.

The mediums most generally employed have been woodcut and copper engraving. There has been little change even in the tools of these two crafts.

The woodcut carries its virtues of harmonizing with the printed page, from the black letter of the *Incunabula* to the newest of modern type faces. Its use increases in popularity with each year, wherever the modern book is printed. Some of its leading exponents such as Clare Leighton in England and Lynd Ward and J. J. Lankes in the United States, have given great impetus to what seems to be renewed interest in true book illustration. The modern woodcut is a spirited and creative art. New forms are being developed and new fields for its use are being explored.

Lithography, too, has done much to place in the hands of the illustrator a variable and sensitive medium, capable of almost any degree of light and shadow. When used directly on the stone or zinc, it is autographic and reproduces in unlimited quantity the effect arrived at by the artist. The examples of Daumier and Toulouse-Lautrec have inspired many modern practitioners of this art, and the problem of its relation to type gradually is being solved.

The subject of illustration in color deserves independent consideration and is not even touched upon since we are concerned here with illustration in black and white. Many advances have been made in the field of reproduction. Photo-engraving in color has come a long way.

In line engraving, by which is meant the use of a burin on copper unaided by the process of photo-engraving, much new and interesting work is being done.

Looking backward, the copper engravings of the Sixteenth Century may be charged with lowering the standard that bookmaking had reached at that time. It had become an extremely popular medium and was vulgarized by hack craftsmen who, literally, worked it to death. The fine engravings of Stephen Gooden and Eric Gill point the way to new uses of the copper plate. Gooden's modern work for the Nonesuch Bible is a

fine example of line engraving. The contrast between these two modern artists, each using the same medium with such varied results, speaks well for a means of illustration that in recent years has been little used.

In the final analysis, it is the quality of imagination and design, plus intelligent preparation for reproduction that enables the artist, whatever his medium, whether it be wood engraving, copper engraving or line drawing, to make a beautiful book. The way is easier now than it has ever been.

During the preparation of this volume the world has passed from a troubled and uneasy peace to a conflagration the like of which no history records. Its effect upon the peaceful arts of nations is impossible to foretell.

Some of the men and women whose work appears in the later pages of this book are now engaged in the bitter struggle to preserve for themselves and those who come after some semblance of the freedom and dignity of a life they held to be dear. Some may have already paid the full price; others in France, Czecho-Slovakia, Poland, Holland and Germany itself now know slavery and degradation.

The artist, as the unfolding of the pictures of this book will show, has always concerned himself with the current of life about him, his works reflect it, and even in the case of a Goya, a Daumier, or a Köllwitz may have had some small part in the shaping of things to come.

After the darkened cities of Europe and Asia again assume their civilized aspect, after the concentration camp remains but a bitter memory, out of this welter of dead and maimed, the inevitable new world will make its way and through the graphic arts will continue to express its aspirations and give visual form to its ideas.

<div align="right">H. S.</div>

New York, 1942

THE PAST

IN THE BEGINNING

I T WAS in 1440 that the great Gutenberg discovered that movable
type could be used in printing. Previous to this time the crude block
books contrasted poorly with the beautifully illuminated manuscripts of
the same period. Each page was cut on a single block of wood. Because of
the very limited number of people who could read, the subject of the
book was in most part borne by the illustrations. Comparatively little type
appeared to explain the pictures. Perhaps the chief reason for this lack of
text was the difficulty encountered in cutting the type on the wood block.

A glance at the page of the Biblia Pauperum, most famous of the block
books, will show that this work was intended for the diffusion of knowl-
edge rather than of art. And it will be observed that these block books were
in no way influenced by the high degree of conscious decoration already
at its full flower in the Renaissance manuscripts.

Up to this time the common man had been possessed of very little
opportunity to read, and the first books were hungrily seized upon by the
laity. The seed of the Reformation was sown in these early volumes.

The illumination and decoration of manuscripts had been confined for
the most part to Italy, Spain and Austria. The movement seems to have
failed to touch Germany at all. But Gutenberg lived in Nuremberg, and
because of his inventive genius Germany found herself the center of an
infant industry which was to become more extensive than even the most
fanciful of its progenitors could imagine.

Other arts have had long and difficult struggles before they developed

into any semblance of maturity, but under Gutenberg, printing was created in the full bloom of its beauty. The first book printed with movable type, the Gutenberg Bible, is a noble, splendid volume. The clarity of its letterpress and the fine proportion of its margins presaged for the infant craft its important place in the spread of world enlightenment.

The illustrated book as we know it today was almost coincidental with the invention of printing. Most important among the early books in a study of illustration is Anton Koberger's *Nuremberg Chronicles,* a summary of history and the known wonders of the world. It is a large volume and profusely illustrated, although it naïvely and amusingly makes a woodcut portrait of one emperor do duty for many others in the course of the book's historical summary. Michael Wohlgemuth, Dürer's master, worked for Koberger at that time, and it was generally believed that Dürer had some small part in the making of a few of the numerous wood engravings. At any rate, their relation to type is excellent and shows a great deal of skill and inventiveness.

The names of Albrecht Dürer and Hans Holbein the Younger may in themselves be said to sum up the German Renaissance, and it was indeed a fruitful period. Their distinguished contemporaries included Lucas Cranach the Elder, and that celebrated engraver, Hans Burgkmair. It was supposed that the latter studied under Dürer, but there was only one year's difference in their ages, and Burgkmair's style differs from that of Dürer; he was rather the founder of a school of his own. He is represented here by an illustration from *The Wise King,* a book published in Vienna and containing two hundred and thirty-seven plates depicting the principal actions of the Emperor Maximilian I. Hans Sebald, Hans Baldung-Gruen and many others carried on the German tradition to the end of the Sixteenth Century.

Augsburg, Nuremberg, Mainz, Bamberg and Frankfort are great names in the history of the printed book. Each had its own school of designers and found its own style in decoration.

2

A tide of books and secular learning swept over Europe; in its wake came the Reformation. It was through the invention of printing, more than through any other development of the time, that Luther was enabled to spread his doctrines.

Italy, too, had her day of glory, and the Italian book soon became a thing of beauty. One of the great names in the history of learning is that of Aldus Manutius, scholar, Greek classicist and printer extraordinary. Five years before the close of the Fifteenth Century, in Venice, he published a Greek and Latin *Grammar* for which he had designed a complete font of Greek letters. This was in itself a tremendous task as the font, with its accents and ligatures, consisted of more than six hundred characters.

After this successful attempt, Aldus produced a great number of splendid books, among them the most famous specimen of printing in all Fifteenth-Century Italy, *The Dream of Poliphilius*. The text of this allegory was decorated with drawings of exquisite workmanship, and the relation between type and drawing has rarely been equaled in the subsequent history of illustration. Various authorities, among them Vasari and Lanzi, have attributed these illustrations to Mantegna, Bellini, Raphael and almost every other great artist of the time.

In this book a great fertility of imagination, poetic and pagan by turn, is effectively reinforced by a beautiful simplicity of line. The excellent craftsmanship of the engravings, in all probability done by a hand other than the artist's, should also be noted. For one hundred and two years the famous device of the anchor and dolphin continued to mark the work of the press of Aldus. The master printer, his son and grandson, all made printing history.

Ratdolt, a native of Augsburg, worked in Venice and followed Aldus in importance. He was a skillful and conscientious craftsman, and to him is attributed the first decorative title page. He was also the first to print in color, using two impressions of the press and improving upon the laborious hand coloring that preceded it.

To John Froben, printer of Basle and friend of the great scholar Erasmus, may be credited the discovery of Hans Holbein. Froben employed Holbein to make many of the illustrations for the books printed by him between 1518 and 1524.

Antoine Verard was the most important figure in early French printing. His first book, a *Decameron,* appeared in 1485. For his patron, Charles the Eighth, he printed many elaborate, lavishly illuminated works. The Estienne family, too, played a great part in establishing the book in France. Henri Estienne, the founder of the house, appeared as printer to the Sorbonne in 1496.

The most highly skilled of the French designers, Geoffrey Tory, was also a poet, artist and teacher. He is best known for a work of his own writing, *Champ Fleury,* which is the earliest book on the theory and design of the Roman letter.

It is impossible to overestimate the place of these men of learning in the early art of book illustration. Their taste and sense of design, wedded to the best graphic talent of their day, has left us the heritage of a rich and moving art.

Damisella Trivuliza from Boccaccio's De Claris Mulieribus. Printed by Forestis. Ferrara, 1497. Artist unknown

Fifteenth Century Woodcut from De Claris Mulieribus. Printed by Zainer in Ulm, 1473. Artist unknown

Page from wood block book, Pauper's Bible, a popular Fifteenth Century substitute for the Latin Bible.
Artist unknown

6

Fifteenth Century Woodcut from De Claris Mulieribus. *Printed by Zainer in Ulm, 1473. Artist unknown*

Illustration to Aesop's Fables. Printed by Tuppo, 1485 (Naples). Artist unknown

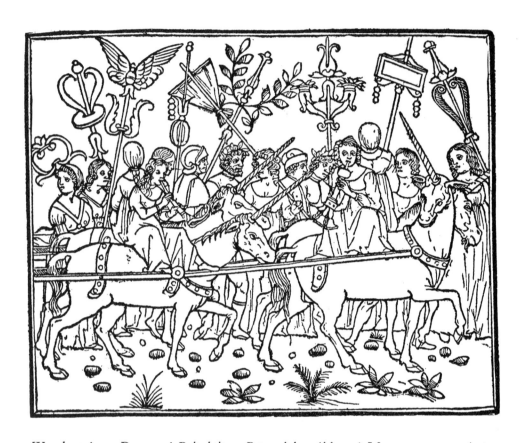

Woodcut from Dream of Poliphilius. Printed by Aldus of Mantua, 1499. Artist unknown

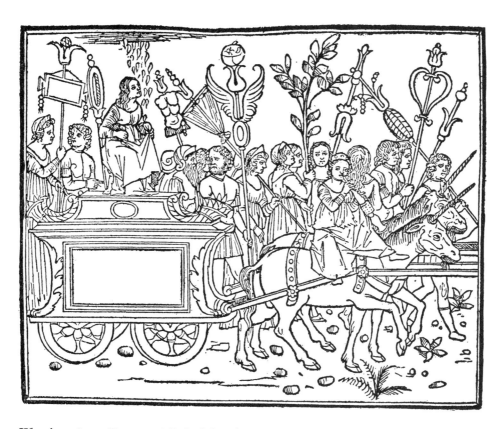

Woodcut from Dream of Poliphilius by Francisco Colonna. Printed by Aldus of Mantua, 1499. Artist unknown

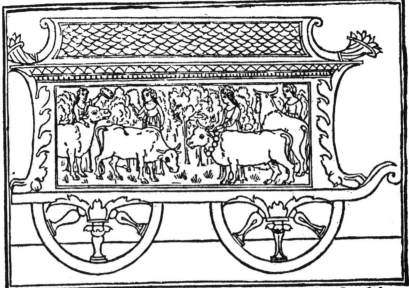

Quella Nympha cófiſa la ſiniſtra tabula cótineua, che aſcenſo hauea
ſopra il manſueto & candido Tauro. Et quello ꝗlla p el tumido mare tï
mida, tráſſretaua. SECVNDA SINISTRA.

Nel fronte anteriore, Cupidine uidi cú ínumera Caterua di promi
ſcua géte uulnerata, mirabódi che egli tiraſſe larco ſuo uerſo lalto olym
po. In nel fronte poſteriore, Marte miraí dinanti al throno del magno
Ioue, Lamentátiſe che el filiolo la ípenetrabile thoraca ſua egli la haueſ
ſe lacerata. Et el benigno ſignore el ſuo uulnerato pecto gli monſtraua.
Et nellaltra mano extenſo el brachio teniua ſcripto, NEMO.
 k iiii

Page from Dream of Poliphilius

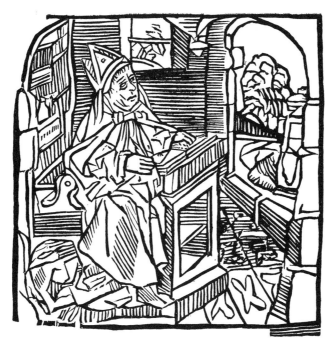

A woodcut of St. Ambrosius. German School, Fifteenth Century. Artist unknown

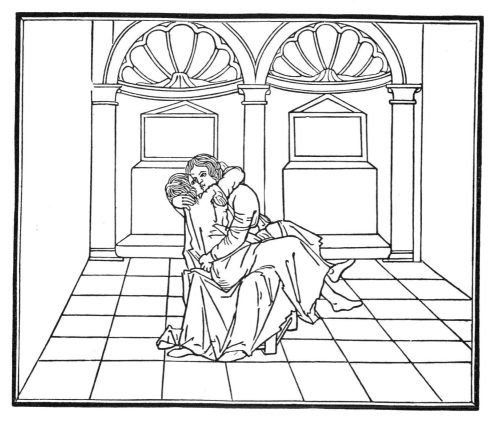

Woodcut from Dream of Poliphilius

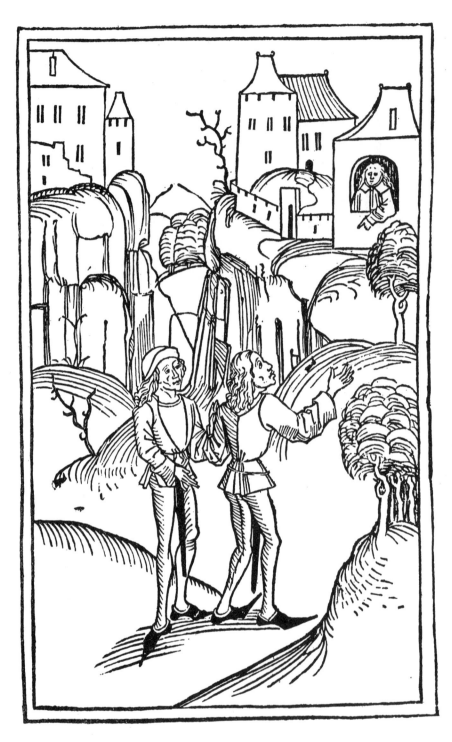

Fifteenth Century Woodcut from the Swabian Chronicles. Printed by Konrad Dinckmut in Ulm, 1486. Artist unknown

12

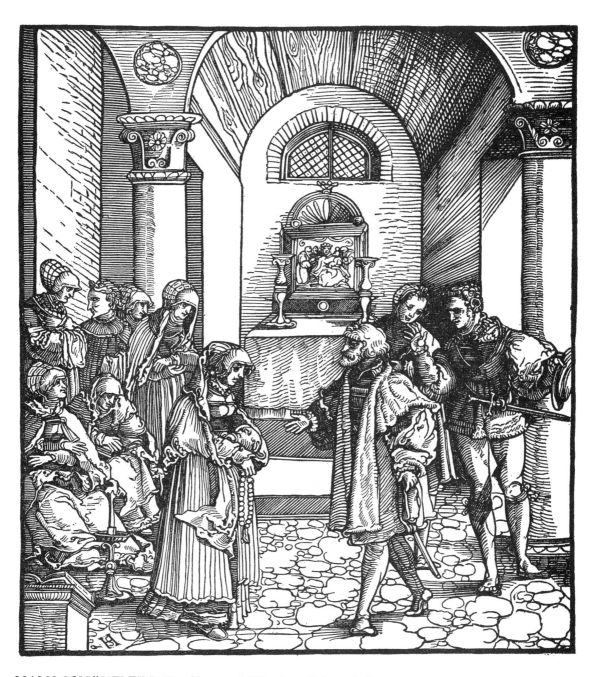

HANS SCHÄUFLEIN. *'Die Trauung' Woodcut, Fifteenth Century*

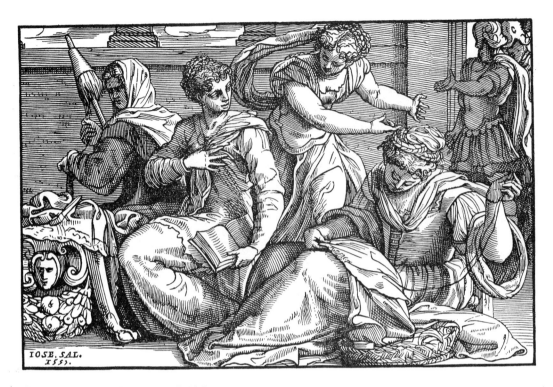

GUISEPPE PORTA-SALIRATI. *'Lucretia and Her Ladies' Woodcut, Fifteenth Century*

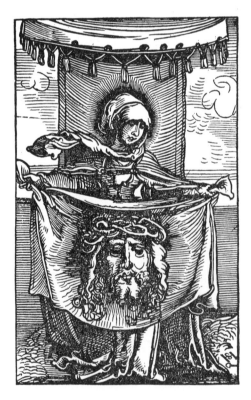

HANS SCHAEUFFLEIN. *'St. Veron-
ica' Woodcut, Fifteenth Century*

14

HANS BURGKMAIR. *'Maximilian I and Maria of Burgundy'* *Woodcut*

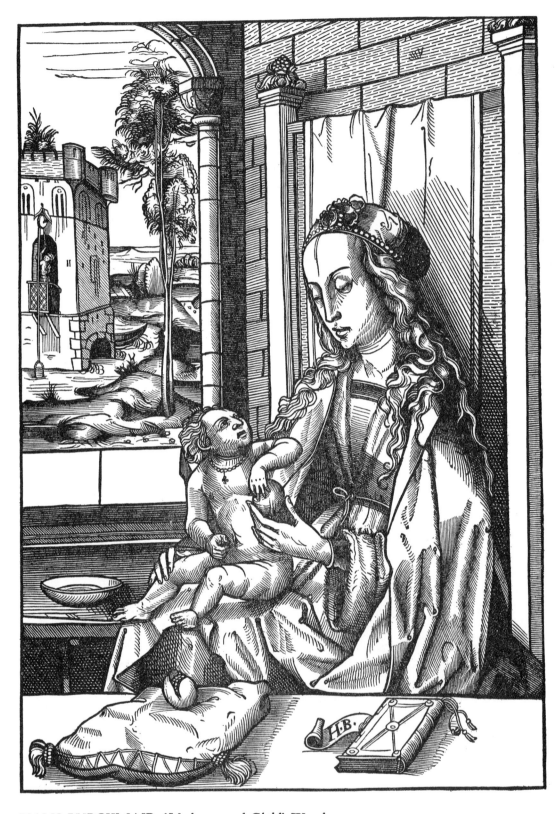

HANS BURGKMAIR. *'Madonna and Child'* Woodcut

16

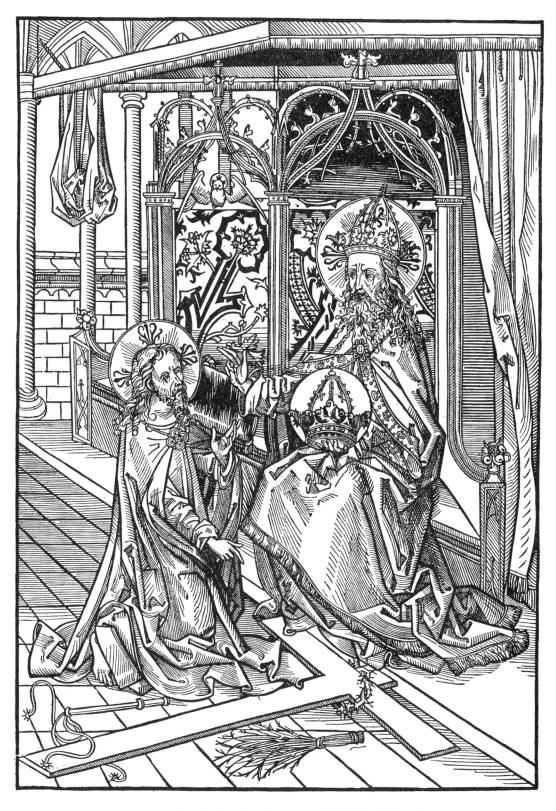

MICHEL WOHLGEMUTH. *'The Glorification of God's Son'* *Woodcut*

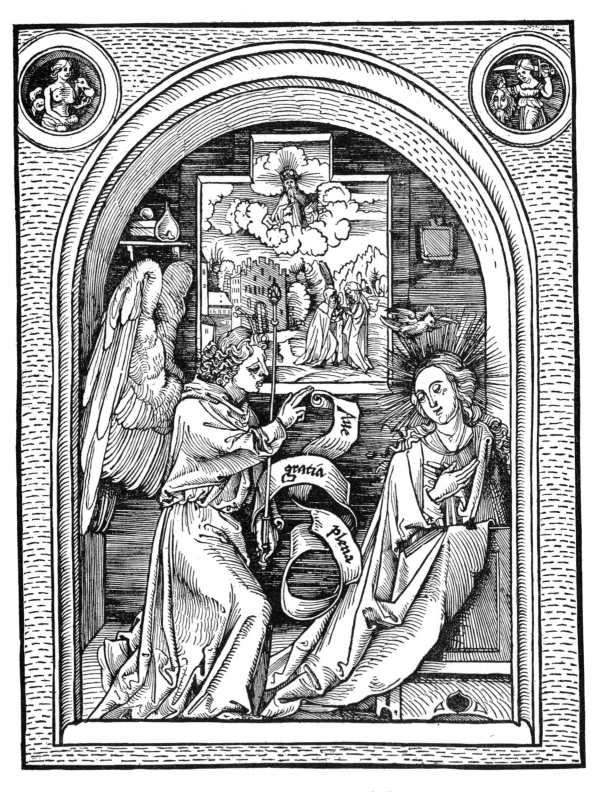

HANS WAECHTLIN. *'Annunciation' Woodcut, Sixteenth Century*

18

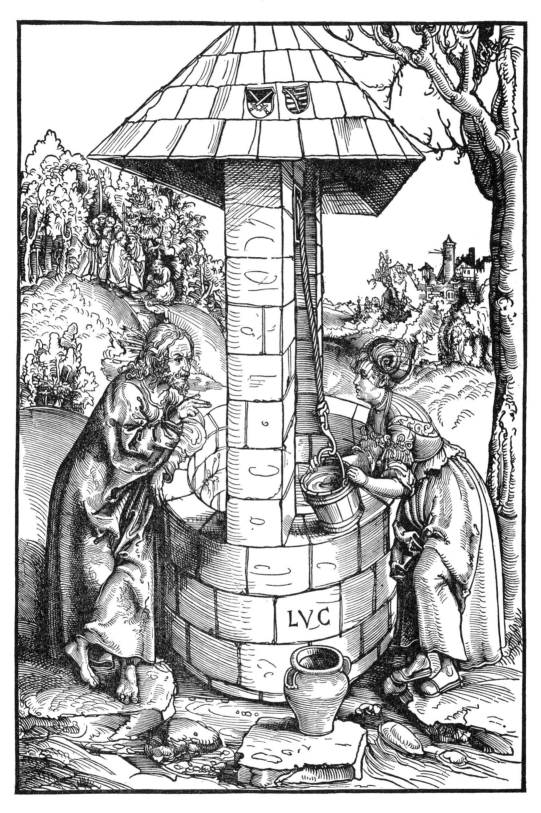

LUCAS CRANACH THE ELDER. *'Christ and the Samaritan' Woodcut*

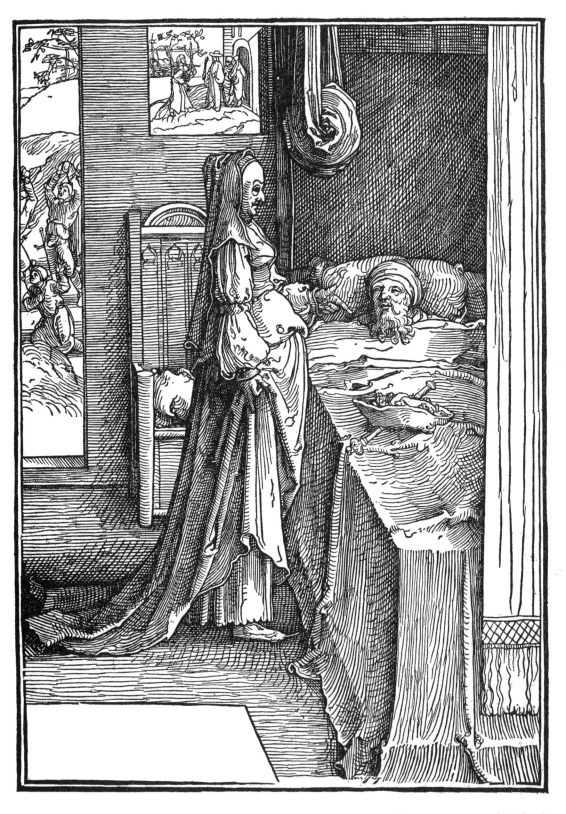

LUCAS VAN LEYDEN. *'Ahab and Isabel'* Woodcut, Sixteenth Century, Dutch School

20

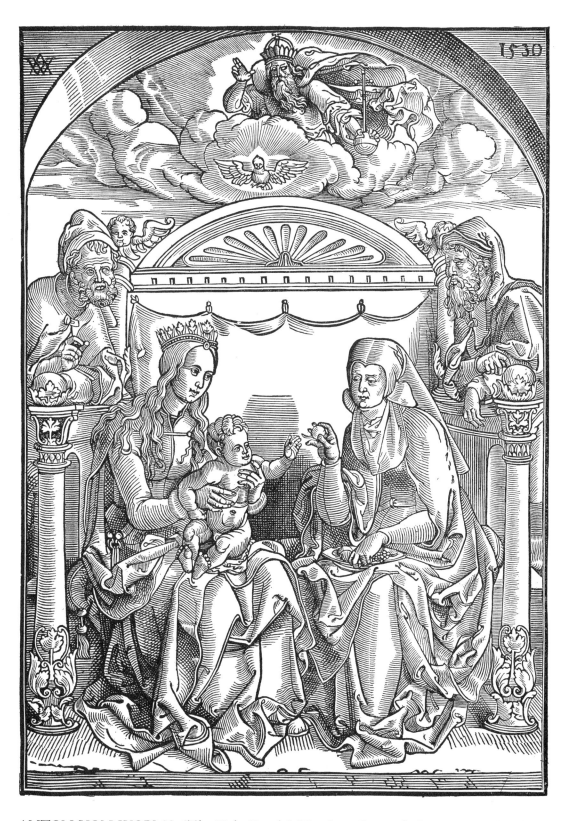

ANTON VON WORMS. *'The Holy Family' Woodcut, Sixteenth Century, Dutch School*

LUCAS CRANACH THE ELDER. *Three Plates*

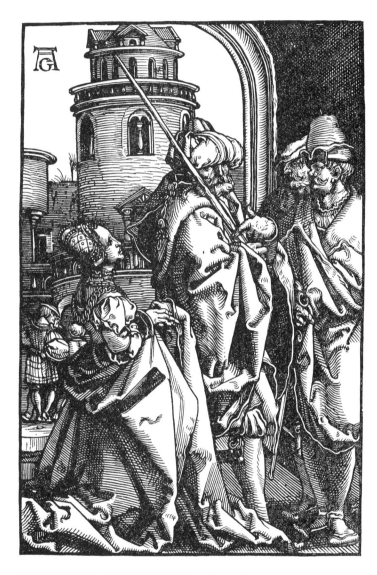

HEINRICH ALDEGREVER. 'Potiphar's Wife Accuses
Joseph', Woodcut

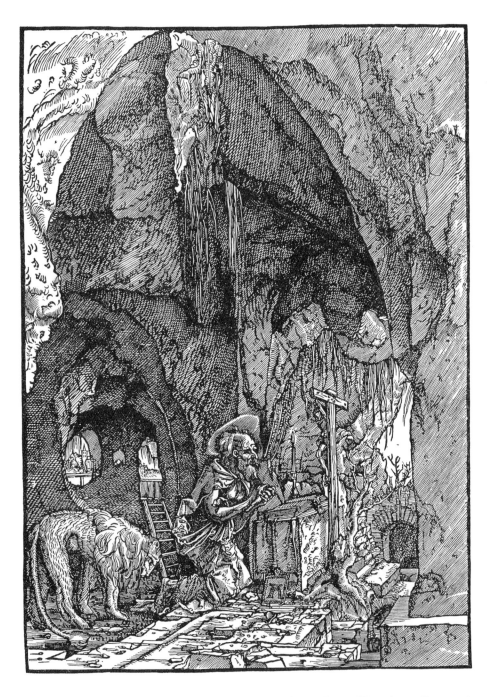

ALBRECHT ALTDORFER. *'St. Jerome in His Cave' Woodcut, Sixteenth Century*

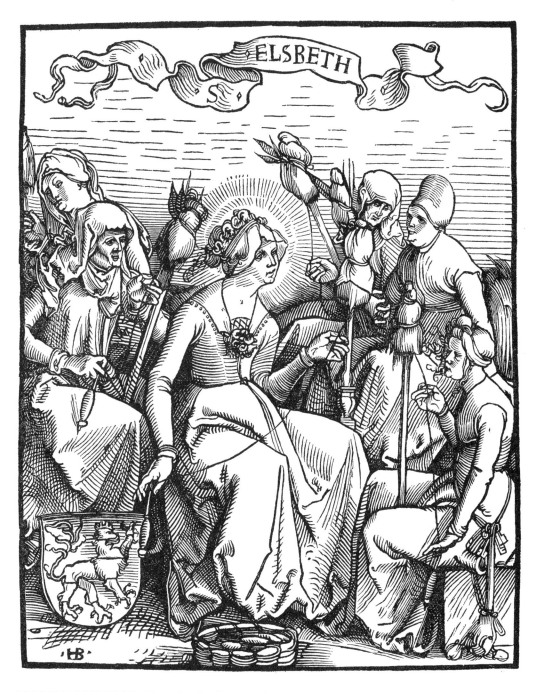

HANS BALDUNG. *'St. Elizabeth'* *Woodcut*

25

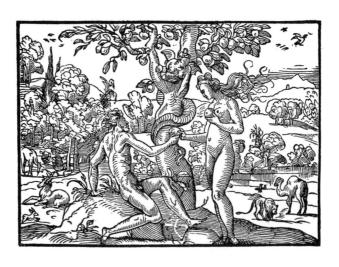

BERNARD SALOMON. 'The Fall of Eve' Wood-
cut, Sixteenth Century, French School

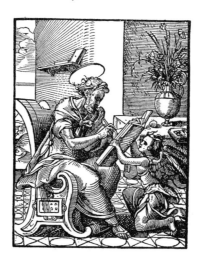

BERNARD SALOMON. 'St.
Matthew' Woodcut, Sixteenth
Century, French School

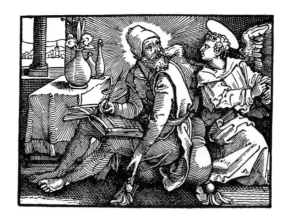

HANS SEBALD BEHAN. 'St. Matthew'
Woodcut

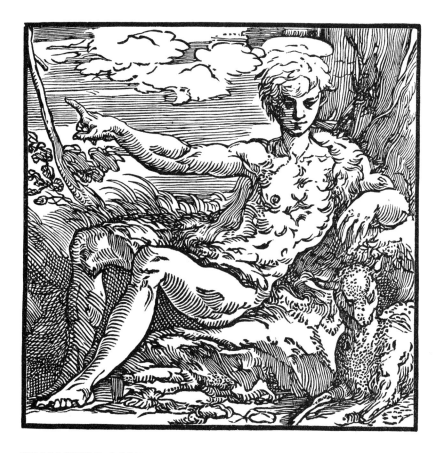

FRANCISCO MAZZUOLI. 'St. John' Woodcut, Italian School

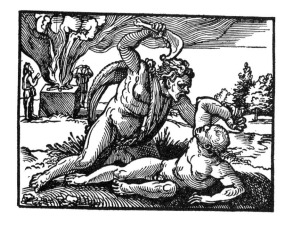

HANS SEBALD BEHAN. 'Cain Slays His
Brother' Woodcut, Sixteenth Century, Ger-
man School

DÜRER'S father migrated from Hungary shortly before Albrecht's birth, and the possibility remains that the artist owed at least as much to the inspiration of his Magyar blood as to the methodical perseverance instilled by his Teutonic instruction and environment.

After learning the rudiments of design from his father, Dürer received his first instruction in painting and engraving from Martin Hapse. In 1486, when Dürer was not quite fifteen, he became a pupil of Michael Wohlgemuth, then the first artist of Nuremberg. During the four years that followed, he also cultivated the study of perspective, mathematics and architecture, in all of which he acquired a profound knowledge. The next four years he spent in traveling through Germany, the Netherlands, and the adjacent countries and provinces.

An excellent painter, Dürer derived most of his fame from his skill as an engraver, and he is generally assumed to have surpassed every artist of his time in this branch of the arts. He carried engraving to a perfection that has never been surpassed and it would be difficult to select a specimen of executive excellence greater than his print of *St. Jerome,* engraved in 1514.

Dürer had a perfect command of the graver, and his works are executed with remarkable clearness and neatness of stroke; we find in them everything that can be desired from the viewpoint of illustration. His woodcuts harmonize perfectly with type which more often than not was cut by the artist also. To him is attributed the invention of etching; and if he was not

the inventor, he was the first who excelled in the art. He also invented the method of printing woodcuts in *chiaroscuro,* or with two blocks. His great mathematical knowledge enabled him to form a regular system of rules for drawing with geometrical precision.

Dürer engraved both on wood and copper. Among his most celebrated copper-plates are "Fortune", "Melancholy", "Adam and Eve in Paradise", "St. Hubert" and "St. Jerome". Among his best woodcuts are the so-called *Small Passion* in sixteen plates, the *Great Passion,* with the frontispiece numbering thirty-seven plates; the *Revelation of St. John,* with frontispiece, fifteen plates; and the *Life of the Virgin,* in twenty plates. One of his best woodcuts is "St. Eustachius Kneeling before a Stag". This cut is widely known and loved, particularly for the beauty of the dogs, which are represented in various attitudes.

Dürer lived in a frugal manner, without the least ostentation despite the honors heaped upon him. He applied himself to his profession with the most constant and untiring industry, which, together with his great knowledge, great facility of mechanical execution enabled him to rise to high distinction, and to exert a powerful influence on the character of German art for a great length of time.

He was the first artist in Germany who practiced and taught the rules of perspective, and of the proportions of the human figure, according to mathematical principles. His treatise on proportions is said to have resulted from his studies of his picture of "Adam and Eve". His two principal works on Symmetry and the Figure were published at Nuremberg in 1532 and 1534. These works were written in German, and after Dürer's death were translated into Latin. The figures illustrating these works were executed by Dürer, on wood, in an admirable manner.

Some authors have attempted to prove that Dürer did not execute any of his engravings on wood. Zani and Bartsch are decidedly of this opinion, and give reasons to show that only the designs were Dürer's, and that the mechanical operation of cutting was entrusted to skillful workmen in that

line. This decision of Bartsch extends also to Schaeufflein, Hans Burgkmair, Hans Baldung, Altdorfer, Lucas Cranach, and others—rather a sweeping declaration. But where could Dürer have found such skillful workmen in that early period of engraving, unless he had rendered them as skillful as himself by a course of instruction? That he had assistants in executing his numerous works cannot be doubted; nevertheless, they bear the genius and inspiration of his own directing hand, and they are as much his as were the immortal works of Michelangelo and Raphael in the Vatican, though they, too, had numerous assistants.

Dürer insisted that the woodblock in black and white be considered a complete design, making unnecessary the addition of pigment or gold to heighten the effect. The centuries have served to prove that he was right.

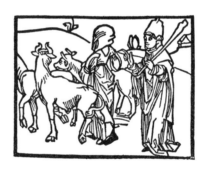

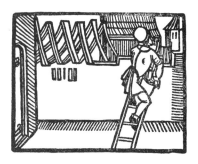 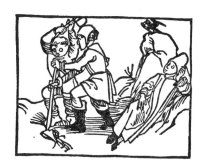

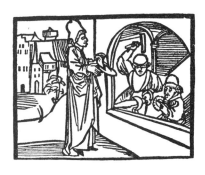 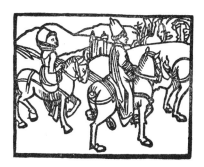

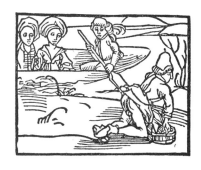 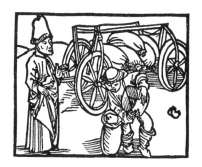

ALBRECHT DÜRER. *Seven woodcuts ascribed to Dürer's period of apprenticeship at Nuremberg, 1490*

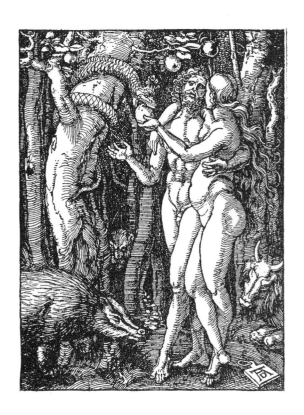

ALBRECHT DÜRER. 'Expulsion from Paradise', a woodcut from The Small Passion, 1510

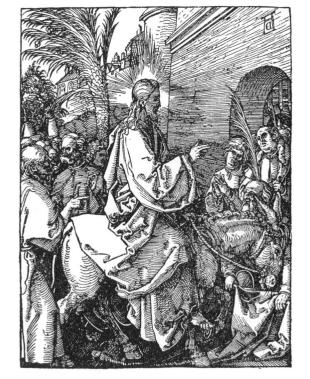

ALBRECHT DÜRER. 'Christ's Entry into Jerusalem', woodcut from The Small Passion

32

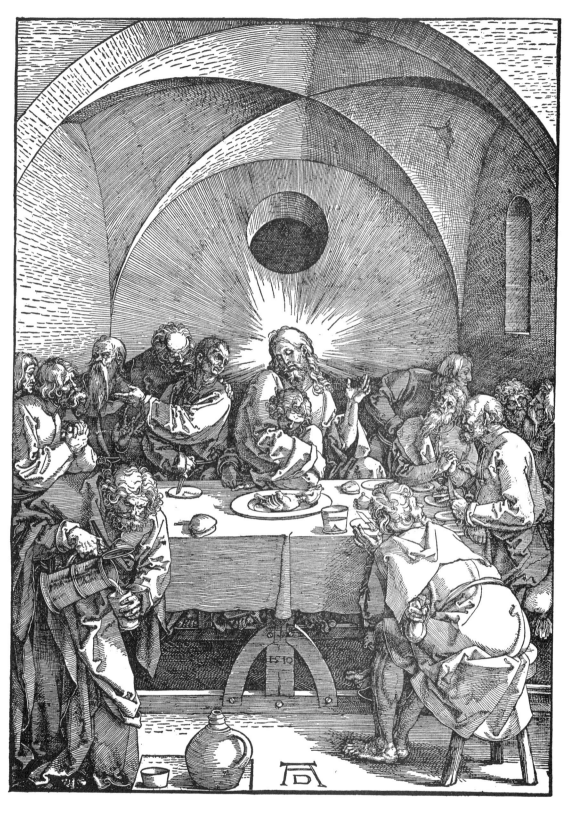

ALBRECHT DÜRER. 'The Last Supper', from the Great Passion, 1510

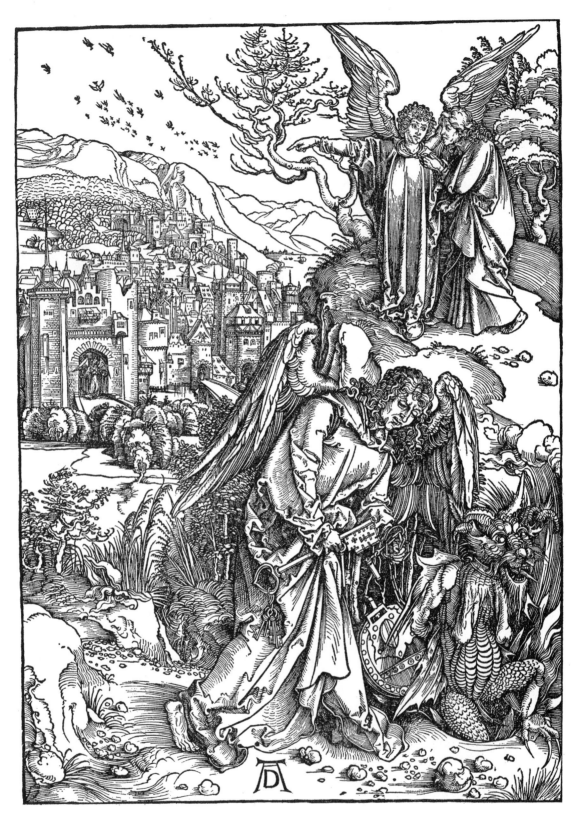

ALBRECHT DÜRER. *'The Angel With the Key'* Taken *from the Apocalypse Series*

34

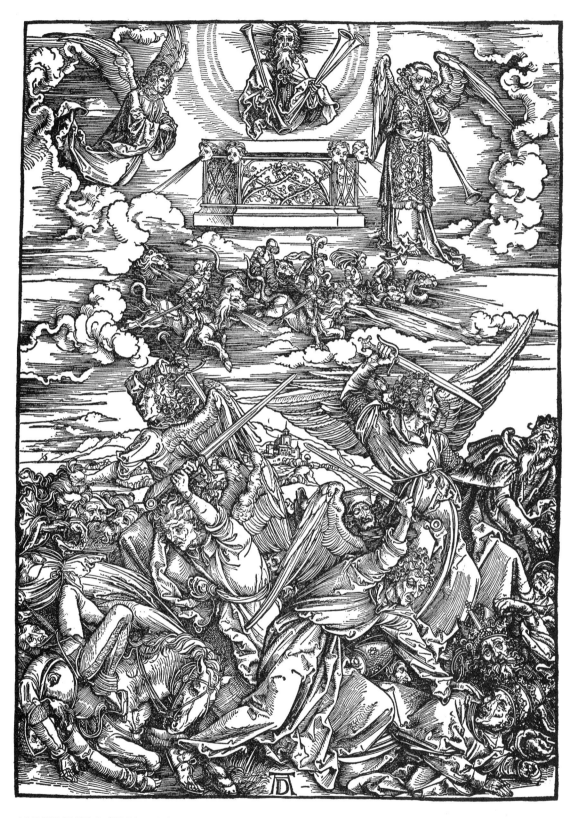

ALBRECHT DÜRER. *'The Battle of the Angels' Apocalypse Series*

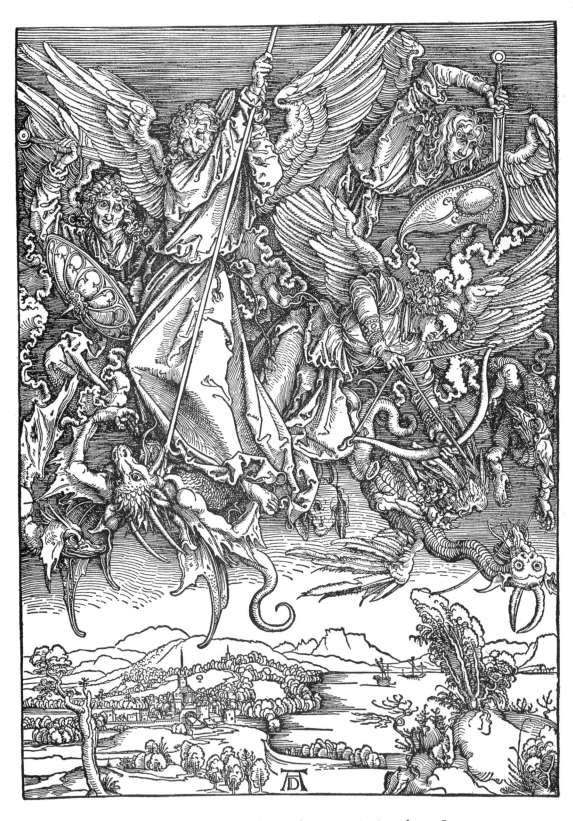

ALBRECHT DÜRER. 'St. Michael Fighting the Dragon' Apocalypse Series

36

THE EMPEROR MAXIMILIAN'S TRIUMPHAL PROCESSION

ALBRECHT DURER was the first great master of the woodcut. His strong personality and matchless technical equipment influenced a long line of fine artists, among them Altdorfer, Behams, and Burkmair in his own country, Bernard Salomon in France, and Marcantonio Raimondi in Italy. To this day, Durer remains a fountain of inspiration to engravers of the woodblock.

Durer, like Leonardo da Vinci, possessed the artist's vision together with the scientist's mind. This extraordinary combination of talents has nowhere been better reflected than in the woodcut series, the Triumphal Procession executed at the command of Emperor Maximilian. In their amazing detail and intricacy of design, these plates display the versatility of the artist's mind. In the drawings of the procession cars, his preoccupation with and understanding of the mechanical detail show his thorough grasp of science as well as design.

A remarkable feature of this series, above and beyond its historical and scientific interest, is the delicacy of treatment with which the whole involved project has been handled. The woodcut is commonly thought of as a broad rather than a subtle medium. Here the woodcut has been treated with the fine grace in line that we are accustomed to associate with a copper engraving.

With his sure feeling for composition, Durer in Plate 3 of this series has contrasted the rhythmic flow of lines in the lower half of the Plate with the strongly composed straight lines of the pikes in the battle scene above it. The winged lion and the supine figures beneath it serve both to repeat the flowing water lines in the lower part of the picture and to accentuate the allegory and symbolism of the subject matter. As plate after plate of the Procession unfolds such contrasts are developed and expanded.

The symbolism expressed in these plates was probably suggested by his friend, the humanist writer Pirkheimer, and the cutting was possibly done by another hand, but the magnificent fertility of invention in design is all Durer.

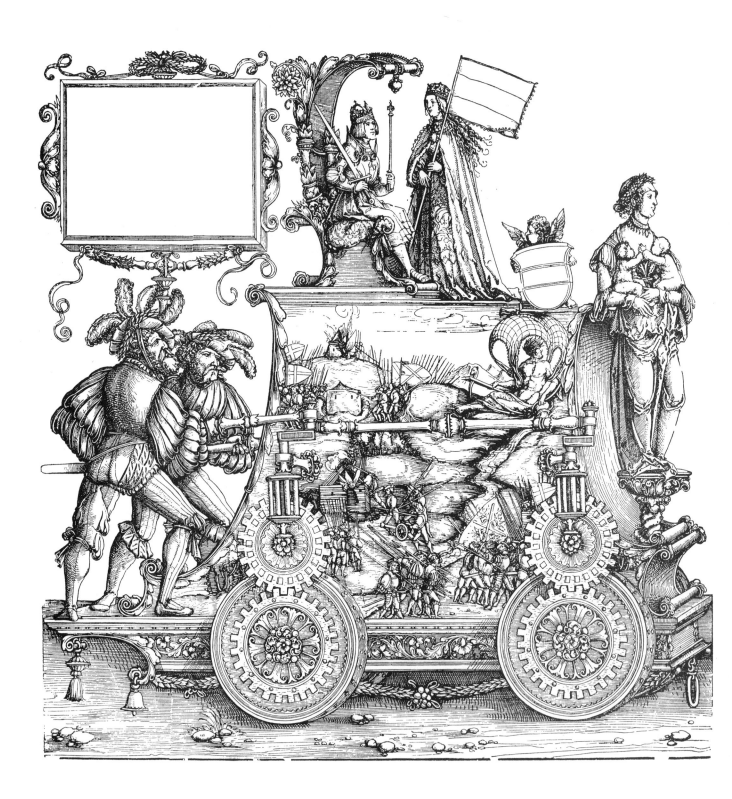

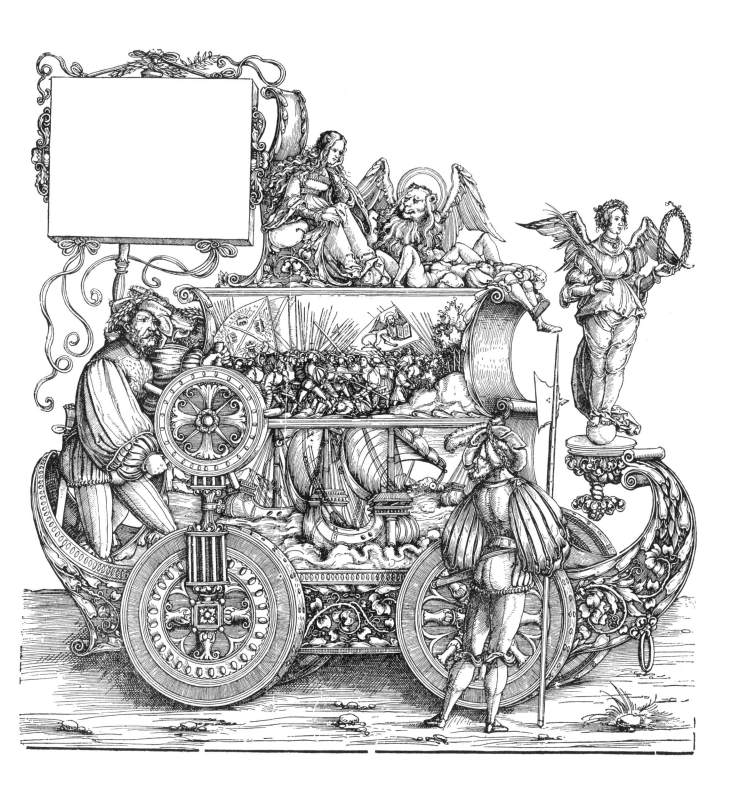

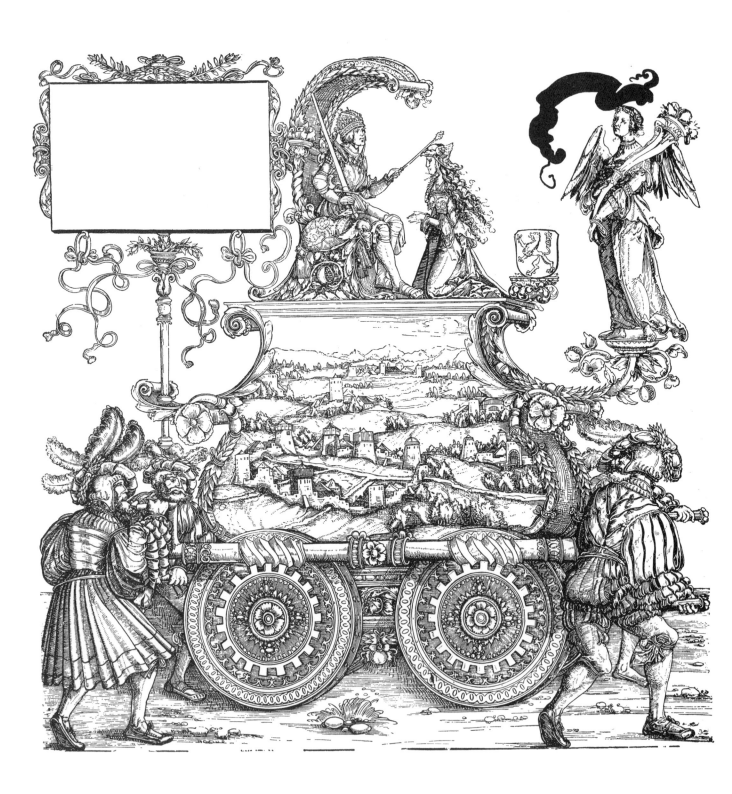

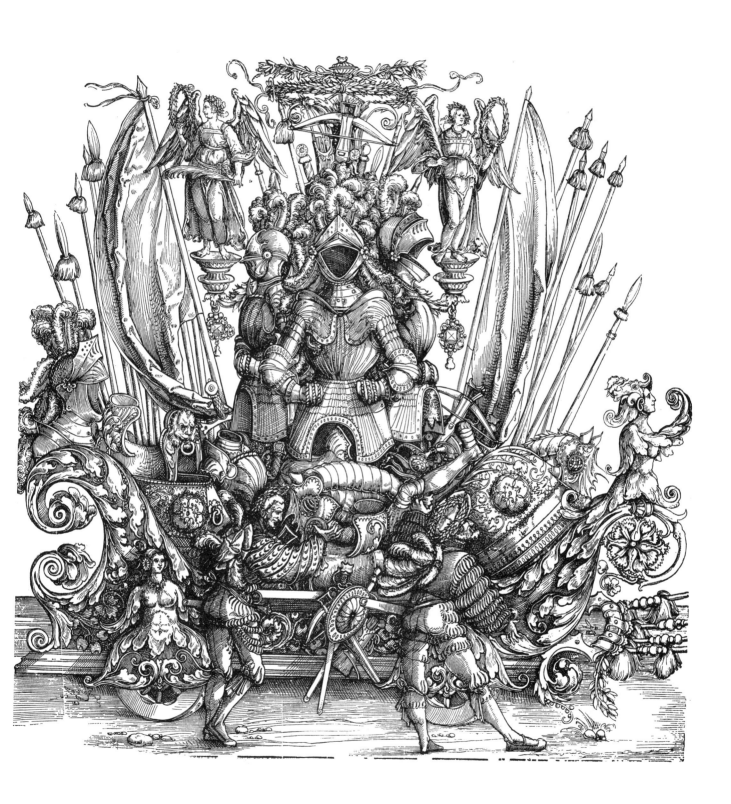

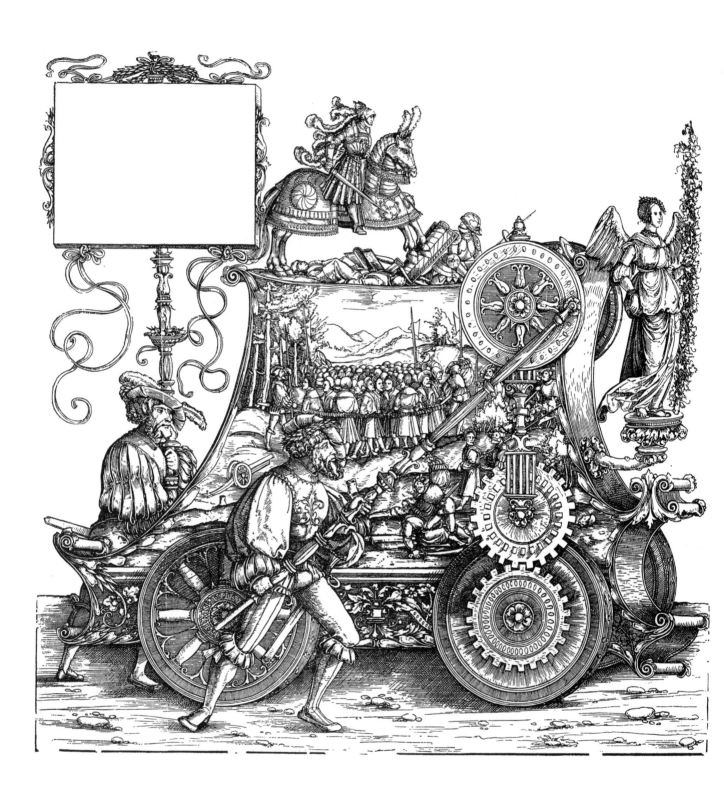

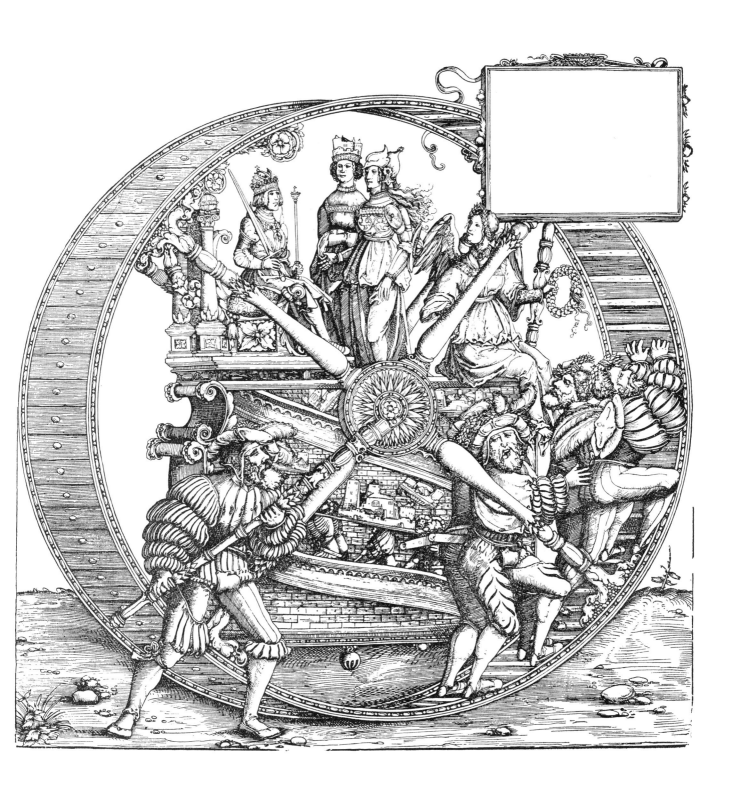

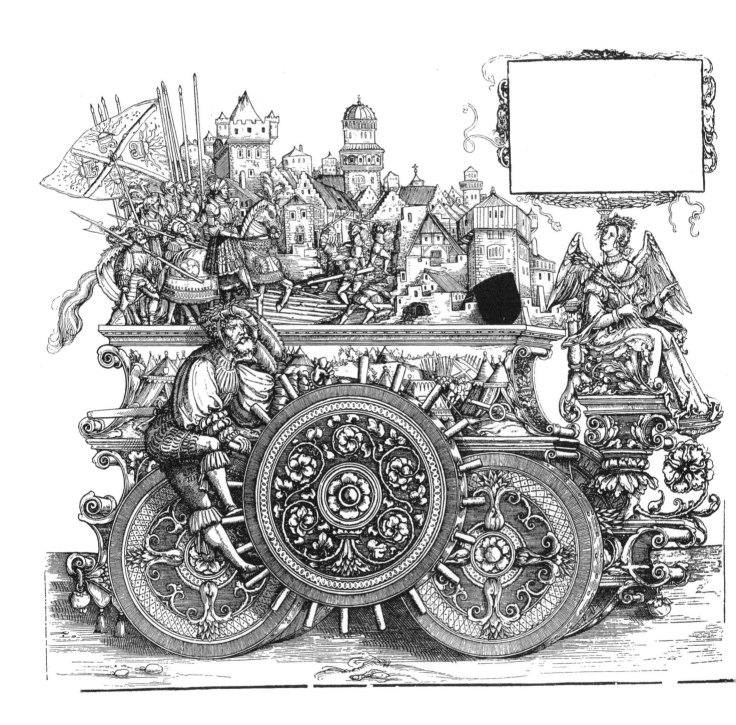

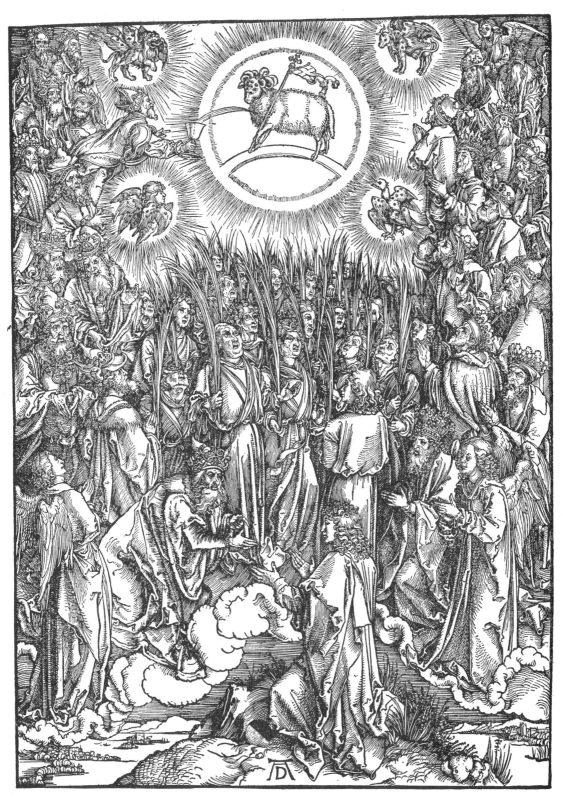

ALBRECHT DÜRER. *'The Adoration of the Lamb and the Hymn of the Chosen'* *Apocalypse*
Series

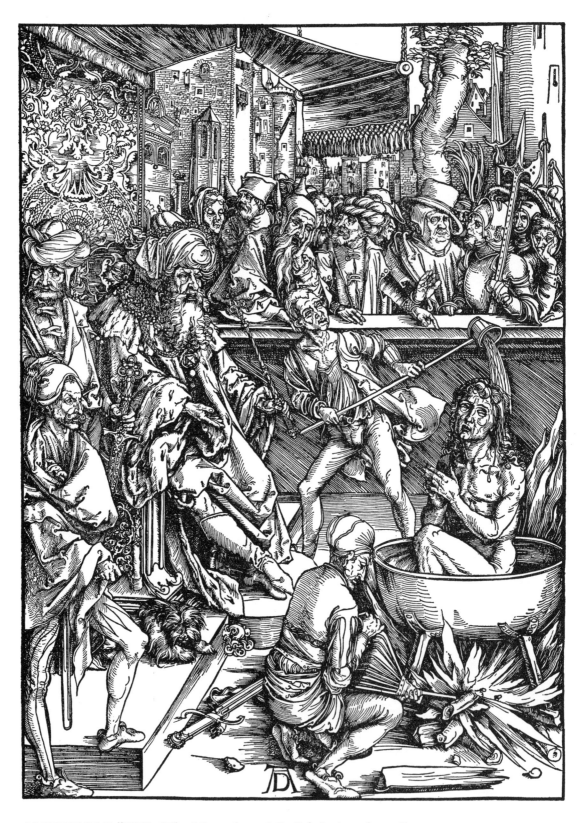

ALBRECHT DÜRER. *'The Martyrdom of St. John' Apocalypse Series*

38

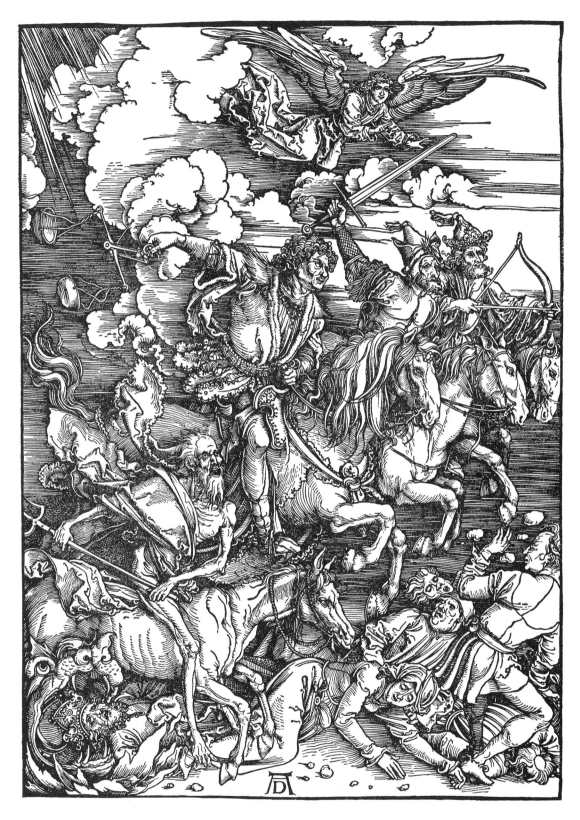

ALBRECHT DÜRER. *The Four Riders of the Apocalypse* 1498

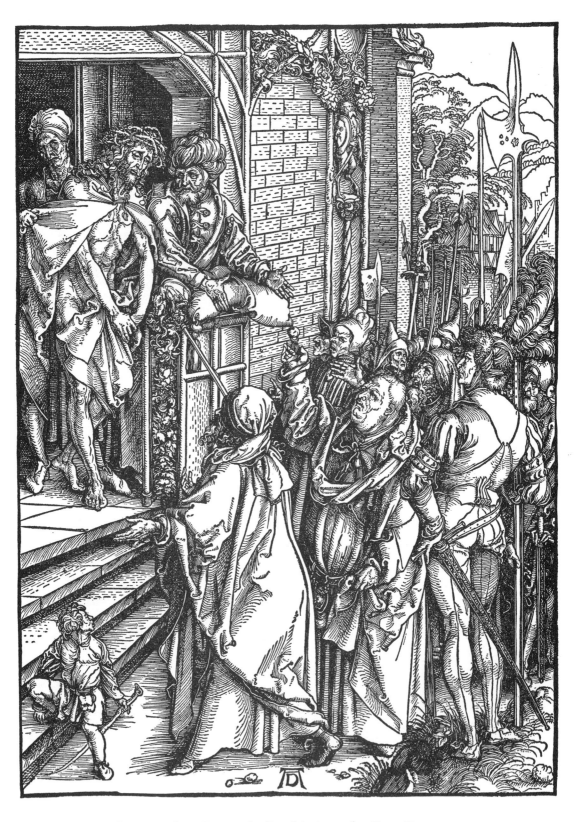

ALBRECHT DÜRER. *'Christ Before the People', from the Great Passion*, 1500

40

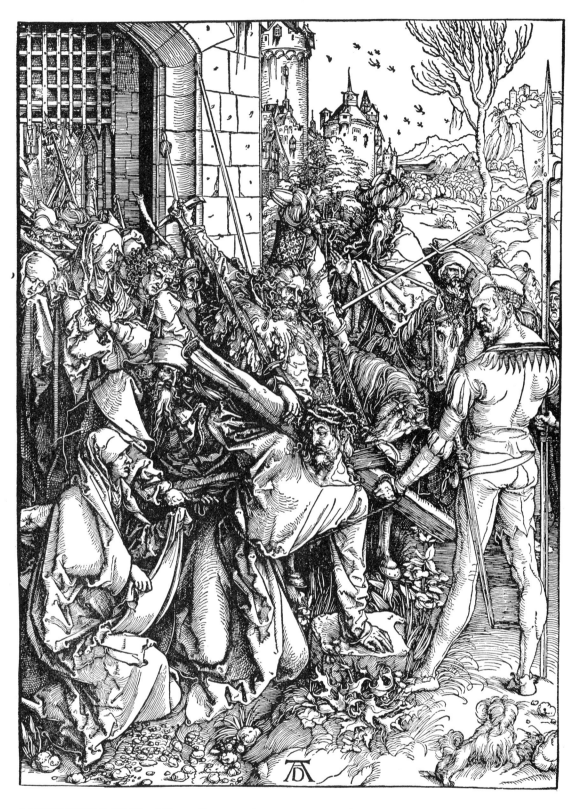

ALBRECHT DÜRER. 'Christ Bearing the Cross', from the Great Passion, 1500

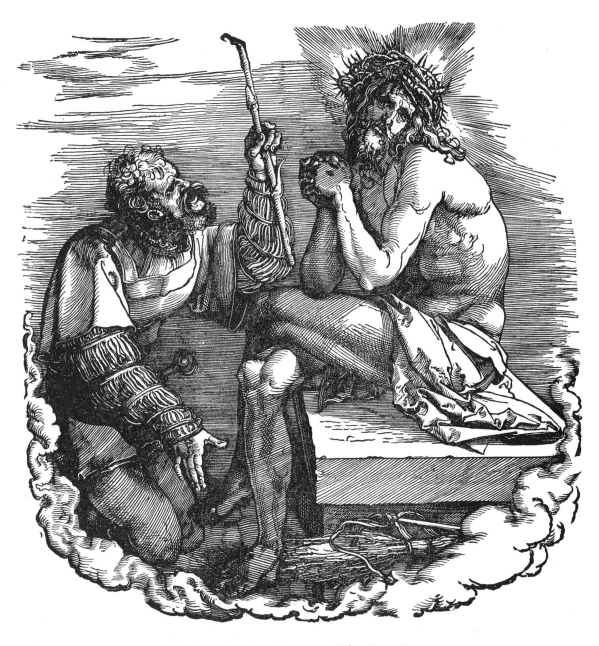

ALBRECHT DÜRER. *Woodcut for the title page of The Great Passion*

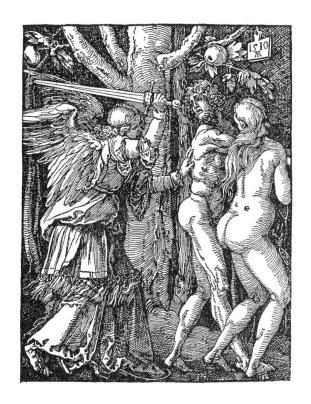

ALBRECHT DÜRER. *'The Fall'*, from *The Small Passion*

ALBRECHT DÜRER. *'The Annunciation'*, from *The Small Passion*

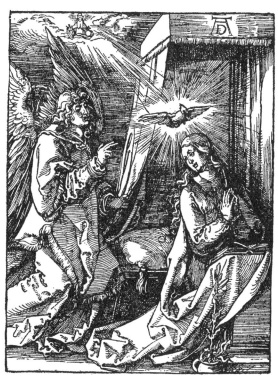

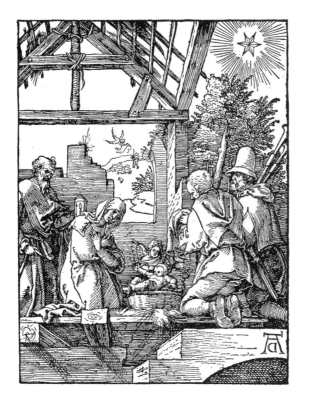

ALBRECHT DÜRER. *'The Nativity', from The Small Passion*

ALBRECHT DÜRER. *'Christ Taking Leave of His Mother', woodcut from The Small Passion*

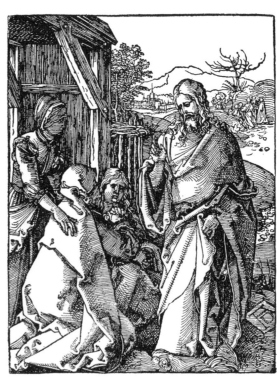

44

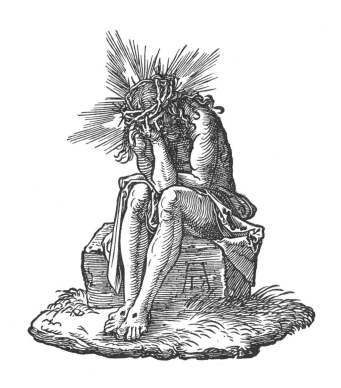

ALBRECHT DÜRER. 'The Man of Sorrows',
woodcut from the title page of The Small Passion

HANS HOLBEIN THE YOUNGER 1497-1543

FIRE, the carelessness of succeeding generations, the heavy hand of time: all these played their part in the destruction of Holbein's works. But enough remains from the hand of this prodigious worker to assure him a place in the first rank among the masters of illustration. There was no form of graphic or decorative art that was foreign to him. Holbein was a painter of frescoes, a portraitist, an architect, a designer of jewelry and furniture, and a book illustrator almost without equal.

There has been a fair amount of controversy as to the place of Holbein's birth. Some claim that it was Augsburg; others would have it Basle, in Switzerland. However, both groups agree to the date, which was 1497. At any rate, Hans Holbein was the son of Hans Holbein the Elder, who settled at Basle and resided there during the rest of his life.

In 1515 Holbein made a series of marginal drawings to *In Praise of Folly* by Erasmus. Erasmus' own copy bears Holbein's note that the drawings were made "in ten days especially for my friend." The illustrations were marvels of invention and rapid execution, wittily done with free, easy pen strokes. Where the text mentions the author, Holbein has given us a portrait of Erasmus in his study.

At the age of twenty-six, he designed a large series of drawings on wood for Luther's translation of the New Testament, printed by Thomas Wolff. Besides these, he made twenty illustrations to "Revelations." These drawings show in some measure the influence of his great predecessor, Dürer.

46

As a wood engraver, Holbein is said to have executed some works as early as 1511, and before his departure from Switzerland he engraved a great many woodcuts for the publishers of Basle, Zurich, Lyon and Leyden. The most important of these was a set of woodcuts entitled the *Dance of Death,* after his own design, which, complete, consists of fifty-three small upright plates, but is seldom found with more than forty-six. The first impressions are said to have been made in 1530; but there are later impressions, one being made at Lyon in 1549. They were copied on wood by an old engraver, in very inferior style.

There is also a set of ninety small cuts of subjects from the Old Testament, executed in a bold masterly style, but with great delicacy. The best impressions of these were published at Lyon in 1539, by Melchior and Gaspar Treschel; but there is a later edition, with two Latin verses eulogizing Holbein, and in this the cuts were copied rather poorly by Hans Brosamer.

Nearly all of Holbein's later designs on wood were cut by Hans Lutzelburger. He had a masterly skill in translating into the difficult medium of wood the exact quality of Holbein's beautiful line.

In later years, Holbein traveled to England. The date of his arrival is unknown, but his friendship with Erasmus was of value to him, for the scholar was held in high esteem there. Even more important, his earliest patron was Sir Thomas More. It was an auspicious beginning, and it meant that the future of the painter was assured. Sir Thomas was then at the height of his power, and his many friends employed Holbein to paint their portraits and decorate their homes. Henry the Eighth was pleased with his work and retained him. In St. John's College, Cambridge, is Henry the Eighth's Bible, printed on vellum, with Holbein's cuts finely illuminated.

After three years Holbein returned to Basle. A cold reception by his wife convinced him that England would be a more pleasant permanent home. He made provision for his family—he never failed to look after his children—and returned to Henry's court.

Thereafter Holbein's life was chiefly devoted to portrait painting. Holbein's prestige was so great that when a nobleman complained to Henry the Eighth of an assault provoked by the artist, the King replied, "Out of seven ploughmen I can make seven lords, but of seven lords I cannot make one Holbein".

It has been a matter of much speculation and comment that Holbein should have been content to spend the last twenty-eight years of his life as court-painter, neither developing nor fully using the gifts so generously endowed him by nature. He did well under the patronage of Henry the Eighth as court-painter but it was not the path to the highest achievement.

It is said of the years which followed 1526: "Hitherto with each work accomplished he had conquered a new dominion—made good a step onward and found that every height in his art was attainable, and that not a few had been already gained. The many-varied sides of existence stood before him in their fullness and with a depth at command such as hardly belonged to any other great painter of that grand time; and though neither the ideal greatness of the Italians, nor the strength of Albert Dürer, was an element of his nature, yet the wealth and power of his character offered a noble compensation for these, and, next to Dürer, he had become the greatest painter of the North".

The plague that swept London in 1543 accounted for Holbein's death.

Holbein's fame as an illustrator rests chiefly on his woodcuts, both his Bible illustrations and the celebrated *Dance of Death,* which remain as supreme examples of the illustrator's art. No more than three inches square they have the breadth and bigness of a mural. In them is a marvelous economy of line, an extraordinary amount of graphic skill. In them there is dramatic and tragic power, grim and sardonic humor. Death is no mere rattler of bones or a slinking figure of half shadows but rather, paradoxically enough, a living creature endowed with many human qualities. He is sometimes ludicrous, occasionally mischievous, but always a definite personality, the most important actor in each scene.

48

HANS HOLBEIN. *Initials for Dance of Death alphabet*

49

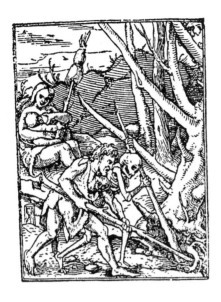

Birth and Death

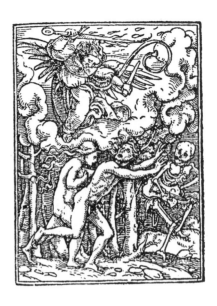

The Expulsion

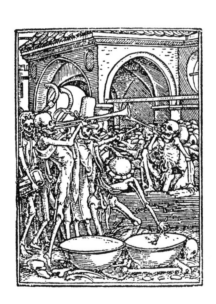

Death Goes Forth

HANS HOLBEIN. *Woodcuts from the Dance of Death*

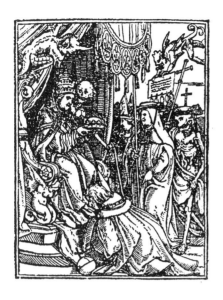

The Pope

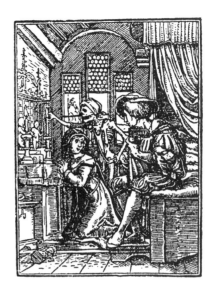

The Canoness

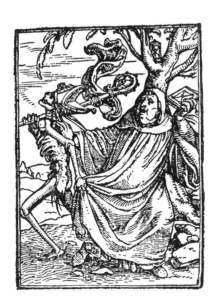

The Abbott

HANS HOLBEIN. *Woodcuts from the Dance of Death*

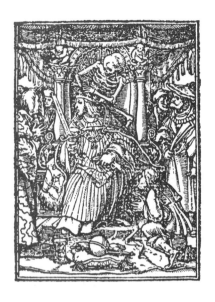

The Emperor

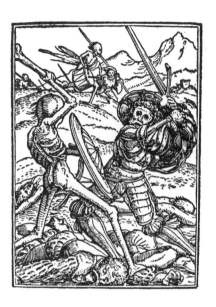

The Soldier

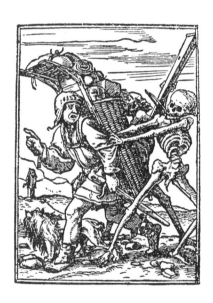

The Pedlar

HANS HOLBEIN. *Woodcuts from the Dance of Death*

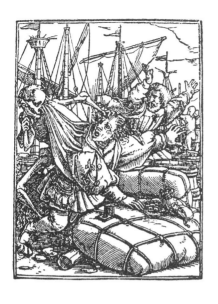

The Merchant

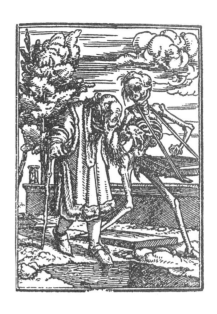

The Old Man

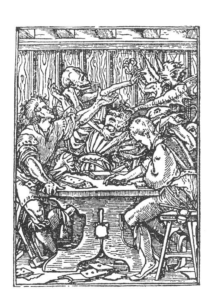

The Gamblers

HANS HOLBEIN. *Woodcuts from the Dance of Death*

53

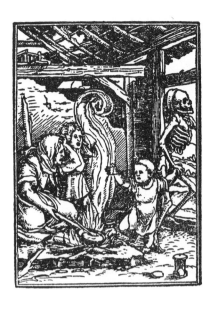

The Young Child

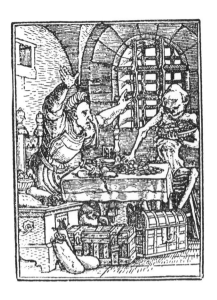

The Miser

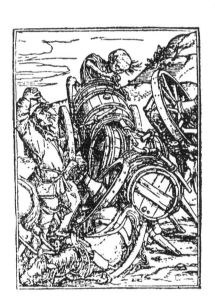

The Waggoner

HANS HOLBEIN. *Woodcuts from the Dance of Death*

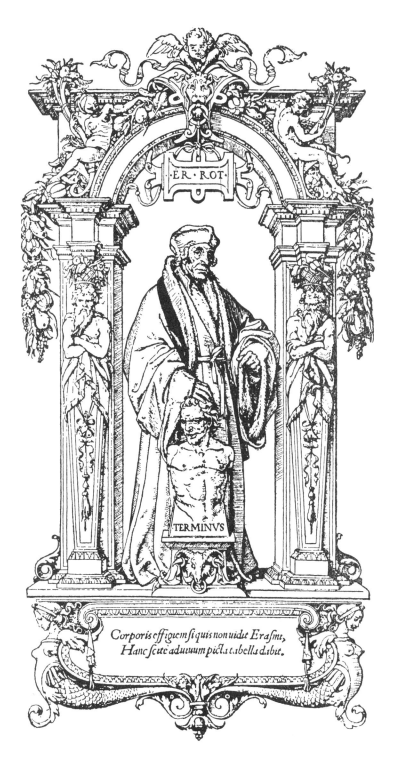

HANS HOLBEIN. *Portrait of Erasmus, woodcut*

HANS HOLBEIN. *Title page of the Coverdale Bible, woodcut*

56

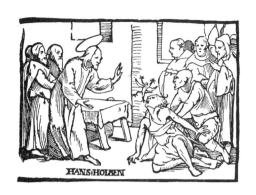

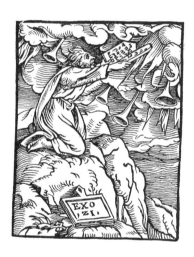

HANS HOLBEIN. '*Moses on Mount Sinai*', *woodcut*

WILLIAM HOGARTH 1697-1764

THIS eccentric genius was born in London in 1697. His father was a schoolmaster, and apprenticed him at an early age to an engraver of arms on plate. While thus engaged, his inclination for painting manifested itself in a remarkable manner. On a hot summer day Hogarth with some companions on an excursion to Highgate, the weather being very hot, they entered a public house, where before long a quarrel occurred. One of the young men struck another on the head with a quart pot, cutting him severely. The blood streamed down the man's face, whereupon Hogarth picked up a pencil and sketched the scene in a most truthful and ludicrous fashion.

At the expiration of his apprenticeship, he entered the Academy of St. Martin's Lane and studied from the model, but he did not immediately draw excellent figures. His first employment was the engraving of shop bills, and next the execution of prints for the booksellers.

The self-portrait of William Hogarth shows an honest open face. His work is equally honest and forthright. He gave us the London of his day, teeming with poor, and filled with purveyors of every sort of vice. London formed the background for his stirring sermons in pictorial form. He knew the great city well. Cheapside, Charing Cross, Bridewell, Fleet Street Prison, all were familiar to him and became part of the moving pageantry he set down.

There were indications in his early work that he had studied the great French satirist and etcher Jacques Callot. In Hogarth's crowded plates there

58

is the same preoccupation with little figures, each carefully individualized, carrying on the business of life.

It was by the small illustrations to Samuel Butler's *Hudibras* in its 1726 edition that Hogarth first became known to his profession, although one year previously he had engraved some prints for Beaver's *Military Punishments of the Ancients*. The *Hudibras* illustrations are not too original and closely resemble earlier illustrations for the same book. But it was not easy for Hogarth to fit into the mold of another man's ideas. He preferred to plan and illustrate his own books.

Hogarth has told us that he cared little for drawing from the nude; he regarded the practice as merely another form of copying. After he left the Academy he ceased almost entirely drawing from the model. Instead he fixed the scenes and people in his memory.

It was a very natural move for Hogarth to change from portraiture to the field in which he was to excel. He found that portrait painting, when done conscientiously, is laborious, and it was "not sufficiently profitable" to pay the expenses of his family. "I therefore turned my thoughts," he said, "to a still more novel mode, namely painting and engraving modern subjects, a field not broken up in any country or any age." It was in this field that his apprenticeship as an engraver stood him in good stead. Hogarth first painted in oil the subjects of his many series, and then, with increasing skill, engraved them on copper. His own engraving was always superior to that of the professional engravers who worked from his drawings after his death.

Hogarth scorned the conventional, drawing always from his full store of human knowledge. With a sure sense of design he was able to make a work of art from materials which in lesser hands might have become mere sentimentality. But beyond the moralizing and story-telling, the framework of great pictorial art stands as the sincere expression of compositions well understood and well drawn. The dynamic feeling for design is one of Hogarth's most important contributions to modern art.

It is interesting to note that Hogarth was not always held in the high esteem with which he is regarded today. The serious critics of the last century looked upon him in an entirely different light. The following excerpt from Spooner's *History of the Fine Arts* serves as an illustrious example:

"His [Hogarth's] design and coloring possessed little merit. He was incapable of conceiving or illustrating a single noble passion of the human soul, and combined his burlesques with elevated subjects in a most disgusting manner, of which his "Sigismunda' is an example. His mind was of a very low order, totally devoid of delicacy, refinement or education. Naturally of a vulgar and satirical disposition, his asperities were never softened by contact with refined society. Like many others who attain position by wealth alone, he evinced his narrowness of mind by affecting to despise all knowledge which he did not himself possess, and continued gross and uncultivated during his whole life."

The eulogy above was published in New York exactly one hundred years after Hogarth's death.

It is true that the pathetic tales expressively told in "The Harlot's Progress" and "The Rake's Progress" will hardly produce the same effect today as their creator so solemnly expected. But in the early Eighteenth Century they were immensely popular. Hogarth's public very probably cared little about artistic merit, but in Moll Hackabout, the harlot, it found a subject close to its understanding. Moll's success was followed by the "Rake's Progress", and then came the most finished, technically, of the plates, "Marriage à la Mode", in which Hogarth bitterly satirized upper-class society in six trenchant scenes.

The artist seemed to take great delight in taunting those with whose opinions he differed. He became involved in a controversy with Wilkes, in which he gave the first offense by an oblique attack on Wilkes and his friends in his published print, "The Times".

Wilkes answered by a severe article in the *North Briton,* and Hogarth retorted by a caricature of the writer. Churchill, the poet, then entered the

arena of this ludicrous strife and wrote his *Epistle to Hogarth,* which the latter answered by a caricature of Churchill, represented as a canonical bear, with a ragged staff and a pot of porter.

But the great of his day found Hogarth of their own stamp. Fielding wrote of him with appreciation; and when his fame had spread to Dublin, the ironic Dean Swift, author of *Gulliver's Travels,* sent these lines to him:

> *How I want thee, humorous Hogarth,*
> *Thou I hear a pleasant rogue art.*
> *Were but you and I acquainted,*
> *Every monster should be painted.*
> *You should try your graving tools*
> *On this odious group of fools.*
> *Draw the beasts as I describe them,*
> *Form their features while I jibe them.*
> *Draw them like, for I assure ye*
> *You will need no caricatura.*
> *Draw them so that we may trace*
> *All the soul in every face.*

And Hogarth did.

WILLIAM HOGARTH. *'Gin Lane'*, engraving

WILLIAM HOGARTH. 'A Modern Midnight Conversation'

O Vanity of youthful Blood,
So by Misuse to poison good.
Reason awak's 'tis all in vain,
To hug the fetterd Slaves of Love.

Banish'd o'er every Youthfull Blessing,
All Charms in Sin caress'd,
But turn to thee, and Plague's at once,
Are to thy Bosom join't to Love.

Each Divine to entrant Viewing
After Masses of Ruin,
And Thou, in Ref of Self divine,
Sweet Person of Misused Wine.

With Freedom led to every Part,
And Secret Chamber of y Heart,
Def Thou thy Friendly Host Coenay,
And there thy pious gang of may,

To enter in with sweet Trogan,
O show the atom in quantity Ragon
To ransack the attainend Place,
And revel there with wild Exert
 race,

Invented, Painted, Engraved & Publish'd by W.m Hogarth June y.e 25. 1735. according to Act of Parliament.

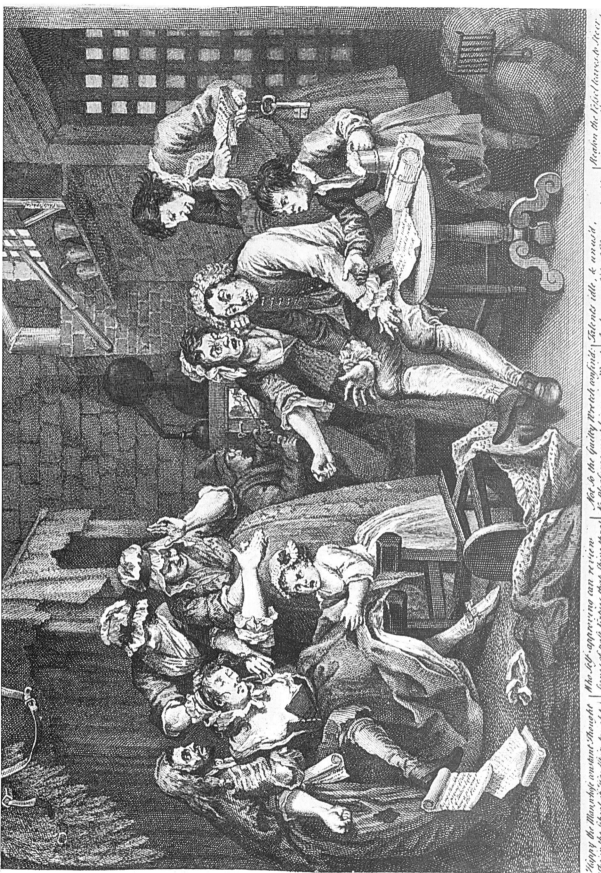

WILLIAM HOGARTH. *Plate VII from The Rake's Progress*

65

Beer, happy Produce of our Isle
Can sinewy Strength impart,
And wearied with Fatigue and Toil
Can chear each manly Heart.

Labour and Art upheld by Thee
Successfully advance,
We quaff Thy balmy Juice with Glee
And Water leave to France.

Genius of Health, thy grateful Taste
Rivals the Cup of Jove,
And warms each English generous Breast
With Liberty and Love.

WILLIAM HOGARTH. *Beer Street*

66

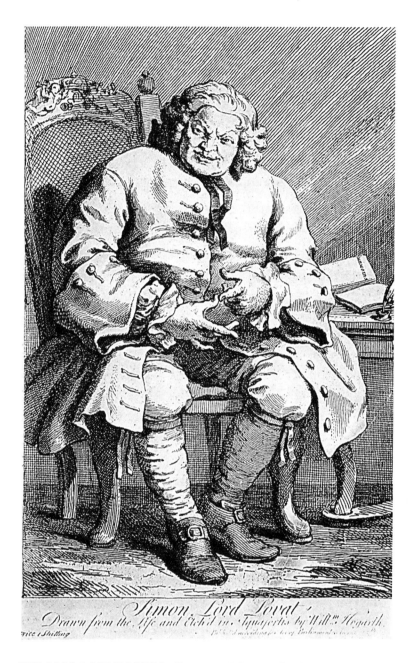

WILLIAM HOGARTH. *Portrait of Simon Lord Lovat*

67

WILLIAM BLAKE 1757-1827

IT IS difficult to reconcile the figure of William Blake with the England of his time. George the Third was king, and the ways of commerce and the need for expansion held full sway. In their tradesman's prosperity, the newly wealthy Britons looked abroad for culture and art. The popular English portraitists were those who could render the faces of the blunt English squires and their angular ladies in the soft, flattering style of the Italians. Backgrounds were cluttered with columns and statuary and the other trappings and appurtenances of wealth. Blake, of course, had no place in this scheme of things.

He was born of a poor family, one of several children. His father would have allowed him to follow his inclination and study to be a painter, but the young boy felt that this would place too great a burden upon his parents. Instead he was apprenticed to Basire, the engraver. There he found himself at work upon the engravings for Gough's sepulchral monuments in Westminster Abbey. The austere Gothic beauty of the great cathedral impressed itself deeply upon him. He read the Bible, Locke and Bacon assiduously. In 1778 he completed his apprenticeship and soon his circle of friends included Stothard, Flaxman and Fuseli, each of whom played a large part in his later life.

Blake's marriage with the young Catherine Boucher was a happy one, perhaps the only joyful event in his harried life. The artist-poet taught his wife to read and write; soon she was able to copy his manuscripts and even color his engravings. Her sensitive willingness to humor his many moods

balanced in some measure his high-strung and nervous temperament. Before the advent of psychoanalysis into our civilization, Blake was often called mad. But now we know that this was scarcely the word to describe his overpowering belief in visions and the supernatural.

Blake invented a process by which he lettered words and drew pictures with an acid-resistant medium on copper-plate, then etched it with acid. The text and decorations remained in relief. It could be printed in black and later colored by hand. *The Songs of Innocence,* written and illustrated by Blake, were done in this manner. The book was completed in 1789 and sold for a few shillings. In it the lyrical and mystic elements of Blake's strange genius are closely mingled.

Except for four years at Felpham, where he worked on a life of Cowper under the author's eyes, Blake spent his entire life within the walls of London. His circle of friends widened to include a Captain Butts, for thirty years the artist's faithful admirer and patron.

Were Blake living today, it is doubtful that he would be less incomprehensible to us than he was to his contemporaries. Ceaselessly he fought against materialism. He was deeply religious, although his convictions were not at all in accord with the more conventional forms of worship. His mental experiences are described at great length in his own writings. His greatest work, the illustrations for the "Book of Job", was completed in 1821. Their mystical content has not prevented the twenty engravings of this series from becoming the most widely known of his work. Other examples of his industry and genius are his illustrations for Young's *Night Thoughts, Jerusalem,* and Blair's *Grave.* He was one of the first illustrators to design his engravings with geometrical precision, sometimes sacrificing the individual form to the effect in its entirety.

The things of everyday life have no place in the works of William Blake. He actually believed that the visions revealed in his work came directly to him from God, and that this imagery was the only reality. When he died a lifetime of tremendous labor was rewarded with a pauper's grave.

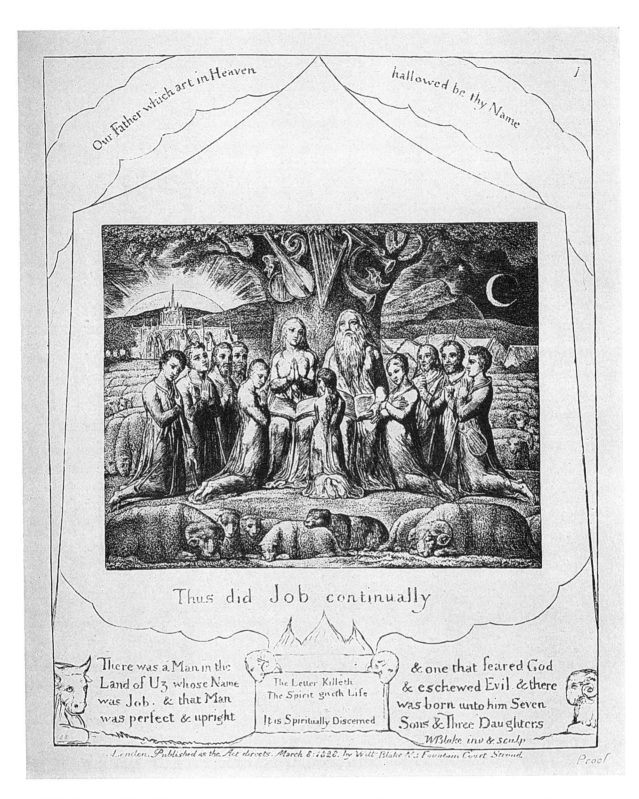

Our Father which art in Heaven *hallowed be thy Name*

i

Thus did Job continually

There was a Man in the
Land of Uz whose Name
was Job. & that Man
was perfect & upright

The Letter Killeth
The Spirit giveth Life

It is Spiritually Discerned

& one that feared God
& eschewed Evil & there
was born unto him Seven
Sons & Three Daughters

W Blake inv & sculp

London. Published as the Act directs. March 8: 1828. by Will. Blake N.s Fountain Court Strand.

Proof

WILLIAM BLAKE. *The engraving on this page and the following ten plates are from The Book of Job, illustrated, engraved and printed by William Blake*

70

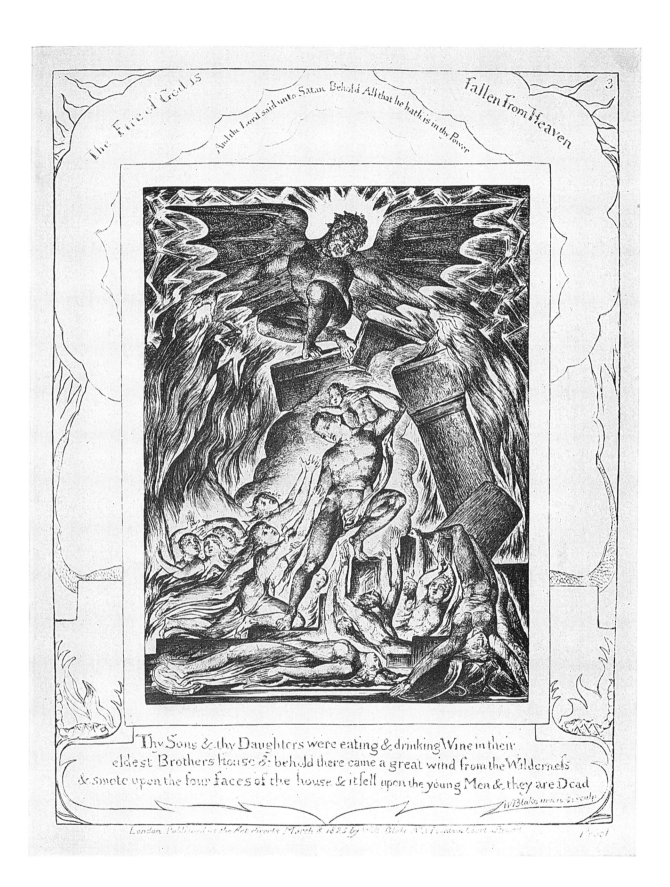

The Fiend God is And the Lord said unto Satan Behold All that he hath is in thy Power fallen from Heaven

Thy Sons & thy Daughters were eating & drinking Wine in their
eldest Brothers house & behold there came a great wind from the Wilderness
& smote upon the four faces of the house & it fell upon the young Men & they are Dead

W Blake inven & sculp

London, Published as the Act directs March 8 1825 by Will Blake N 3 Fountain Court Strand

Proof

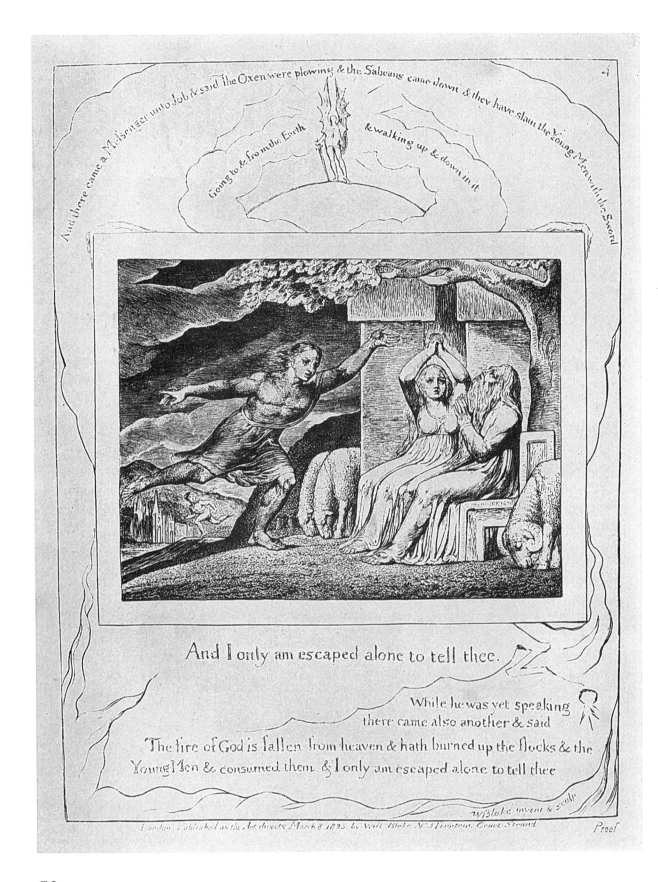

And there came a Messenger unto Job & said the Oxen were plowing & the Sabeans came down & they have slain the Young Men with the Sword

Going to & fro in the Earth

& walking up & down in it

And I only am escaped alone to tell thee.

While he was yet speaking
there came also another & said

The fire of God is fallen from heaven & hath burned up the flocks & the
Young Men & consumed them & I only am escaped alone to tell thee

W Blake invent & sculp

London, Published as the Act directs March 8 1825 by Will Blake N 3 Fountain Court Strand

Proof

72

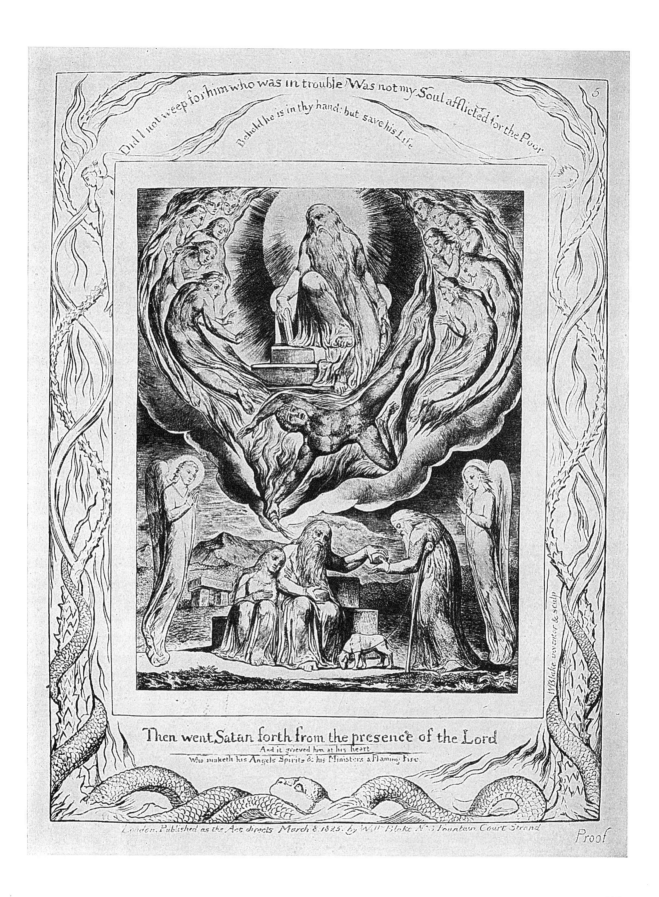

Did I not weep for him who was in trouble Was not my Soul afflicted for the Poor

Behold he is in thy hand: but save his Life

Then went Satan forth from the presence of the Lord

And it grieved him at his heart

Who maketh his Angels Spirits & his Ministers a Flaming Fire

WBlake inventor & sculp

London, Published as the Act directs March 8.1825. by Will: Blake N 3 Fountain Court Strand

Proof

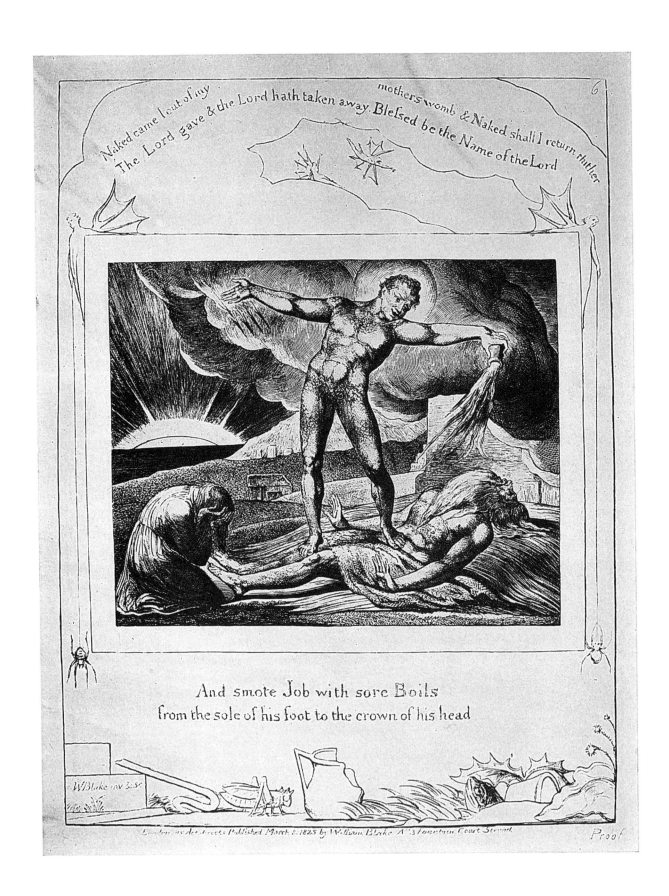

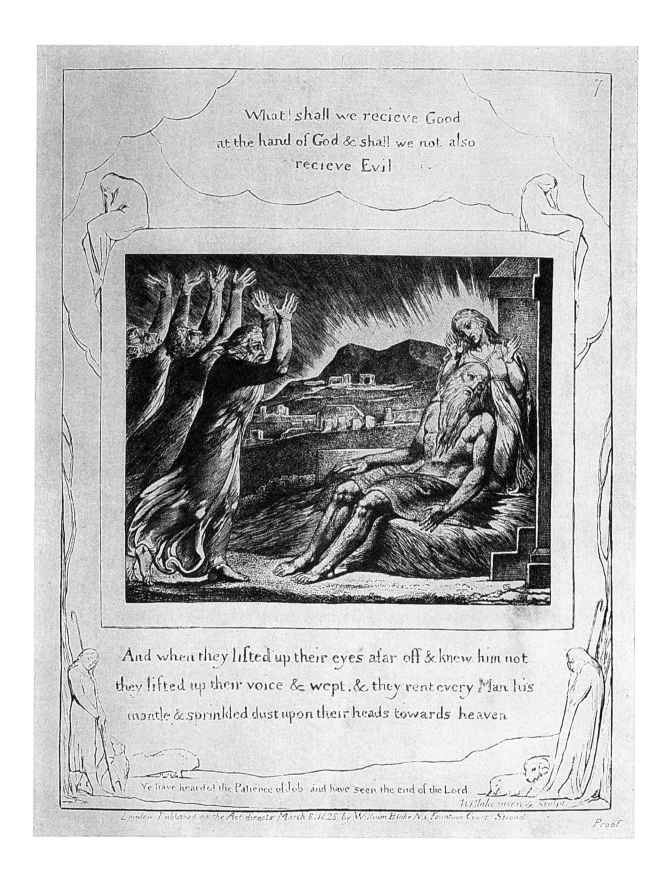

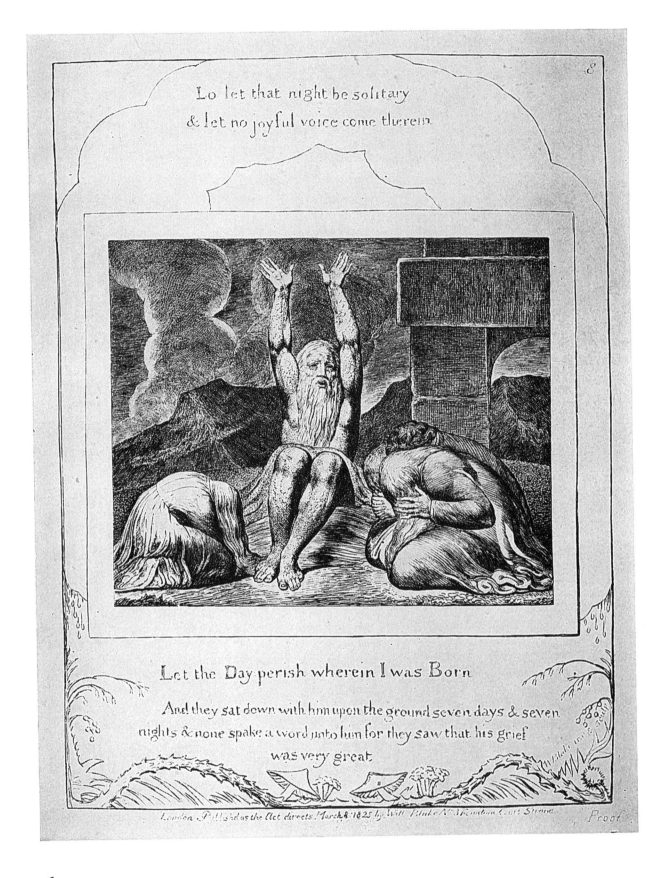

Lo let that night be solitary
& let no joyful voice come therein.

Let the Day perish wherein I was Born

And they sat down with him upon the ground seven days & seven
nights & none spake a word unto him for they saw that his grief
was very great

London Publish'd as the Act directs March 8: 1825 by Will Blake N 3 Fountain Court Strand. Proof

76

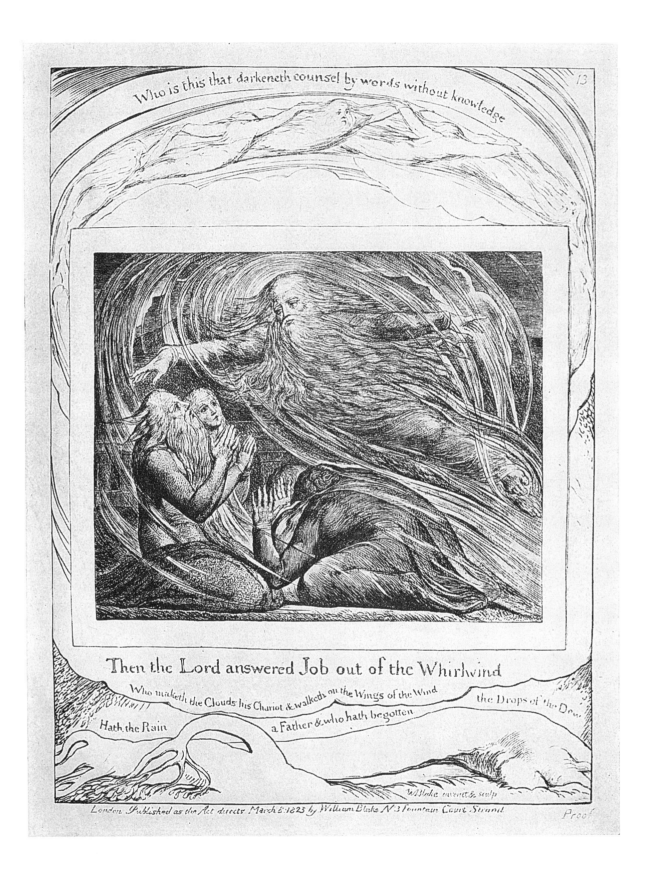

Who is this that darkeneth counsel by words without knowledge

13

Then the Lord answered Job out of the Whirlwind

Who maketh the Clouds his Chariot & walketh on the Wings of the Wind the Drops of the Dew

Hath the Rain a Father & who hath begotten

W Blake invent & sculp

London Published as the Act directs March 8: 1825 by William Blake N 3 Fountain Court Strand

Proof

77

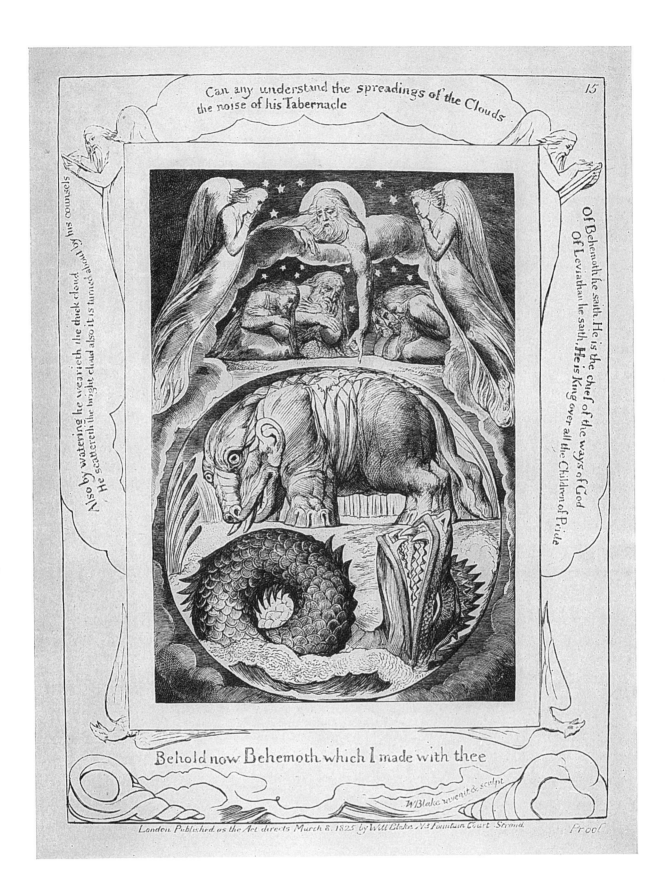

Can any understand the spreadings of the Clouds
the noise of his Tabernacle

15

Also by watering he wearieth the thick cloud
He scattereth the bright cloud also it is turned about by his counsels

Of Behemoth he saith. He is the chief of the ways of God
Of Leviathan he saith. He is King over all the Children of Pride

Behold now Behemoth which I made with thee

W Blake invenit & sculpt.

London Published as the Act directs March 8. 1825 by Will Blake N.3 Fountain Court Strand.

Proof

78

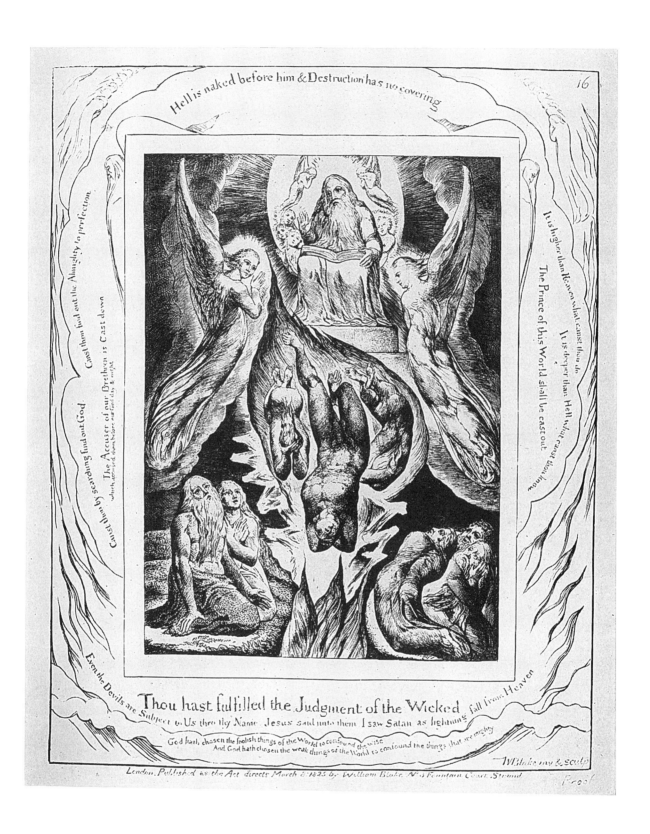

Hell is naked before him & Destruction has no covering

Canst thou find out the Almighty to perfection

Canst thou by searching find out God.

The Accuser of our Brethren is Cast down
which accused them before our God day & night

Even the Devils are

It is higher than Heaven what canst thou do

It is deeper than Hell what canst thou know

The Prince of this World shall be cast out

Thou hast fulfilled the Judgment of the Wicked fall from Heaven
Subject to Us thro thy Name Jesus said unto them I saw Satan as lightning

God hath chosen the foolish things of the World to confound the wise
And God hath chosen the weak things of the World to confound the things that are mighty

WBlake inv & sculp

London, Published as the Act directs March 8 1825 by William Blake N 3 Fountain Court Strand

Proof

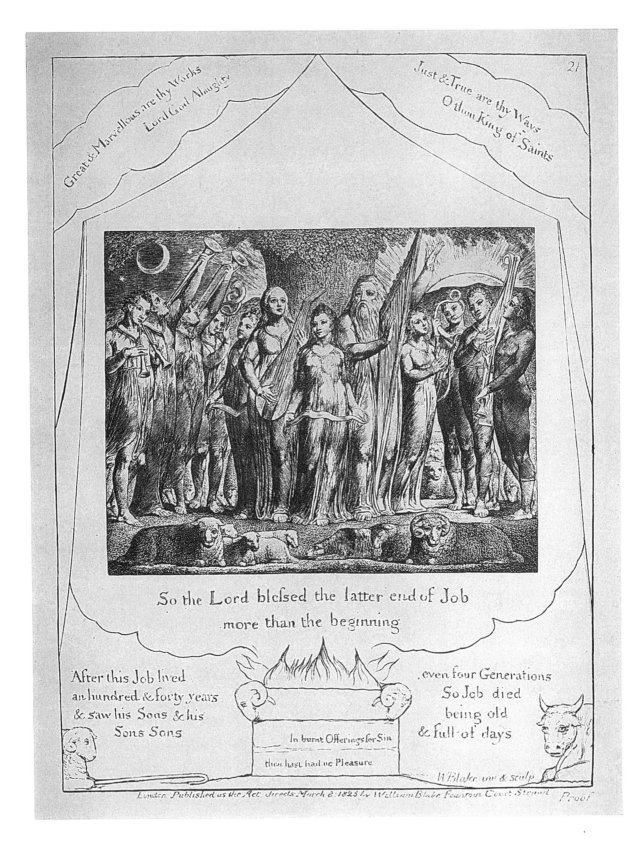

FRANCISCO JOSÉ DE GOYA Y LUCIENTES
1746-1828

THE WORKS of Goya are a mirror of his country and his times. Spain of the Eighteenth Century was a land filled with abuses, drenched with blood, decaying with a stench that filled the entire continent of Europe. Into a royal court peopled by harlots and weaklings, strode a stocky peasant, who by means of his singular genius was to etch for all time a history of the ghastly comedy that was the Spain of Charles the Fourth.

In 1746 Francisco Goya y Lucientes was born at Fuendetodos, a miserably poor mountain village. His father was a farmer; his mother a descendant of bedraggled nobility. In outward appearance, Goya is known to us chiefly through his later paintings of himself. He was short and snub-nosed, and his eyes were set deep in his head.

Goya's early life was wild and undisciplined, a possible factor in his slow development as a painter. He was healthy and full-blooded, and he rarely passed up a drinking bout. He took a lively interest in bullfighting, as may be evidenced by his convincing graphic records of that native sport. While we can learn little of his early artistic progress, we do know that at the age of twenty he was forced to leave Saragossa under the cover of night. His unscheduled flight was the result of an affair of the previous evening, during which three people were killed in a brawl. He went to Madrid, where he conducted himself in the same manner, and so was forced to flee again.

This time he went to Rome. Nothing about his stay at the Eternal City

hinted that this was the man who was to be the connecting link between the last of the great Renaissance masters and the first of the moderns. But in Goya's thirtieth year, upon his return to Spain, a new influence found its way into his art. The King had been induced to commission Goya to design a set of tapestries for the royal palace. Throwing convention to the winds, Goya executed these thirty cartoons in the spirit of his own time. Deliberately he rejected the time-honored classical and mythological subjects in favor of the scenes that surrounded him. Yet at thirty-seven Goya had still produced nothing of true worth, not one of the pictures on which rests his fame.

However, his reputation advanced steadily and by 1795, when he was again well of an illness that had affected his sight and hearing for some years, he was appointed first Court Painter, a coveted position. This most uncompromising of artists loved to have honors bestowed upon him. But his opportunity for observation at the Court was dangerously close to being his undoing, for the satire in some of the biting plates of *los Caprichos* was discovered by the objects of his ridicule. First to be identified among his fantastic figures were the favorites of the Queen, then the Queen, and finally the King himself. The Inquisition, quickly infuriated and inexorable in its punishment, was moved to act—then rescue came from the most unexpected source. Charles the Fourth, despite his many other faults, did possess a rare sense of humor. He ordered an edition of 240 copies of the series, then purchased the plates themselves.

When the Revolution broke out in 1808, Goya witnessed the terrible massacre of civilians by the soldiers at Puerto del Sol. Out of this came one of the most shockingly realistic of all paintings of war.

Goya left countless etchings—*los Caprichos* alone is a series of eighty plates—lithographs and drawings. Their varied subjects inspire horror, and amazement at the artist's diabolical inventiveness. There are garrotted men, and mothers offering their daughters as prostitutes. There are scenes of the bull ring made with evident enjoyment, the tortures of the Inquisition, and

the brutality of the Revolution. All these things charged Goya's needle with fire. Fiendish imagery, violence, fierceness and scorn characterize them all. Yet never did Goya allow his emotions to overbalance his artistry. Nothing was overdone. In the aquatint he was supreme. A few lines suffice to suggest a crowded square or a mood of terror.

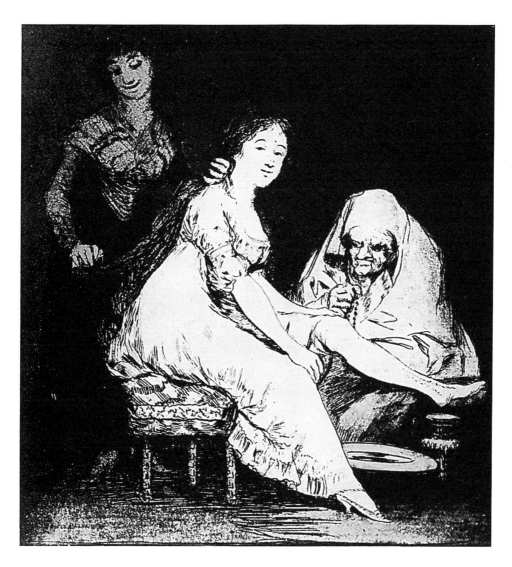

FRANCISCO GOYA.

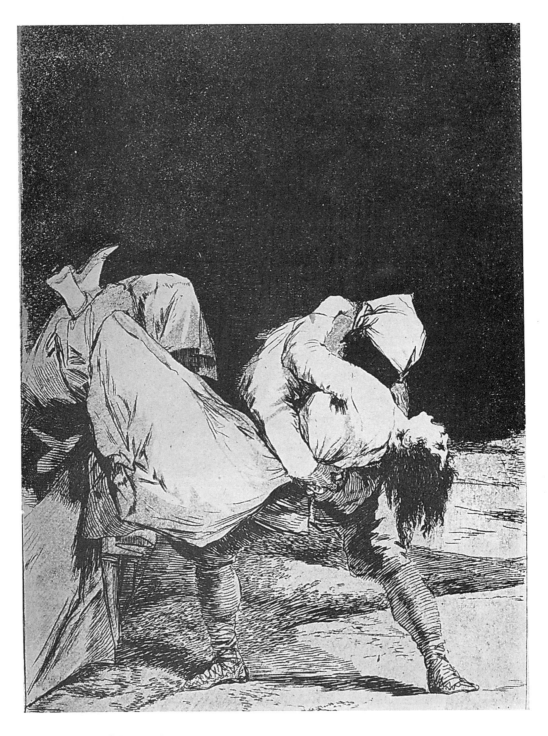

FRANCISCO GOYA. *Illustration from Los Desastres de la Guerra*

84

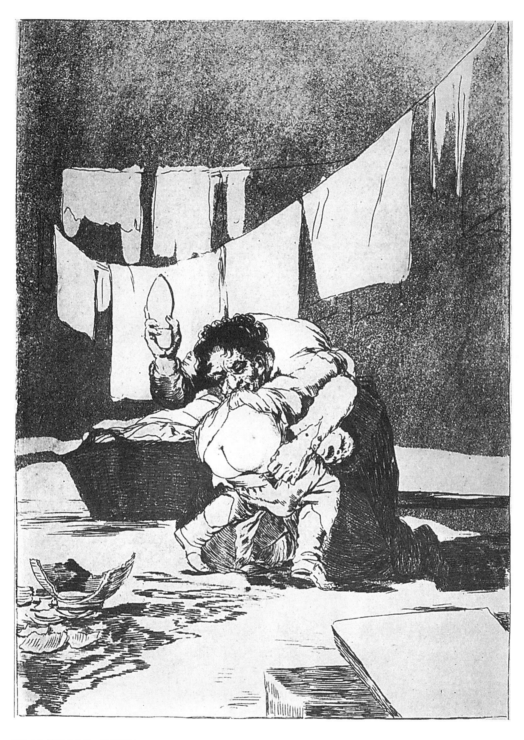

FRANCISCO GOYA.

FRANCISCO GOYA. *Illustration from Los Desastres de la Guerra*

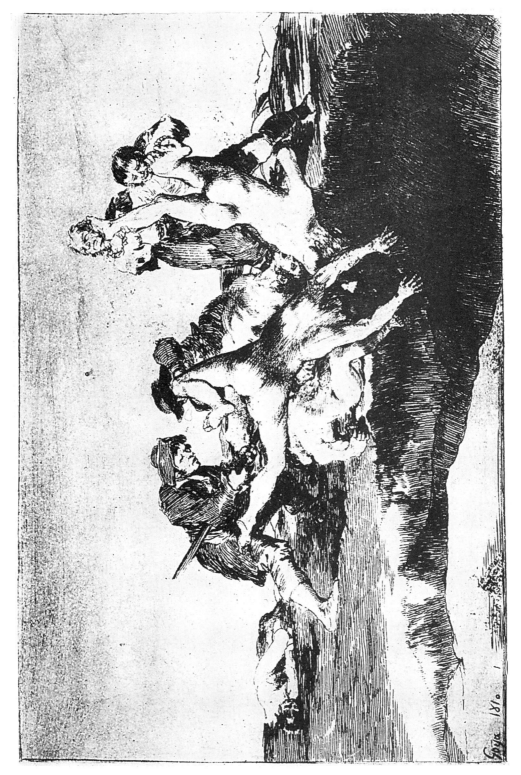

FRANCISCO GOYA. *Illustration from Los Desastres de la Guerra*

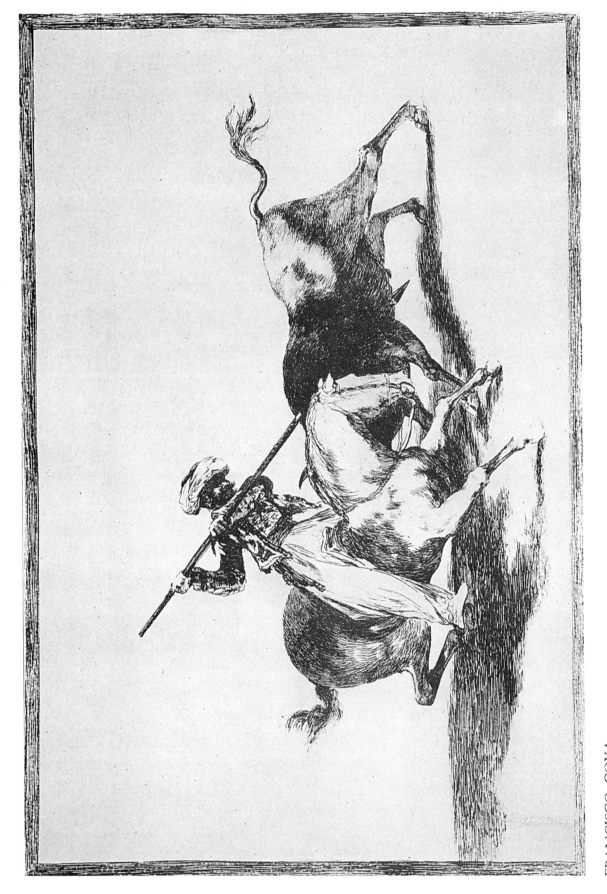

FRANCISCO GOYA.

THOMAS BEWICK 1753-1828

IT DOES NOT require more than one glance at his drawings to learn that Thomas Bewick, in childhood a sturdy farm boy, never overcame his nostalgia for the pleasant English countryside. Cherryburn House, his birthplace, lay not far from Eltringham in the heart of the Northumberland country.

Bewick was one of eight children and his was the usual English childhood. He attended a nearby school, where he learned some little Latin and more than a fair amount of English, although his tongue was never to lose its broad country accent. At school he was better known for the drawings he made as marginal notes than for any scholarly attainments. Later in life he wrote in his Memoirs: "At this time I had never heard of the word drawing, nor did I know of any other paintings besides the "King's Arms" in the church, and the signs in Ovingham of "The Black Bull", "The White Horse", "The Salmon", and "The Hounds and Hare". I always thought I could make a far better hunting scene than the latter. The others were beyond my hand."

At fourteen Bewick was apprenticed to an engraver at Newcastle, which in 1771 was already famous as a mining center. The industrial growth of England under George the Third had begun to be visible. Long afterward, this same sovereign was to examine with amazement the woodcuts of Bewick and exclaim: "Can these have been engraved on wood?"

In Newcastle Bewick worked, and, though he liked his master, he wrote: "But to leave the country behind me with which I had been charmed to

89

an extreme degree and in a way I cannot describe, I can only say my heart was like to break." This yearning for pastoral scenes was to be expressed throughout his life in many tender and charming wood-engravings.

Bewick served his apprenticeship under Ralph Beilby whose business consisted mainly of engraving crests and initials in copper and steel. There were also many clock faces to cut, a particularly hard form of work since most clock faces were made of brass. Bewick's first important work was the engraving of wood blocks for a book on Mensuration. Due to the author's insistence and procurement of the necessary wood blocks and tools, Bewick engraved on wood and thus started a revival which was to have far-reaching effects. No one knew better than Bewick the expense and slowness of printing illustrations from copper plates and if fine-line book illustrations could be made from wood blocks, an enormous saving in time and money would result.

While still an apprentice at Newcastle, Bewick designed and executed the illustrations for Gay's *Fables*. Some time later, after Bewick had left the shop, the book was published. Bewick's old master thought so well of the cuts that he sent them to London where they received a prize of seven guineas from the Society of Arts.

Too insistent application to his work caused a breakdown in Bewick's health. He found it necessary to concentrate on regaining his health. He had often walked from Newcastle to Cherryburn in order to see his parents, setting out after seven in the evening to walk a distance of more than eleven miles. And so in the summer of 1776 he conceived a desire to travel the country on foot. He sewed three guineas in his belt and started through the Cumberland, north to the Highlands. He went from one farmhouse to another, meeting everywhere simple, kindly hospitality. His constitution became so hardened that no weather, however severe, presented hazards to him. This new-found vitality was to prove of value later, when he drew the *Land Birds* and *Water Birds*, making his studies out of doors.

But Bewick rarely drew from nature. He would go out and look at

things, then return to draw them. Again and again the rural scenes among which Bewick was raised are found in his work. A farmyard plate from *Land Birds* shows a scene filled with living creatures, set in a landscape rendered with great fidelity, the entire plate measuring only about two by three inches. Many of the tailpieces, too, show an extraordinary inventiveness and a great deal of skill in the engraving.

In 1777 he formed a partnership with his former master and set about perfecting the art of wood-engraving. He is responsible for the invention of several tools that have since come into general use among wood-engravers.

A series of animal illustrations Bewick did for a children's book aroused so much favorable comment that he soon started the wood-engravings for his now famous *History of Quadrupeds* published in 1790. The success of this book led him to undertake his *History of British Birds*.

Thomas Bewick's contribution to the art of the book is further notable for his invention of the white line in engraving. Before Bewick's discovery, it was customary to make pen drawings on the block. The engraver would carefully remove all the white space that remained around the drawing, leaving only the draughtsman's lines in relief. When printed, this gave the effect of a pen drawing. Bewick used a graver on the polished end-grain of the wood in the manner of a metal engraver. By this change in procedure he was enabled to engrave white lines on a black surface, using variable widths to achieve his *chiaroscuro.*

The gradation of color, from the lightest grays in the most delicate parts of his engravings, was obtained by lowering, through scraping, those parts of the block which were intended to print lightly. He had much difficulty with his printers who used the method, common then, of daubing the ink upon the block with a pad. This usually resulted in blurring the engraving.

When *Water Birds* was completed, Bewick was fifty years old. He had reached his prime. Although he was to live another twenty-four years, his best work was already behind him.

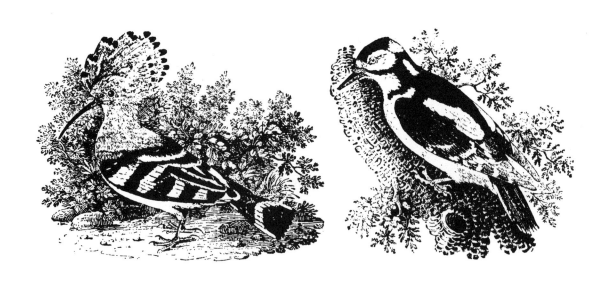

THOMAS BEWICK. *Illustrations from Figures of British Land Birds. Wood Engravings*

THOMAS BEWICK. *Illustrations from Figures of British Land Birds*

93

THOMAS BEWICK. *Two illustrations from a General History of Quadrupeds*

THOMAS BEWICK. *Two illustrations from a General History of Quadrupeds*

THOMAS ROWLANDSON 1756-1827

OSBERT SITWELL once said: *"If England were tomorrow to be sub-
merged, so long as a few typical drawings of Rowlandson survive, it
would be very simple to reconstruct the life and appearance of her people."*

That statement is true, for although Rowlandson worked and died more
than a century ago, his drawings still reproduce the countenances of our
cousins across the sea. Should you look at a crowd at Epsom Downs, or at
people traveling in the London underground, or at Englishmen anywhere
going about their business with a perfect lack of self-consciousness, you will
be gazing at the unchanging Briton of Rowlandson's drawings.

Thomas Rowlandson was born at London in 1756 and, from the first,
life was gentle to him. His father, a city merchant of standing and means,
sent him to a good school. At sixteen he began his studies at the Royal
Academy. Sir Joshua Reynolds was then the head of the Academy, and
he regarded Rowlandson's gifts in draughtsmanship and design as extraor-
dinary.

For two years Rowlandson studied in Paris. There his reckless, pleasing
personality and facile pencil made him immensely popular. He had a lean-
ing toward strong drink and a love for boisterous company, but the hours
he spent at the gaming tables wasting his patrimony may also be credited
toward stimulating his artistic endeavor. For had he not spent his inherited
fortune in gambling, it is almost certain that his output of drawings would
have been less. The need of money was his only admitted reason for work-

ing. As it happened, he was forced to make his precarious living from art.

Of the world around him he wove the fabric of his pictures. No dry-throated Puritan reformer could point a moral better than could Rowlandson with his drawings of the red and bloated faces of men intent upon their play, of the fat, leering, soddenly drunk middle classes.

His early drawings are marvels of wit and graceful draughtsmanship. He had a genuine appreciation and love of the countryside, and for the light, humorous and more picturesque aspects of town life. There are tenderness and restraint in his drawings of young and pretty women, and, in strong contrast, there are the wanton and gross surroundings in which he set them.

An artist's physical being can, to a certain extent, be determined from his drawing. Rowlandson was an enormous, bear-like man. His powerful physique makes itself felt clearly in the rollicking freedom of his line. There are no traces of smallness in either the man or his work. It is to be regretted that no publisher saw fit to commission him to illustrate the works of Rabelais.

Rowlandson painted nothing in oil; all of his work is in water color. He was the first to use the color print for caricature, and he used it savagely on personal and political subjects. In later years he perfected his technique in the illustration of books. He designed and executed the drawings himself. The best known of his illustrated books are *Dr. Syntax, The Dance of Life,* and *The Dance of Death*.

Edgar Browne, the critic, wrote: "Rowlandson is the ancestor of early Victorian caricature, and undoubtedly set the fashion for the succeeding comic draughtsmen. . . . He had a fine sense of beauty, yet his drawings are crammed with people obese, flabby-cheeked, broken-nosed, one-eyed, bandy-legged, crooked-backed, bald-headed, knock-kneed, loathsome and deformed, who were supposed to be amusing and who did indeed vastly amuse the public."

It is true that deformities excited laughter rather than sympathy, and

Rowlandson did express his time in so far as feelings were coarse and had to be coarsely expressed.

In refutation of the moralists, it may be recorded that Rowlandson was able to consume great quantities of liquor and yet reach his seventy-first year, a goodly span for that hectic period.

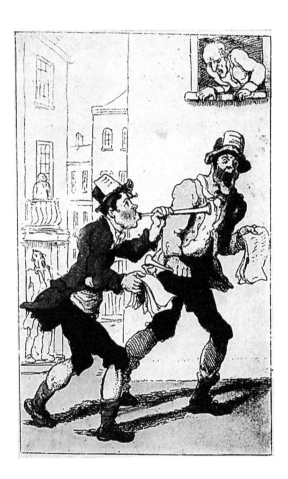

THOMAS ROWLANDSON.

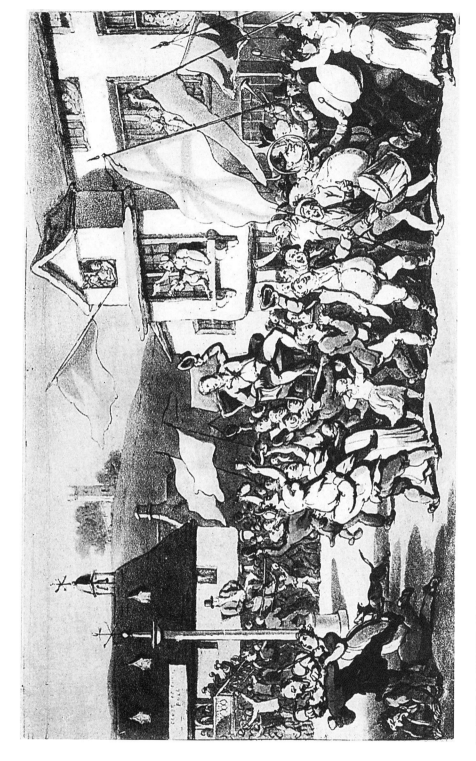

THOMAS ROWLANDSON. *Illustration from The Dance of Life*

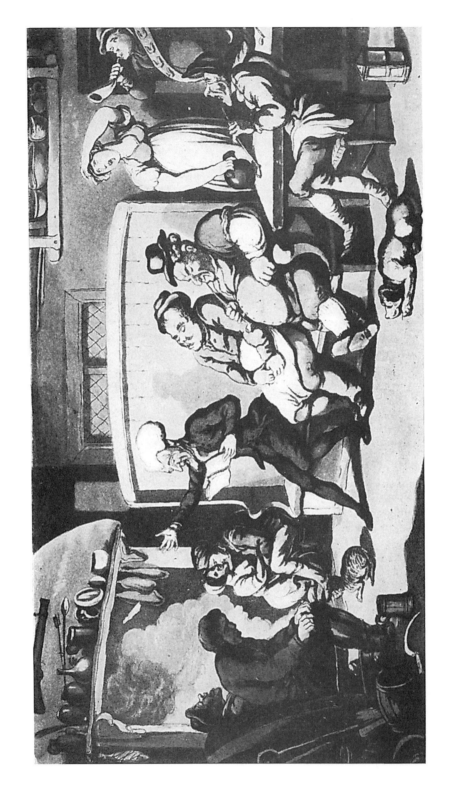

THOMAS ROWLANDSON. 'Doctor Syntax Reading His Tour'

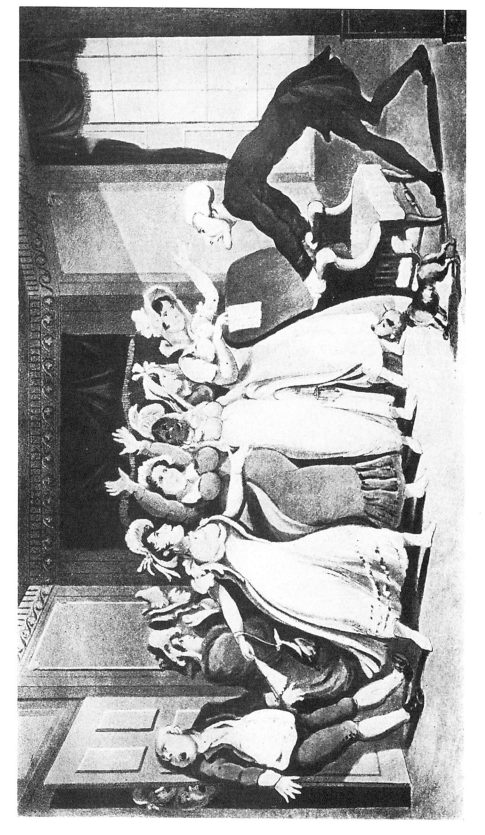

THOMAS ROWLANDSON. 'The Advertisement For A Wife', illustration from Doctor Syntax

THOMAS ROWLANDSON. *Illustration from The Dance of Life*

102

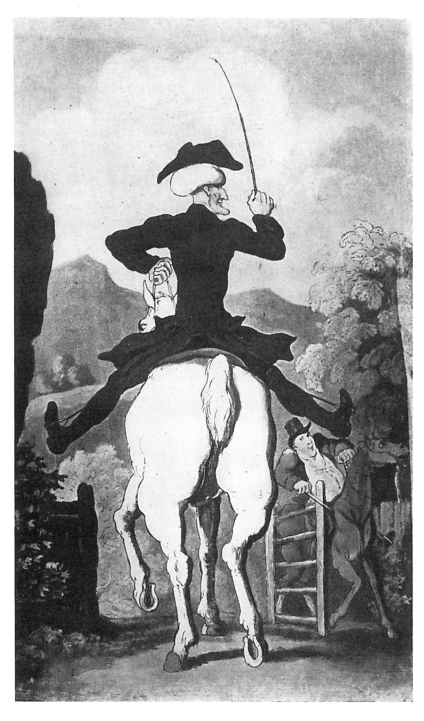

THOMAS ROWLANDSON. *'Doctor Syntax Setting Out in Search of A Wife'*

GEORGE CRUIKSHANK 1792-1878

"MAKE US laugh or you starve; give us fresh fun, we have eaten up the old and are hungry. And all this he has been obliged to do—to wring laughter day by day, sometimes out of want, often certainly from ill health and depression—to keep the fire of his brain perpetually alight, for the greedy public will give it no time to cool, this he has done and well." Thus Thackeray sums up for us the essence of the life of George Cruikshank.

Isaac Cruikshank, father of George, was a successful caricaturist in his own right, and at least one of his contemporaries compared him favorably with Rowlandson. Of the three sons born to Isaac and Mary Cruikshank, Robert and George both showed an early aptitude for drawing and worked with their father. The mother, a hot-tempered and frugal Scotswoman, boasted that she had managed to save a thousand pounds and at the same time bring up her children in God-fearing ways.

The Cruikshank home was large enough to house lodgers and once accommodated the famous traveler, Mungo Park, whose stories so inflamed the wanderlust of Robert, the eldest brother, that he ran off to sea. He made but one voyage and was given up for lost. When he returned to interrupt the mourning there was great rejoicing in the Cruikshank home. In the meantime, George had made great progress and was already launched on his career.

It was a strange workroom in which the brothers plied their art. The decorations included a sou'wester, a skull with a pipe between its teeth,

masks, weapons of all kinds, and two pairs of boxing gloves hung on a peg. The prizefighter of those days was the idol of the crowd, and most of the better known heroes of the ring found their way to the Cruikshank studio to stand for their portraits. The brothers themselves often set aside brushes and put on the gloves, and George's assiduous study of self-defense resulted in his nose becoming an unusually prominent feature of his face. It is displayed in his own amusing self-caricatures.

George Cruikshank was gifted with extraordinary animal spirits. He found adventure in the byways of London, and set down what he saw at the fairs, the taverns, and in Petticoat Lane. Little escaped his penetrating observation.

A glance at a catalogue of the works of George Cruikshank will astound the person unfamiliar with the tremendous productivity of his pencil. More than five thousand subjects, ranging from childish drawings to labored historical pictures, cover the whole pageant of his time. His work bridges a gap between the lusty, forthright compositions of that first great English observer of the passing scene, Hogarth, and the more whimsical Nineteenth Century artists, Leech and Tenniel. The two strongest influences in Cruikshank's drawings are Hogarth and Rowlandson, both of whom formed the major roots of his distinctive art.

Cruikshank's interpretation of Dickens' *Oliver Twist* is an almost perfect example of the possibilities of illustration. So deeply imbedded in the subconscious mind of the public have become the Cruikshank drawings of Fagin, Bill Sykes and young Oliver, that one scarcely thinks of the book without calling to mind the pictured characters. Never was a collaboration between author and artist so closely knit.

Many are the books enlivened by his pencil. He illustrated Smollett, Goldsmith, Fielding and Cervantes. Nor was Cruikshank limited to English publications. In 1842 the famous illustrations for *Peter Schlemiehl* were published in Germany, as were also his illustrations for Grimm's *Popular Stories*. His reputation was international.

The same excess exuberance that caused him in his youth to drink and gamble, in his old age turned him into a scold. He fell out with his publishers and antagonized Dickens. His passion for temperance became a personal and fanatic one-man crusade which lost him old friends and employment. Frederick Wedmore wrote: "Many of us who did not know him at home have at least met him about; for not only was he a familiar figure of the dreary quarter which he inhabited—but he traveled much in London, and may well have been beheld handing his card to a stranger with whom he had talked casually in a carriage, or announcing his personality to a privileged few who were invited to see in him the convincing proof of the advantages of a union of genius with water-drinking."

Despite his tremendous capacity for work, his vigorous health, and his great popularity, there was scarcely a time in his life when he was free from debt.

George Cruikshank lived to be eighty, and when he died he left his monument in the form of the eternally popular and highly imaginative creations of his facile hand.

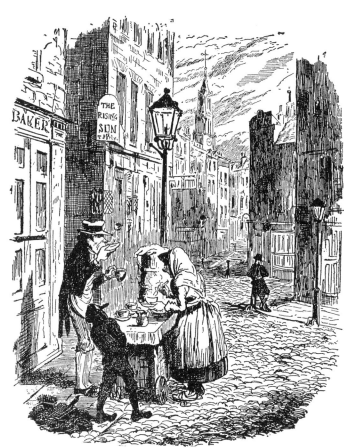

GEORGE CRUIKSHANK. *'The Streets—Morning'*

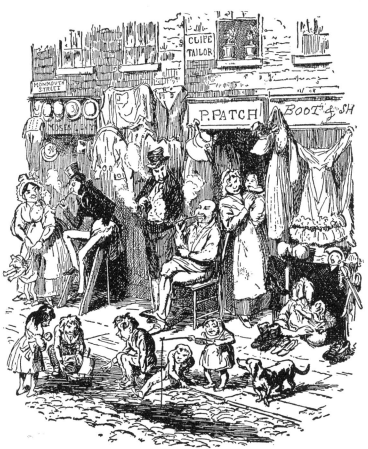

GEORGE CRUIKSHANK. *'Monmouth Street'*

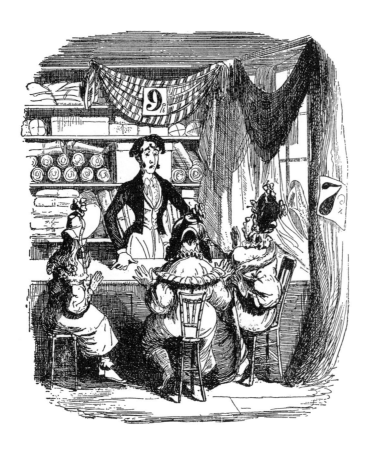

GEORGE CRUIKSHANK. 'At
The Drapers'

GEORGE CRUIKSHANK. '*The
Last Cab-Driver*'

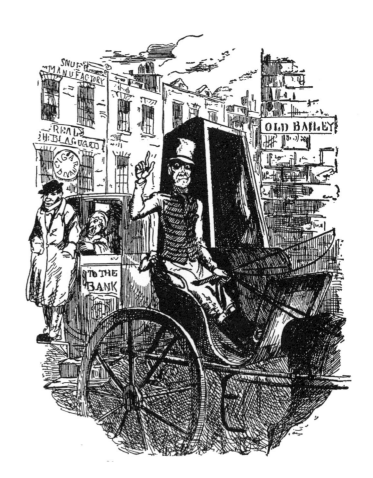

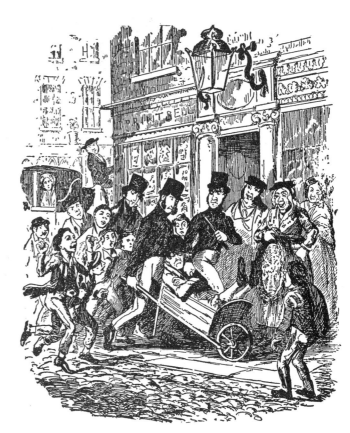

GEORGE CRUIKSHANK. 'A
Pickpocket in Custody'

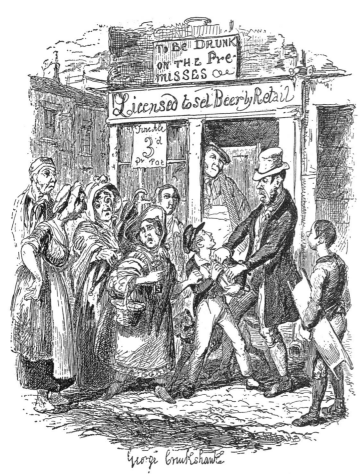

GEORGE CRUIKSHANK. *Illus-
tration from Dickens' Oliver Twist*

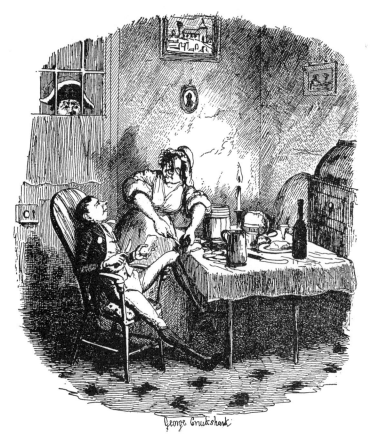

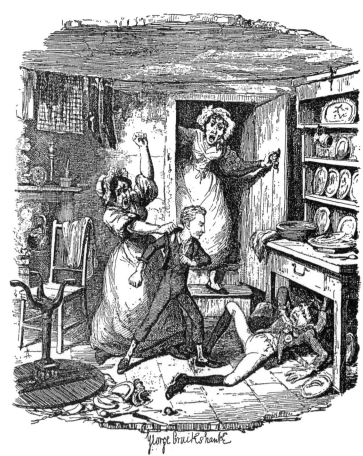

GEORGE CRUIKSHANK. *Illustrations from Dickens' Oliver Twist*

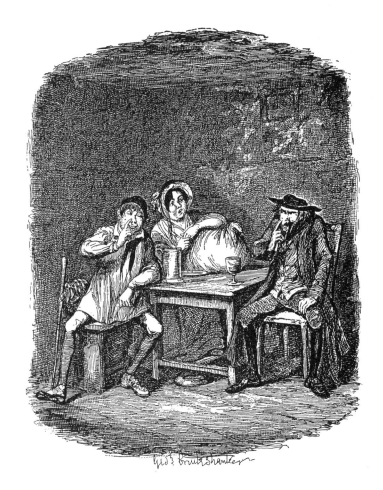

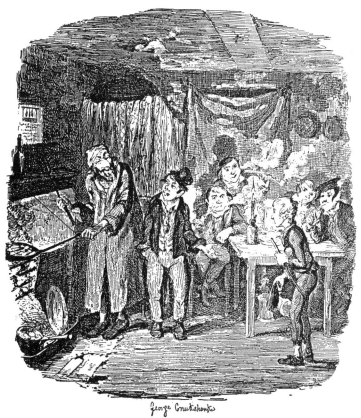

GEORGE CRUIKSHANK. *Illustrations from Dickens' Oliver Twist*

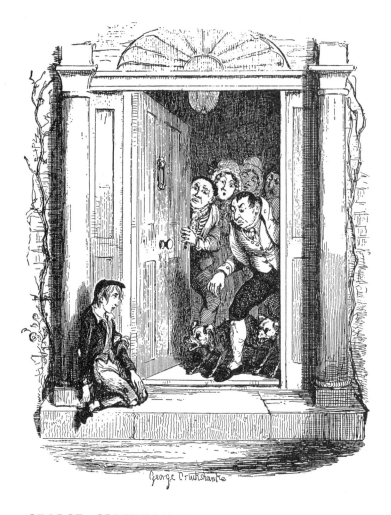

GEORGE CRUIKSHANK. *Illustration from Dickens'*
Oliver Twist

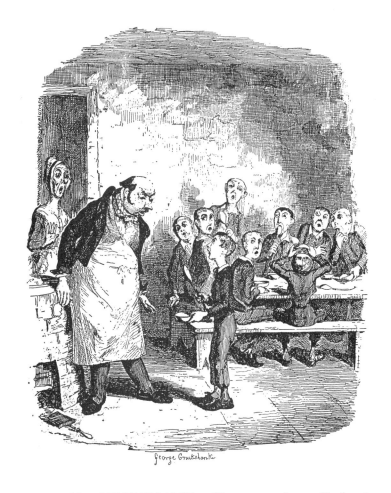

GEORGE CRUIKSHANK. *Illustration from Dickens'*
Oliver Twist

CARICATURE was the fashion when Phiz, Cruikshank and Leech illustrated the numerous volumes that came steadily from Dickens' imaginative and busy pen. For there were two entirely different schools of illustration. One group included the Royal Academicians, to whom one went for genteel, decorative pictures. Caricaturists comprised the second group, by far the more popular of the two.

Hablot Knight Browne, who signed himself 'Phiz', was next in popularity to Cruikshank as an illustrator of Dickens. Of him, his son Edgar wrote: "He drew after the fashion of a child who will draw you a picture of anything without even glancing at the reality. To this faculty of reproducing at will unconscious impressions he owed most of his excellences, together with most of his faults. Careful adherence to fact, and conscientious reproduction of the model and still life, would have resulted in drawing that might have had a great artistic value, but would not have represented Dickens in the slightest degree."

Hablot Knight Browne was born in July, 1815, at Kensington, London. He was educated at a private school and was apprenticed to Finden, a well-known line engraver. Browne, however, was not much interested in the process and spent most of his leisure time learning to paint water-colors and attending life classes in the evening at a nearby art school.

At seventeen he was awarded a medal by the Society of Arts for the "best representation of a Historical Subject".

Dickens, who was three years his senior, chose Phiz to finish the draw-

ings for the *Pickwick Papers* which was the start of a close association that lasted for many years. Phiz competed with one William Makepeace Thackeray for the position. After congratulating Phiz, Thackeray decided to try his hand as a writer rather than remain an illustrator.

It is interesting to note that during his youth Thackeray had seriously attempted to be an artist, going so far as to spend several years studying on the Continent, the only results of the effort being a gradual decline of his ability as a painter.

Phiz was practically a recluse and although possessing a strong sense of humor, as witnessed by his many letters to his son, preferred not to see many people, and did most of his work at home. A friend in town conducted most of his business affairs. Browne did many water-colors to which he signed his proper name, several of which were exhibited. He sometimes used his own name on illustrations and critics when comparing the work of Phiz and Browne, not knowing they were the same, usually preferred Browne's illustrations. One reason for this was that the caricaturists, despite their broad appeal, were not supposed to be technically as proficient as the Academicians.

Phiz preferred to draw from memory and hardly ever attempted to sketch a scene on the spot. Among the books he illustrated for Dickens were: *Pickwick Papers, Barnaby Rudge, Martin Chuzzlewit* and the *Tale of Two Cities.*

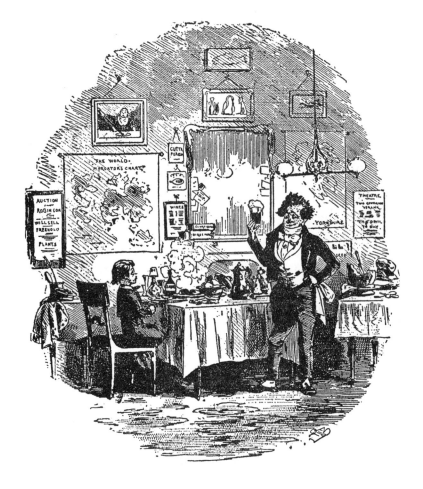

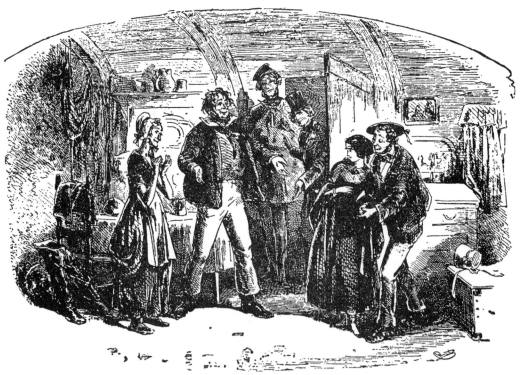

PHIZ. *Two illustrations from Dickens' David Copperfield*

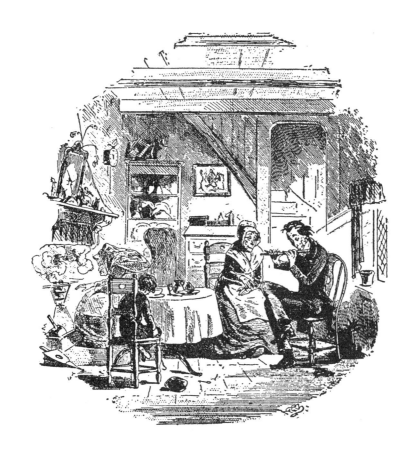

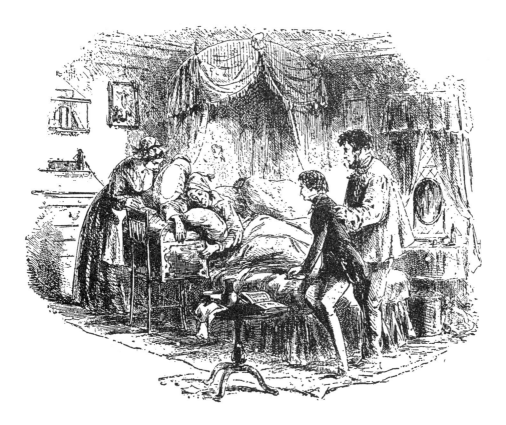

PHIZ. *Two illustrations from Dickens' David Copperfield*

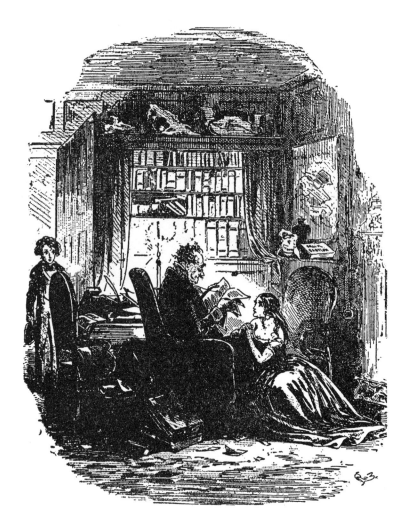

PHIZ. *Illustration from Dickens' David Copperfield*

JOHN LEECH 1817-1864

DRAWING came easily and naturally to John Leech. Flaxman, sculptor and teacher of art, is supposed to have said that Leech should not be taught to draw, and indeed he seems never to have needed instruction. Under the tutelage of Millais he made a few very successful sketches in oil, but his greatest strength was in his drawing. He formed the habit of using a sketchbook and drew upon it for his humorous illustrations in *Punch,* so that characters he had previously sketched often reappeared in his weekly drawings, usually in amusing attitudes.

Most of his work was done in pencil, with a firm clean line. These drawings had a freedom and breadth that could not be captured in the more rigid medium of wood. Some of them rank among the finest of his time.

Leech's artistic preparation was singular in that he studied medicine at St. Bartholomew's Hospital, where his most notable achievements seem to have been some excellent anatomical studies. This knowledge of anatomy, added to an unusually good visual memory, served him well later on. When money grew scarce at the Leech home, he was forced to abandon his idea of becoming a doctor and turn to drawing for his livelihood.

The keen perception of character which was to make him famous was apparent in his illustrations for *The Ups and Downs of Life, or The Vicissitudes of a Swell,* executed when the artist was only nineteen. Leech loved hunting and the English countryside. His knowledge of horses is represented faithfully in Surtees' *Jorrocks' Jaunts and Jollities.*

His best known work is perhaps contained in the illustrations for

Dickens' *Christmas Carol*, but his main source of income was derived from *Punch*, which paid him $200,000 during his career.

Leech was an exceedingly fast worker. He made very few preliminary sketches and most of his drawings were completed in two hours time. He did not use models and occasionally, when he had a sitter, he struggled for a likeness.

The qualities in his work that contributed so largely to his popularity were the truthfulness, the simplicity and the gentle humor of his sketches. Instead of the clever satire of Tenniel or the sharp biting wit of Cruikshank, Leech offered a more tempered humor that laughed in a friendlier mood at the world and its frailties.

For twenty-four years John Leech was the leading spirit of *Punch*. Hardly an issue left the press without at least one of his sketches. He drew many political cartoons and in addition to these, contributed more than three thousand illustrations of the human scene around him.

JOHN LEECH. *'The First Day of the Season'*

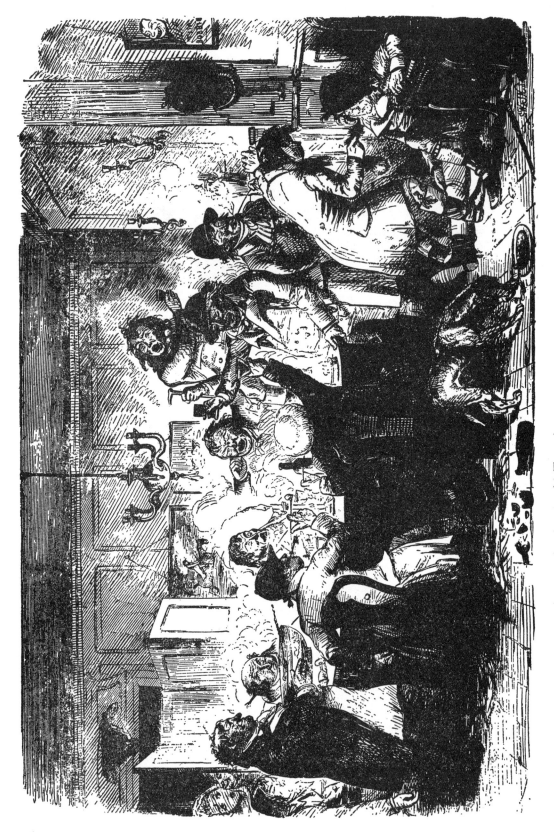

JOHN LEECH. *'Foxhunters Regaling in the Good Old Times'*

122

JOHN LEECH. 'The Queen in Her Store-room', a political cartoon from Punch, also known as 'Keep Our Powder Dry'

RANDOLPH CALDECOTT 1846-1886

AT SIXTEEN Randolph Caldecott was a bank clerk who ardently desired to become an artist. He submitted his first work at the age of twenty-four, and was told that he must "go on working—especially studying horses".

It was in the pages of *London Society* that Randolph Caldecott made his first bow to the public. It always amused Caldecott that he should have been chosen to illustrate the actions of Society. His own background was that of a rural boy. Some of his drawings were too satirical and grotesque and were rejected. The reason given was that they were deemed: "inappropriate to a fashionable magazine".

The first book that Caldecott illustrated was Henry Blackburn's *Harz Mountains,* a book of travel. The illustrations were quick sketches made on the spot. While hardly showing the impressive views and vistas, so dear to the heart of any tourist, they do manage to give the book a light and amusing touch. For the most part they are character studies such as show people straggling back from one of the views or glimpses of odd streets and corners in various towns along the way.

Caldecott's interests were many-sided. Besides book and magazine illustration he became interested in sculpture and started modeling in wax and clay. For several years he was the London correspondent for the *Daily Graphic,* a newspaper published in New York.

Unfortunately many of his best drawings were not printed, as they were sketches included in letters as interesting sidelights for the amusement of

124

his friends. In these simple drawings is a spontaneity of humor, a light and gay wit that is sometimes lacking in his published work.

In 1876 Macmillan published Washington Irving's *Old Christmas* with illustrations by Randolph Caldecott. There were one hundred and twelve drawings in the book. They showed a wide variation in style and concept. Some were almost too sweet and cloying as if bowing to what then was considered the public taste. Others, fortunately, were brilliant character studies that showed a subtlety of wit that was in complete harmony with Irving's gentle humor. So close did some of the illustrations follow the spirit of the text that it is hard to tell which is the supplement. Henry Blackburn in his book about the artist remarks: "It is interesting to note that *Old Christmas* was offered to, and declined by one of the leading publishers of London; principally on the ground that the illustrations were considered, 'inartistic, flippant and vulgar, and unworthy of the author of *Old Christmas*.' It was not until 1876 that the world discovered a new genius".

Old Christmas proved to be such a definite success that it was soon followed by its sequel *Bracebridge Hall* with Caldecott's illustrations.

The particular qualities of Irving's subject matter and style meant that his illustrator faced no easy task; yet Caldecott interpreted his writings to a laudable degree. The one hundred and twenty drawings for *Bracebridge Hall* were photographed on wood and engraved by J. D. Cooper, who had introduced the artist to the author.

RANDOLPH CALDECOTT. *Illustrations from Washington Irving's Bracebridge Hall*

126

RANDOLPH CALDECOTT. *Illustrations from Washington Irving's Bracebridge Hall*

127

JOHN TENNIEL 1820-1914

LIKE LEECH, John Tenniel was a consistent contributor to the pages of the humorous *Punch*. Rarely missing an issue, his cartoons appeared in that magazine over a period of thirty years. But it was by his fine and unforgettable illustrations for *Alice in Wonderland* and *Through the Looking-Glass* that he established his secure place in the art of the book.

The drawings are faithful to the text and at the same time are full of inventiveness and charming humor. It is practically impossible to think of Alice, the March Hare, or any of the other characters, without visualizing the figures of the Tenniel illustrations.

One paradoxical method of Tenniel's is seen in the very solidity with which his drawings represent the extreme whimsy of Lewis Carroll's creations. Despite his enormous success with this children's classic, after doing *Through the Looking-Glass* Tenniel refused to illustrate another book for children. In a letter written to Carroll some years later, he said: "With *Through the Looking-Glass* the faculty of drawing book illustrations has departed from me, and notwithstanding all sorts of temptations I have done nothing in that line since."

As George Kerr has pointed out: "From *Punch* he gained his bread; from *Alice,* his immortality."

JOHN TENNIEL. *Frontispiece from* Alice's Adventures in Won-
derland

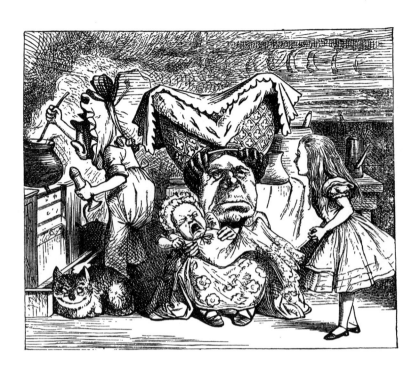

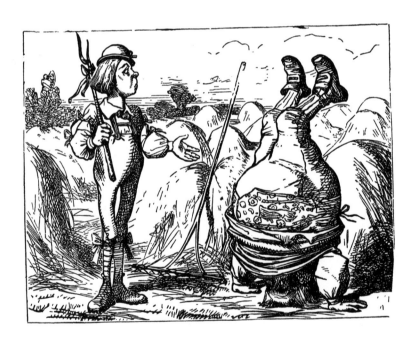

JOHN TENNIEL. *Two illustrations from Alice's Adventures in Wonderland*

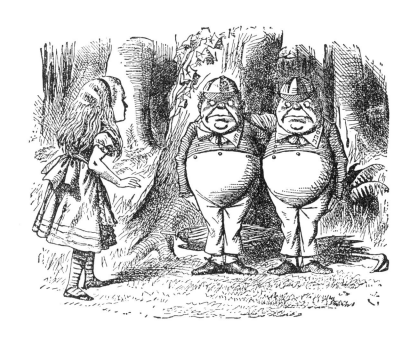

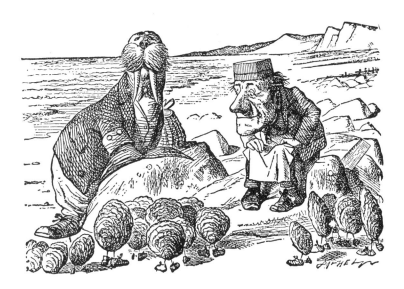

JOHN TENNIEL. *Two illustrations from Through the Looking-Glass*

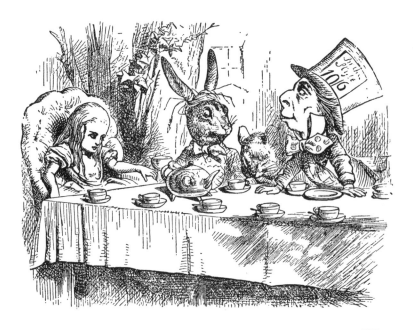

JOHN TENNIEL. *Illustration from* Alice's Adventures in Wonderland

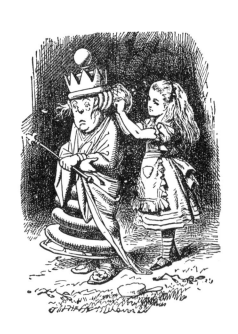

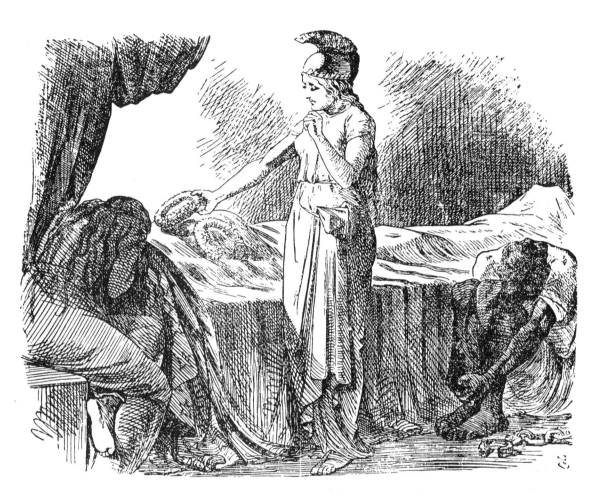

JOHN TENNIEL. *The famous Punch cartoon occasioned by the assassination of Abraham Lincoln*

SIR WILLIAM SCHWENCK GILBERT
1836-1911

W. S. GILBERT'S merits as an illustrator are not generally realized. Austin Dobson referred to him as one of the many lesser luminaries "after the *Punch* school," and ascribed to his drawings "a perverse drollery" which was in keeping with the "erratic text" of the *Bab Ballads*.

Dobson wrote not in detraction, but rather at too close a viewpoint. Gilbert had in great measure the first essential of the good illustrator—a full awareness that his illustrations are subordinate to the text they serve. Perhaps it is easy to hold to this essential when one is also the author of the text. Placed in another setting, Gilbert's little sketches clearly outshine their surroundings. This is evident in a book by Henry Mayhew called *London Characters*. Mayhew borrowed sketches from the *Bab Ballads* to give his readers a visual impression of what were some London characters—not erratic, not perverse, not droll, but sharp observant delineations of the vast variety of people who walked in the streets, sat in the clubs, lived in the homes of Queen Victoria's imperial capital.

Gilbert's illustrations for his own *Bab Ballads* appeared first in *Fun*, a comic magazine. The ballads and the sketches were then collected into a book, and other books soon followed. They picked up a current tendency of illustration in England—caricature. But the element of caricature is less strenuous than in the drawings for the works of Dickens and Thackeray made about the same time; if the work of Gilbert shared the element of caricature, it was because the time demanded it—it is almost impossible to escape caricaturing any great or humble figure of that period.

W. S. GILBERT. *Illustrations from H.M.S. Pinafore and The Bab Ballads*

135

AUBREY BEARDSLEY 1872-1898

THE WORK of Aubrey Beardsley is not so much a reflection of the period in which he lived as it is an outgrowth of the small circle which contained his intimates, a circle dominated by the Wildes and fed by the Douglases. His mode of living no doubt contributed to his early demise, yet in the twenty-six years of his life he had built for himself a lasting fame. A musical prodigy at the age of eleven; at twenty he was widely known as a draughtsman.

Beardsley's was the strange driving power that so often is given to genius when life is to be short. In a seemingly endless stream his drawings rushed forth for *Salomé, Pierrot of the Minuet, Mademoiselle de Maupin, The Yellow Book,* and for the short-lived *Savoy.* Some of these illustrations were rich and elaborate in detail; others were simple and beautiful in line. Weird distortion was ever a part of his desired scheme of black-and-white balance.

Beardsley was first a decorative artist. Even in his earliest work it is apparent that he reduces to conventional forms the human figure and the elements of the subject matter. In this stylization he was influenced greatly by the Japanese printmakers. He borrowed from them because they answered his search for a release from actual representation. Freed from the shackles of realism, he cast aside the ethereal effusions of the pre-Raphaelites and the humanism of Hogarth, and instead built for himself an unhealthy, decadent beauty, a world of his own making, sometimes obscene, more often pathetically gay. The *Lysistrata* illustrations are pervaded with a sex motif that in the light of present-day psychoanalysis illuminates at least one

136

side of his complex personality. His wit and grace of concept founded an entirely new school of book illustration.

Arthur Symons, his friend and contemporary, gives us this picture of Beardsley at the termination of his brief life:

"It was in the summer of 1895 that I first met Aubrey Beardsley. A publisher had asked me to form and edit a new kind of magazine, which was to appeal to the public equally in its letterpress and its illustrations: need I say that I am defining the *Savoy*? . . . As I entered the room, and saw him lying on the couch, horribly white, I wondered if I had come too late. He was full of ideas, full of enthusiasm . . . A little later we met again at Dieppe, where for a month I saw him daily . . . Beardsley at that time imagined himself to be unable to draw anywhere but in London . . . He never walked; I never saw him look at the sea; but at night he was almost always to be seen watching the gamblers . . ."

During his lifetime Beardsley found time to make of himself a writer of prose, a draughtsman extraordinary, and to develop a profound understanding of music. At the height of his frenzy of creative power and expression, Aubrey Beardsley, who had lived the life of a thoroughgoing pagan, died in the peace of the last sacraments of the church.

Like the poet Keats, Beardsley died long before he had reached the powers of maturity. And, as Keats, who exercised a strong influence upon those who were to follow him, so the influence of Beardsley in illustration will be felt for centuries to come.

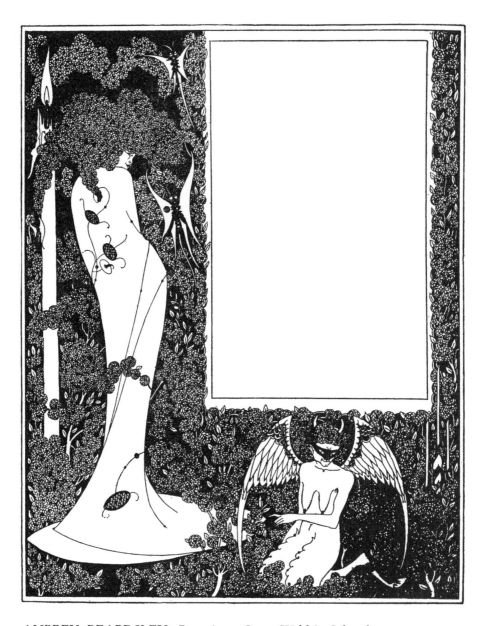

AUBREY BEARDSLEY. *Page from Oscar Wilde's Salomé*

138

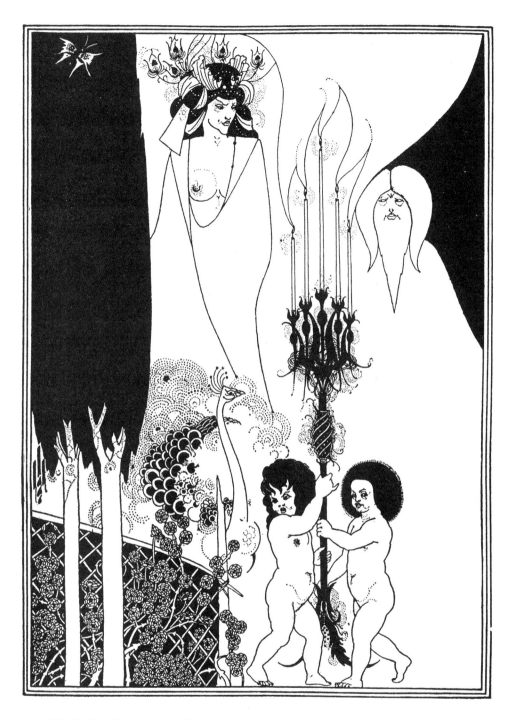

AUBREY BEARDSLEY. *Illustration from Salomé*

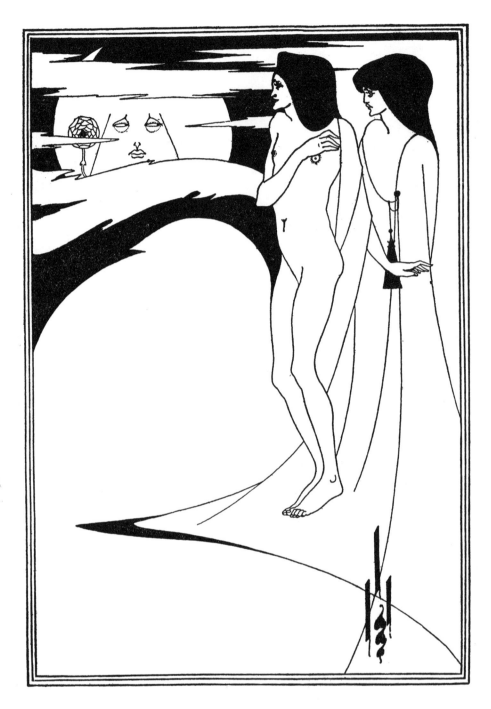

AUBREY BEARDSLEY. *Illustration from Salomé*

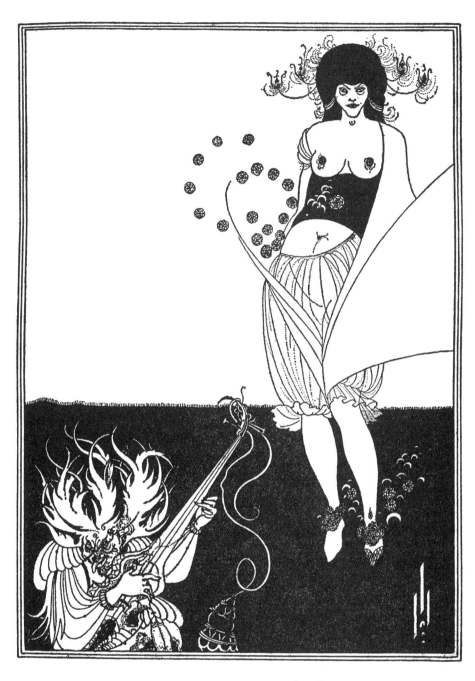

AUBREY BEARDSLEY. *Illustration from Salomé*

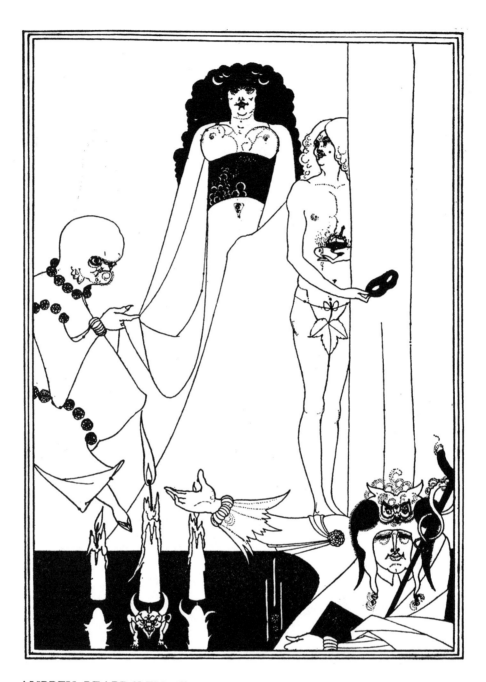

AUBREY BEARDSLEY. *Illustration from Salomé*

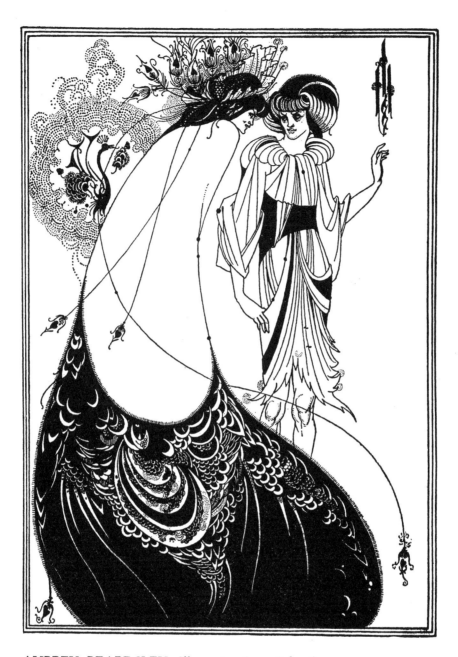

AUBREY BEARDSLEY. *Illustration from Salomé*

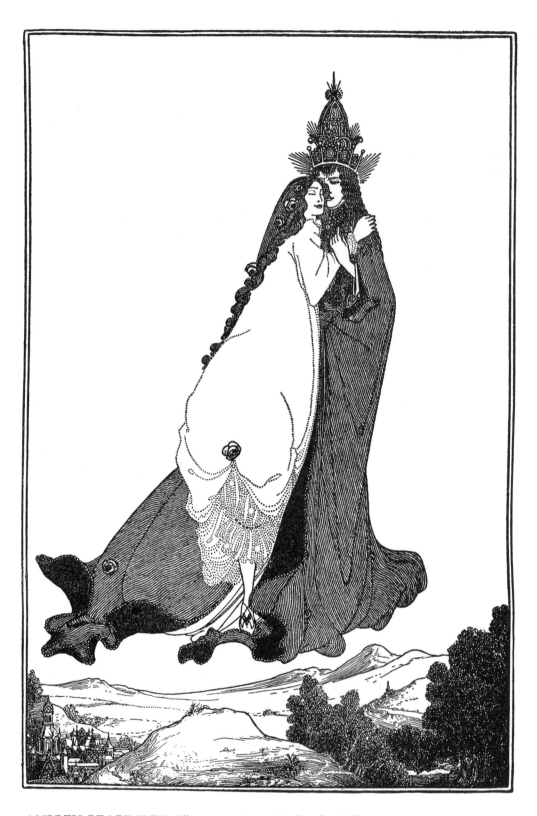

AUBREY BEARDSLEY. *Illustration from Under the Hill*

144

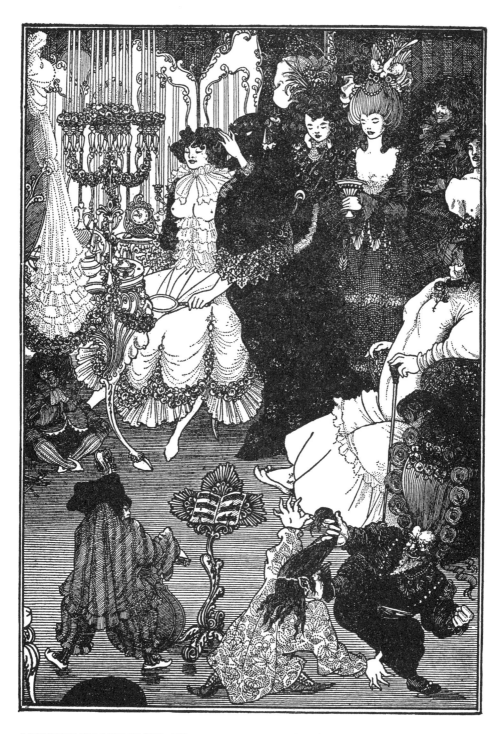

AUBREY BEARDSLEY. *Illustration from Under the Hill*

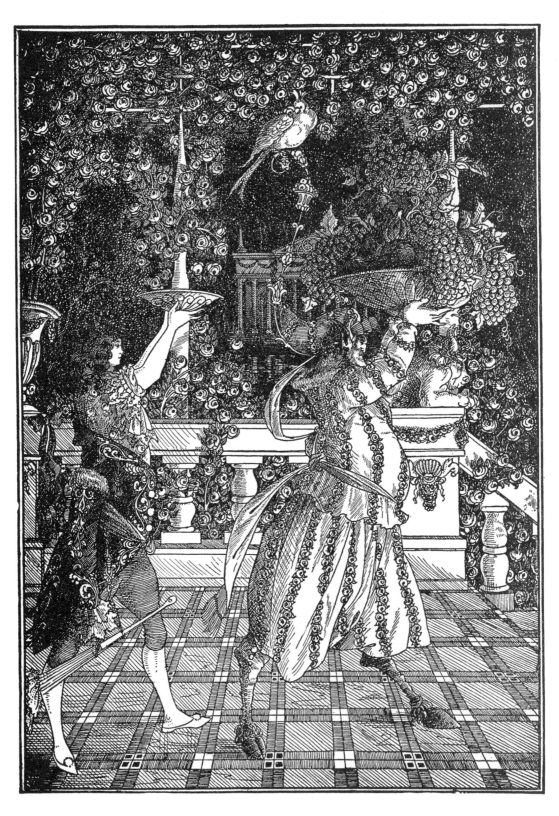

AUBREY BEARDSLEY. *Illustration from Under the Hill*

146

AUBREY BEARDSLEY. *Illustration from Under the Hill*

148

WILLIAM MORRIS 1834-1896

IT WAS at Cambridge that William Morris first met Edward Burne-Jones. It happened at a time when all young Englishmen thought it necessary to start or join some sort of a movement, the more exotic the better. The influence of Keats and Shelley and Byron was strong upon them, and so young William Morris and young Burne-Jones became wholehearted supporters of the pre-Raphaelite movement. Later they were joined by Dante Gabriel Rossetti.

However else it affected his fellow collegians, Morris' course was charted then and there. Although he subsequently widened the scope of his activities to admit other interests, his path never deviated one iota from his original plan.

The enterprise of Morris knew no limitations. This was fortunate for the beauty of his country; otherwise England might have sunk too deeply into the mire of ugly Victorianism which spread with mushroom-like rapidity. It was said of Morris that "he has changed the look of half the houses in London, and substituted art for ugliness all over the Kingdom".

Stained glass windows and fine tapestries came from the workrooms of Messrs. Morris Co., the firm which enlisted the services of his two talented companions, Burne-Jones and Rossetti, and a large staff of assistants. Textiles and carpets and furniture, all these were designed and executed by the energetic Morris. And he still found time to seek perfection in the art of dyeing, to revive the art of weaving, to originate the Society for the Protection of Old Buildings, to be an active Socialist, a woodcut engraver and

149

a publisher. Throughout his life he was an unconquerable foe of the machine, the great proponent of the handicrafts.

Earlier in life, Morris had begun to engrave on wood, copying some of Dürer's woodcuts for practice. The design of books and type had long been subjects dear to his heart. In 1890, with Emery Walker, he set about designing and casting a new font of type. It was the beginning of the Kelmscott Press, and was set up in his own home, Kelmscott Manor.

Morris was essentially a medievalist. He loved the Gothic forms and gave new life to them. Each time he revived a craft he studied it in the period of its greatest perfection, then applied it to the need of the day. So it was with bookmaking. He bought whatever *incunabula* he could, enlarging the type by photography in order to study it in detail. Each new letter was designed first on a large scale, then reduced by photography, a process which added to its refinement. Finally it was revised and handed to the typecutter.

The first book of the Kelmscott Press was published in 1891. Every detail had been carefully and lovingly considered. The paper, the binding, everything was handmade; even the manufacture of the ink had been supervised by Morris himself. Of this book, Joseph Pennell has said: "In every other book the aim of the printer was at that time to get in as many opposing styles as possible. In Morris' book there is a perfect unity in the type itself; there is perfect beauty in the way it is put on the page."

All of the ornaments for the Kelmscott Press were designed by William Morris. The press itself was run co-operatively. Of the many books that were published during the existence of the Kelmscott Press, the last and crowning one is the *Chaucer*. It was begun during the summer of 1894 and completed almost two years later, in the spring of 1896. It contains eighty-six pictures designed by Sir Edward Burne-Jones, engraved in wood by W. H. Hooper, the title page being designed by Morris.

In a history of illustration the name of William Morris must be placed prominently, not so much for his own work in the art, though even here

his contribution was a generous one, but for the effect that the Kelmscott Press was to have upon future printing and illustration.

In the footsteps of William Morris followed a school dominated by a great protest against commercialism, and dedicated to the perfection of fine craftsmanship.

WALTER CRANE. *Opening page from The Sirens Three*

WILLIAM MORRIS. *Title page designed by William Morris and Walter Crane*

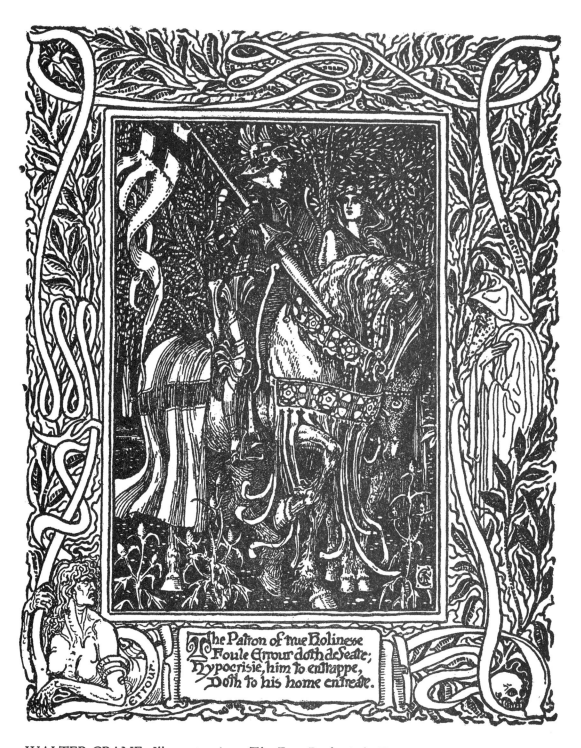

WALTER CRANE. *Illustration from The First Book of the Faerie Queene*

Chapter II. Evil tidings come to hand at Cleveland.

NOT long had he worked ere he heard the sound of horse-hoofs once more, and he looked not up, but said to himself, "It is but the lads bringing back the teams from the acres, and riding fast and driving hard for joy of heart and in wantonness of youth". But the sound grew nearer and he looked up and saw over the turf wall of the garth the

WILLIAM MORRIS. *Chapter page designed by William Morris and Walter Crane*

154

WILLIAM MORRIS. *Chapter page designed by William Morris and Walter Crane*

FOR AN ARTIST who produced so little during his lifetime, Edward Calvert's wide, albeit belated, recognition was truly remarkable. It may have been that Calvert was as fastidious in his output as he was in his style, or it may have been simply that he started his artistic career so late as to complete an infinitesimal amount when compared to the production of his contemporaries.

Calvert was born at Appledore, Devon, in 1803. His family had decided upon a naval career for him, and he entered the Royal Navy when he was fifteen, serving as a midshipman until he was twenty-one. Having done some sketching at sea, he settled at Plymouth where the local artistry encouraged his efforts. He was married there, and in 1824 moved to London. Through a letter from Fuseli, he was admitted to the Royal Academy.

Although Calvert's work is romantic rather than esoteric, he was known to be an ardent disciple of William Blake. Oddly enough, only his paintings were known to the public, and to this day it has not been disclosed as to just where and when he learned engraving. But when his third son published his memoirs, ten years after Calvert's death in 1883, he illustrated the edition with plates that his father had designed and executed.

Within their limited range and style, these engravings come close to perfection. Their precise classicism is consonant with that of his favorite authors, Landor and Chapman, who themselves were also steeped in the Grecian tradition. A third and final printing from the original plates was made at London by Carfax & Company only eleven years after their initial appearance.

EDWARD CALVERT. *Woodcuts*

157

CHARLES HENRY BENNETT 1828-1867

CHARLES HENRY BENNETT was born July 26, 1828, in a house at the corner of Tavistock Court, Covent Garden, and to his residence here he owed the inspiration of his life. The busy marketplace, the crowds of people with eager, varied, often criminal faces, was the only school in which he studied; and upon his early recollections he drew throughout his career of art.

In after years memory, unaided by art training, supplied him with the faces he wanted for his noblest work, the illustrations for Bunyan's *Pilgrim's Progress;* but the most characteristic faces were all of one type: evil.

A self-taught artist, without the benefit of formal training, Charles Bennett nevertheless fills a worthy place in the history of illustration, and one that cannot be overlooked by those who are seriously and genuinely interested.

Nor was it only in the lighter manifestations of an exuberant fancy, such as was shown in *Shadows,* in *Aesop's Fables,* and in his Parliamentary portraits that he excelled; his more serious work, as in the *Heads of the People* and the above-mentioned *Pilgrim's Progress,* was full of considered observation and showed an original talent. The majority of Bennett's books were of so very ephemeral a character that, but for the fact of his being associated with several departures from the ordinary track of caricature artists, they would have been utterly forgotten.

158

CHARLES H. BENNETT. *Pen Drawing from Aesop's Fables*

CHARLES H. BENNETT. *Pen Drawing from Aesop's Fables*

CHARLES H. BENNETT. *Pen Drawing from* Aesop's Fables

ADRIAN LUDWIG RICHTER 1803-1884

RICHTER provides connoisseurs with the example of a famous, deservedly famous, illustrator who was in no degree a great or skilled draughtsman. The virtue of Richter flows out of his human sympathy, his participation in the process of living as it took place among the German people of the nineteenth century. Richter was born in Dresden, and passed his childhood in the atmosphere of the Napoleonic wars. He fell into the company of Johann Erhard, and became this artist's disciple in early youth —but Erhard ended the association in 1822 by the very abrupt act of suicide. But these trying and tragic early experiences seem not to have marked him —there is nothing morbid in any line of his work. He chose simple, homely subjects for his work—and when a commission demands that he deal with a great vague theme, the seasons for example, he selects a simple, homely facet of the ponderous concept.

So deeply is Richter immersed in the German culture that he is little heard of in other countries, and only a few lines about him appear in critical surveys written in English. He has been compared to the Englishman John Leech—not because the styles of the two resemble each other, but because just as Leech is immersed in the life of his England, so likewise is Richter absorbed by the essence of the Germany he knew—particularly the region of his birth and lifelong home, Dresden in Saxony. It is interesting to compare Richter's work alongside a typical example of Kate Greenaway or Randolph Caldecott, and experience impressions without concentrating too sharply on any analytical comparison. The observer who has some skill in

162

drawing will perhaps be ready, a little unhappily, to realize what Richard Muther meant when he charged Richter with having a petty correctness of line, with being pedantic and unemphatic, with displaying a kind of vague roundness.

These technical criticisms may be surprising, in view of Richter's early experience as an engraver; but they are offered. Yet they do not obscure the paramount characteristic of the artist—the love of his subject matter. This love he kept until his very death—at eighty he recorded himself as being in some part a great naïve child, and in some part a benevolent patriarch. Richter may have been sentimental—he was certainly not vain, nor yet apologetic. He acknowledged Chodowiecki, Gessner, and Erhard as "those whose contemplative love of nature guided him to his own path". His diary entry, on his eightieth birthday, sketches his own idea of his achievements: "If my art never entered among the roses and lilies at the peak of Parnassus, it did bloom beside the roads and on the banks, in the hedges and in the meadows; travelers resting by the wayside were made glad by it, and little children created wreaths and flowers out of it. . . ." But this was no relaxation into triviality, no surrender of dignity. Richter knew that his themes were ages old, and he decorated one picture with a quiet assertion of the point that Homer sang of just such things: "Und die Sonne Homers, siehe sie lächelt auch uns".

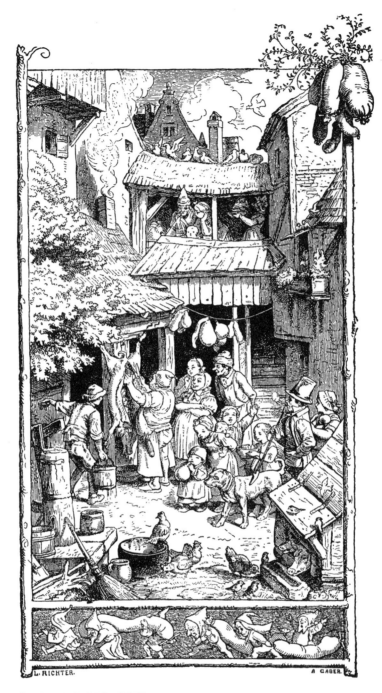

LUDWIG RICHTER.

164

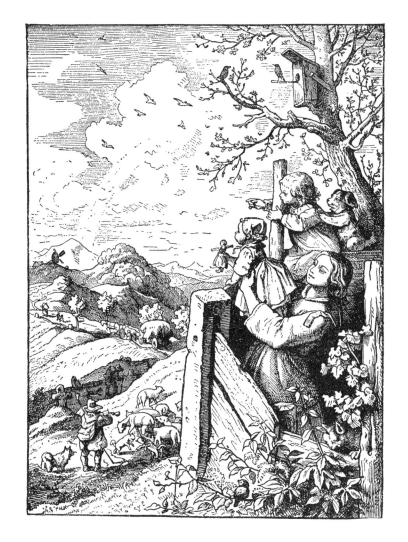

LUDWIG RICHTER.

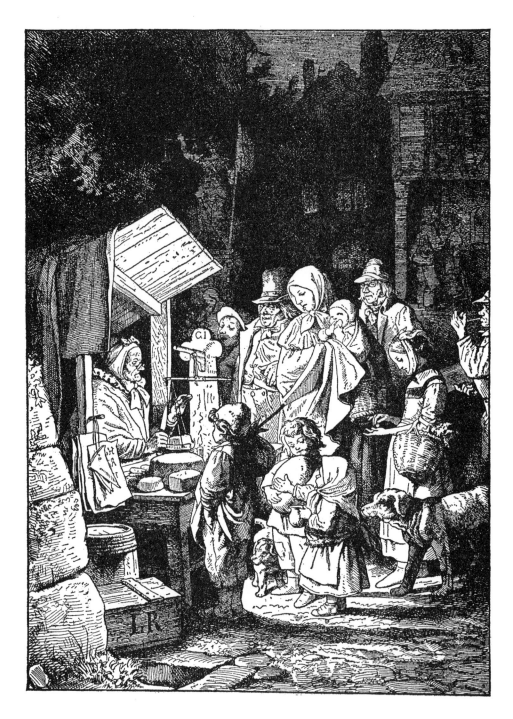

LUDWIG RICHTER.

166

LUDWIG RICHTER.

167

LUDWIG RICHTER.

168

LUDWIG RICHTER.

THE UNASSUMING SIGNATURE, A. Menzel, that accompanied many of his drawings, was that of Adolph Friedrich Erdmann von Menzel, so respected in his old age that colleagues and critics called him "Your Excellency" even before he was officially ennobled in 1898 and privileged to use *von* with his name. More than one critic felt that he was one of the greatest living painters in his old age.

His German reputation depended equally on his paintings and his line illustrations. The choice of his subject, perhaps, contributed to his early renown as an illustrator, for he launched himself into patriotic history in 1836 with *Notable Happenings in the History of Brandenburg Prussia.* This led to his illustrating a series of volumes pivoting around the life, times, and campaigns of Frederick the Great, which appeared in 1843, 1849, 1850, and 1857. In the 1843 opus it is especially interesting to see how the artist's technical ability improved as the work progressed. The medium was wood engraving, the sizes of the blocks were severely limited by arbitrary bureaucratic fiat; Menzel accepted the latter light-heartedly, and decorated his work with a spot cut showing a caliper opened to the exact permitted dimension.

Although such a theme as Frederick the Great contributed much to making an illustrator popular in the Germany of the mid-nineteenth century, pulsing with national pride and expansion, it must not be thought that Menzel was a flag-wrapper. His work is as much admired for its historical and archaeological accuracy as for its intimate rapport with its subject mat-

ter. It was the accuracy of the illustrations, in the *Brandenburg Prussia* work of 1836, that brought the commission for *Frederick the Great* and for this project, Menzel was given facilities for working in the Prussian Historical Museum, observing authentic costume and arms of the times, even of the individuals, who were to be represented.

As for the sympathetic relationship that Menzel's illustrations bear to the text, two of his books are sufficient evidence. One of these was his first publication, *Künstlers Erdenwallen, The Ups and Downs of an Artist's Life,* based on Goethe's book of the same title. A later example is the series of illustrations for *The Broken Pitcher.* Here Menzel erected a famous monument for himself, for his pictures are preserved and reproduced far more often than the story is told.

Menzel never had a master, never seems to have stood in the relation of pupil toward anyone. He was self-taught by observation, practice, and experiment. Some of his experiments went awry—especially in painting, where they resulted in some of his early works turning opaque within his own lifetime. But he was willing to try new devices and new media, yet without resorting aimlessly or frivolously to novelty. His early *Künstlers Erdenwallen* consisted of pen drawings reproduced by the then untried technique of lithography. Menzel was a distinguished draughtsman, although his talent was limited to a narrow concept of the illustrator's art.

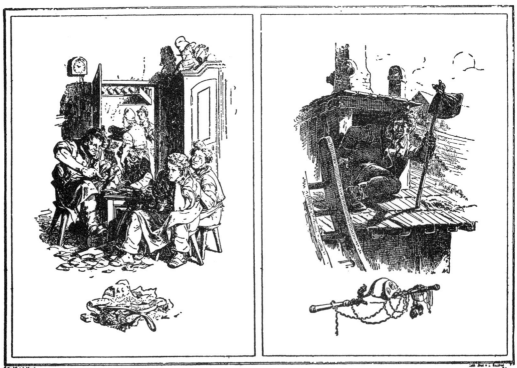

ADOLPH MENZEL. *Illustrations from Künstlers Erdenwallen*

172

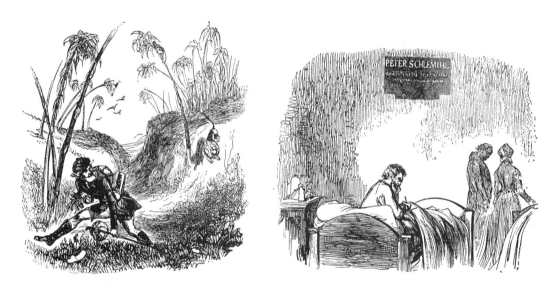

ADOLPH MENZEL. *Two illustrations from Peter Schlemihl*

173

ADOLPH MENZEL. *'Feuersbrunst in Einer Stadt'*

ADOLPH MENZEL. *Illustrations from Künstlers Erdenwallen*

174

ADOLPH MENZEL. *Illustration from Künstlers Erdenwallen*

ADOLPH MENZEL. *Illustrations from Künstlers Erdenwallen*

175

HONORÉ DAUMIER 1808-1879

THE French public accustomed to the enormous and sensational can-
vases of Delacroix and Géricault, found nothing appealing in Dau-
mier's small paintings of homely subjects. It remained for the Twentieth
Century to discover the talents that his contemporaries had ignored.

Honoré Daumier was the son of a poor Marseilles family. His childish
efforts with the crayon marked him for an artistic career. His formal educa-
tion was notable only for its absence, but the streets of Paris, to which he
was brought at an early age, provided the best possible school for the quiet,
deep student of humanity.

Paris was not the fabulous city of gaiety and charm for Daumier, but
the human wretches who infested its quays and shuffled along its byways
and crowded its courts of law provoked in him a sympathy which was mani-
fested in his work from his earliest caricatures until growing blindness
slowed his hand.

His first published work appeared in *Le Caricatura,* a magazine of the
opposition, vitriolic in its attacks against the government. Filled with the
earnest ambition of youth and deeply outraged by the political scene,
Daumier spared no pains to make himself hated by the Orléanists who were
then in power.

For three years a steady stream of cartoons flowed from his crayon to
appear in the pages of the magazine *Charivari*—cartoons which caused dis-
comfort and anger among many who dwelt in high places. Finally roused

176

to action by a bitter attack on Emperor Louis-Philippe, the police authorities removed him to jail, where he remained for six months.

Refusing to be intimidated by this overt move, Daumier continued with his devastating satires. But the daily cartoons never brought him more than a meager living. At forty he gave up his work with *Charivari* in order to devote himself entirely to painting. This change affected his financial condition disastrously. Although many fine paintings came from this, his greatest creative period, he could find no buyers for his canvases. His oils have the same compactness and feeling that one finds in his drawings, which are reminiscent of Michelangelo in their splendid, solid organization.

Daumier had an eye for the grotesque. He saw through the protecting solemnity of the magistrates' billowy black robes and found many of them to be mere silly windbags of the law. He concentrated the attention of the public upon their vapid expressions, upon their hideous Adam's apples and their coarsened features.

"Daumier never felt lonely in his garret", wrote Meier-Graefe. "The hubbub of the streets was to him the resonance of his own work". But in his old age, poor, blind, forgotten by his enemies and remembered by only a few of his painter friends, he faced a bitter end.

It was Corot who saved him from utter destitution with a gesture that can hardly be equaled for sensitiveness and understanding. He presented him with a small house in the country. Thanking him, Daumier wrote: "You are the only man from whom I could take such a gift and not be humiliated".

But his position did not alter his pride. When he was belatedly offered the ribbon of the Legion of Honor, he refused it—a gesture easily understood by those familiar with his great work.

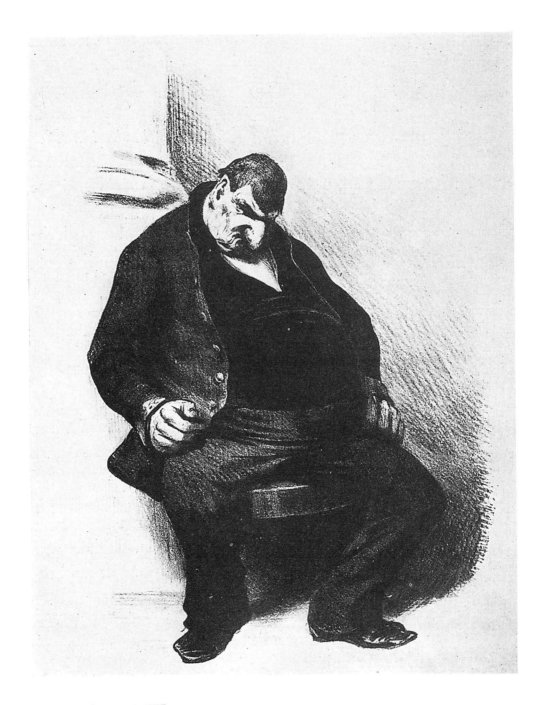

HONORÉ DAUMIER.

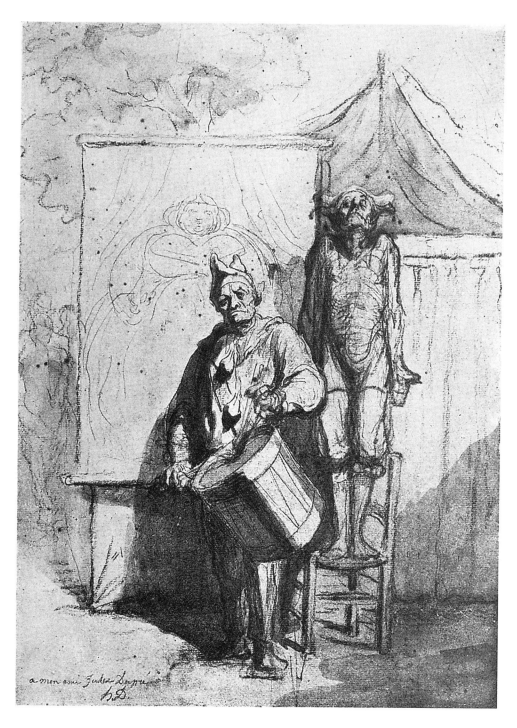

HONORÉ DAUMIER. *'La Parade'*

HONORÉ DAUMIER. *Two illustrations*

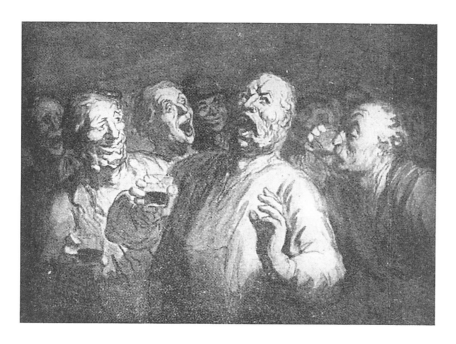

HONORÉ DAUMIER. 'Les Buveurs'

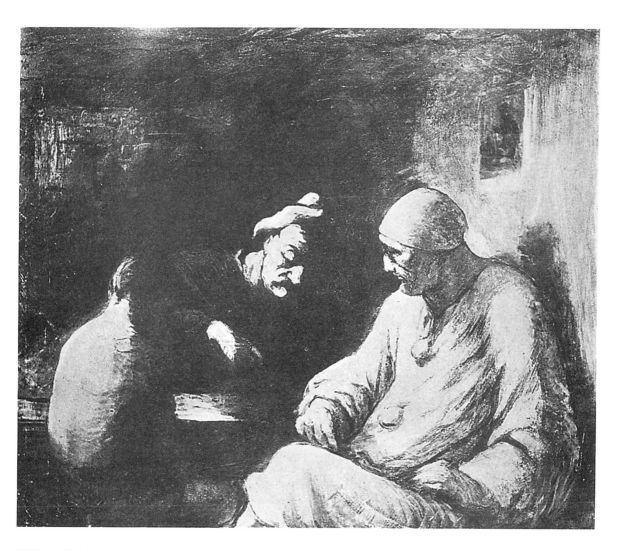

HONORÉ DAUMIER. 'Les Saltimbanques'

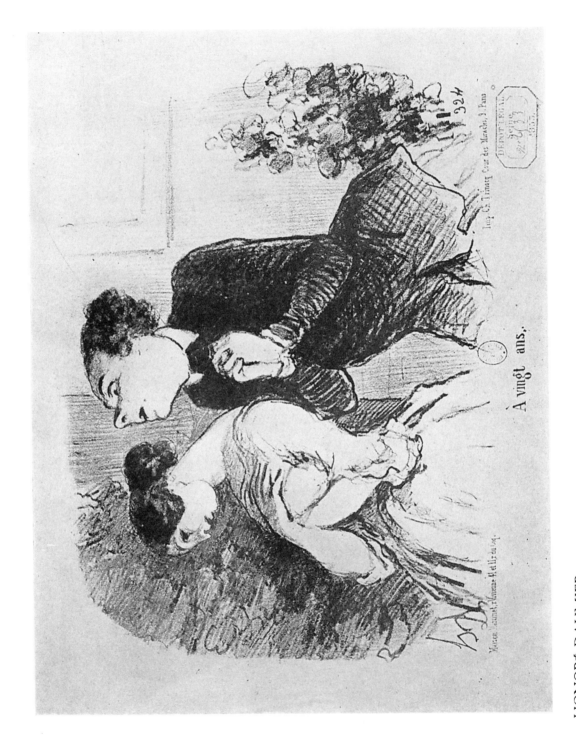

HONORÉ DAUMIER.

182

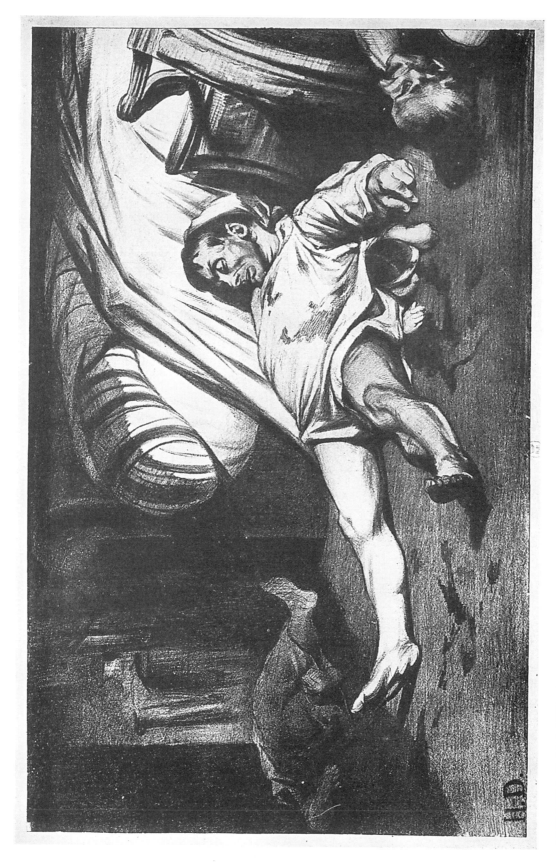

HONORÉ DAUMIER. 'Rue Transnonian, Le 15 Avril 1834'

183

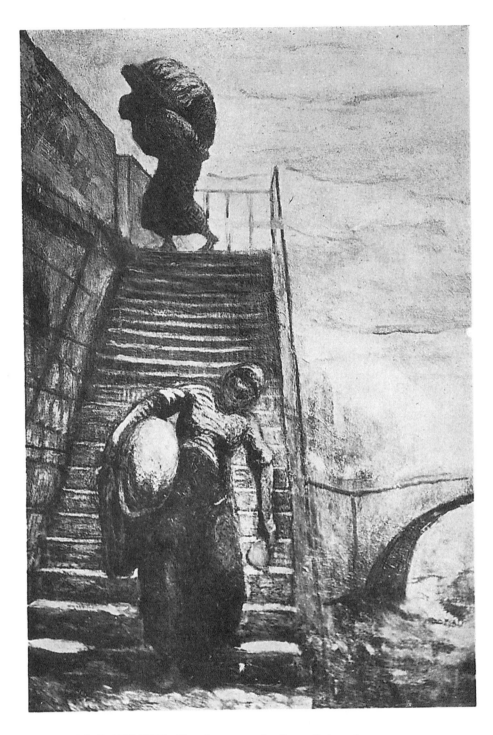

HONORÉ DAUMIER. 'Les Laveuses du Quai d'Anjou'

184

HONORÉ DAUMIER. 'L'Amateur d'Estampes'

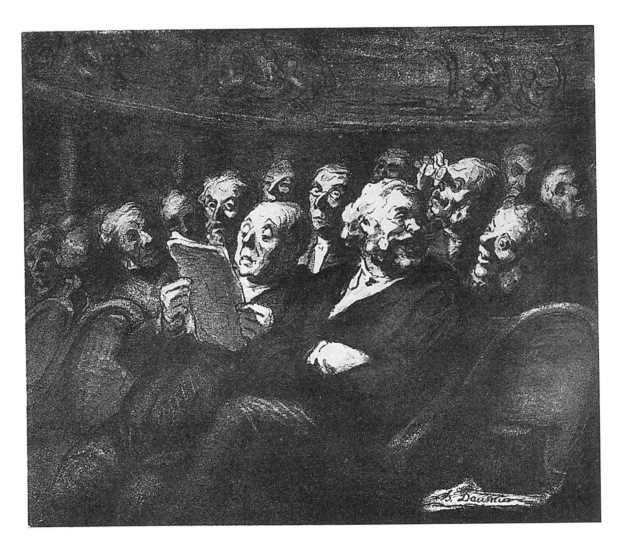

HONORÉ DAUMIER. '*A l'Orchestre*'

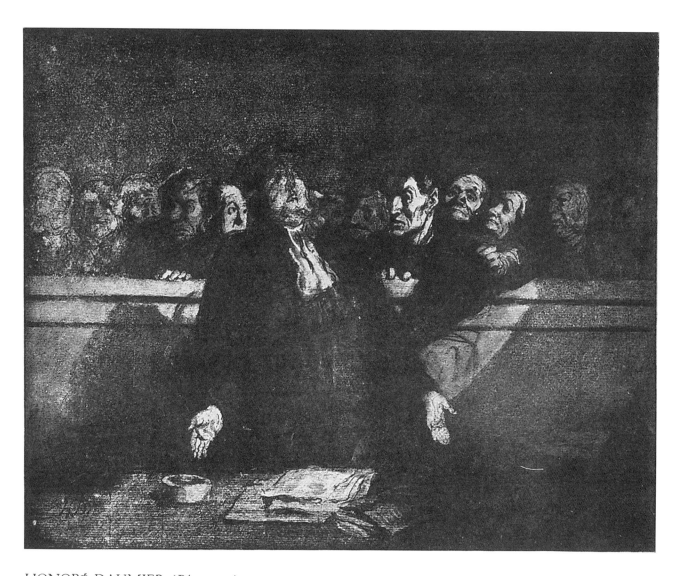

HONORÉ DAUMIER. '*Péroraison*'

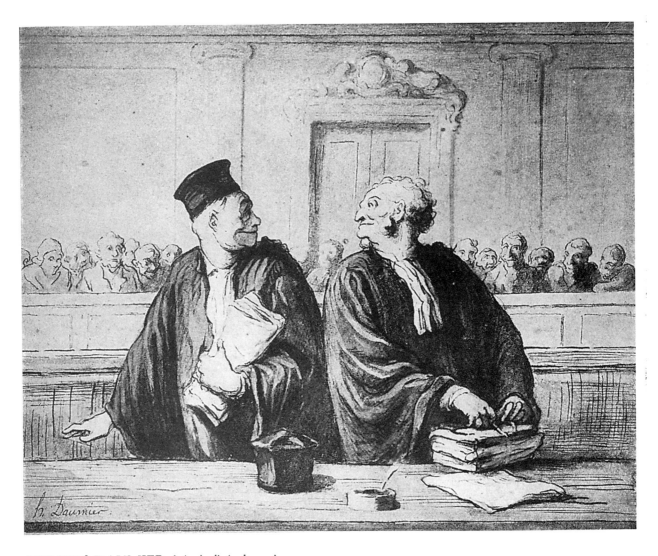

HONORÉ DAUMIER. '*Après l'Audience*'

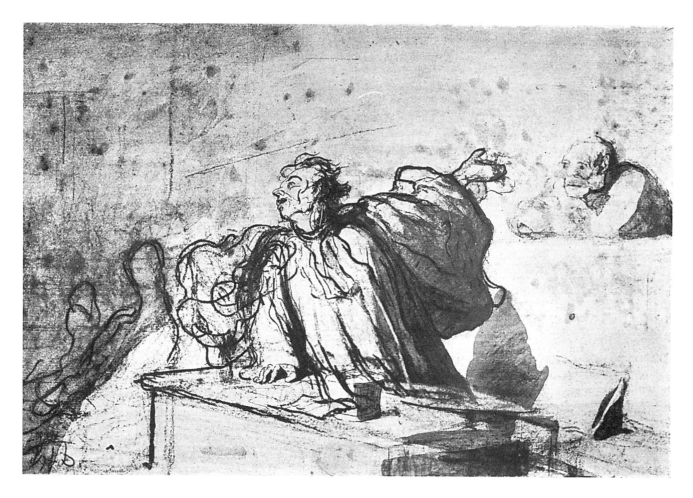

HONORÉ DAUMIER. *'Péroraison'*

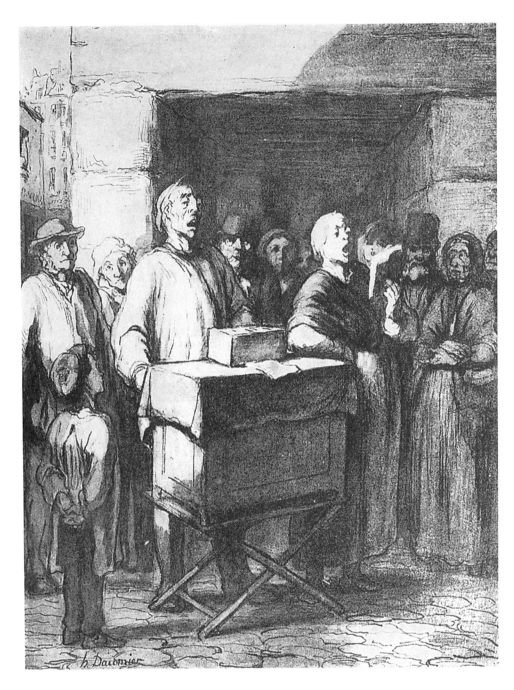

HONORÉ DAUMIER. *'L'Orgue de Barbarie'*

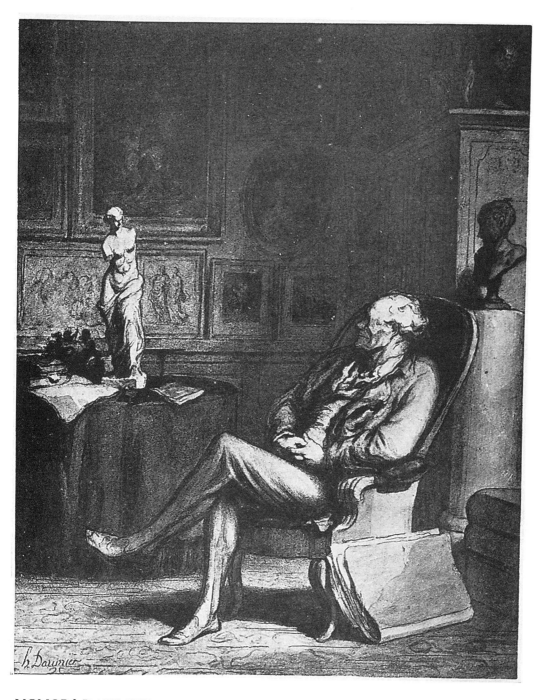

HONORÉ DAUMIER. *'L'Amateur'*

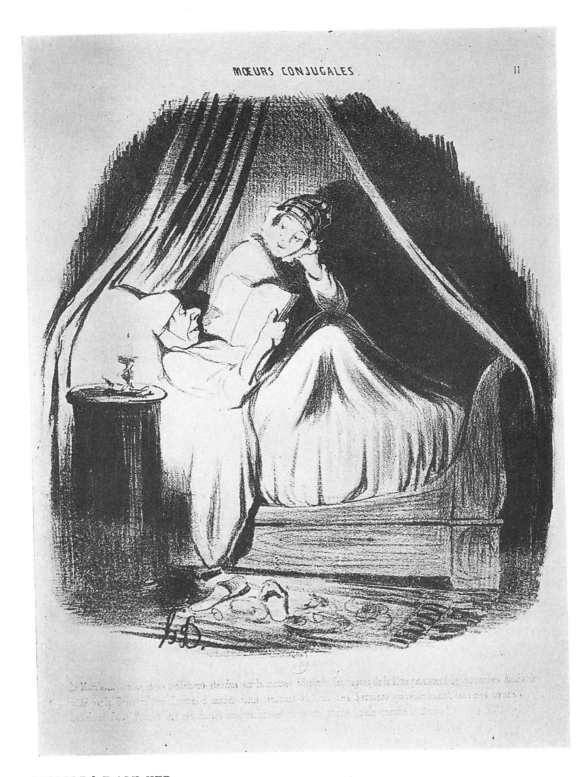

HONORÉ DAUMIER.

192

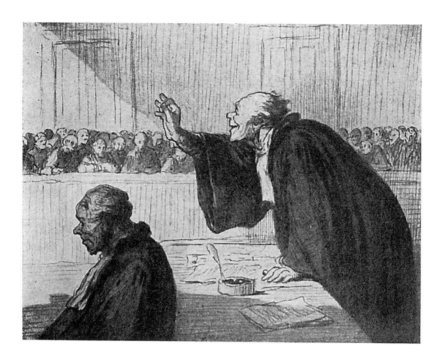

HONORÉ DAUMIER. '*Le Bon Argument*'

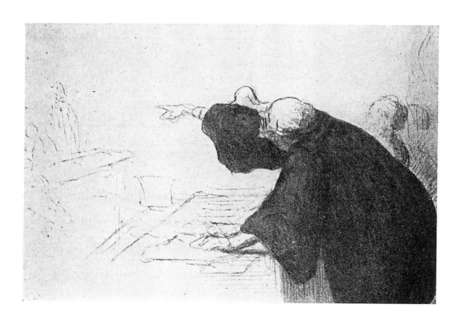

HONORÉ DAUMIER. '*L'Argument Décisif*'

MONTMARTRE was his home. Its people and its cafés, especially the Moulin Rouge and the Rat Mort, found their way into his pictures. He made many friends among the denizens of this part of Paris. They understood him and liked his suave manners. To some extent they even overlooked the deformity which made him so conspicuous wherever he went.

Yvette Guilbert has given us this picture of Henri Toulouse-Lautrec: "Imagine a big brown head like the Guignole Lyonnais, set on the body of a dwarf, a high-colored black-bearded face, thick oily skin, a nose that might garnish two faces . . ." He walked with difficulty on shortened bent legs that had been badly crippled as a result of an accident that had occurred early in his life.

Not a pretty picture, but no less biting than were the lithographs of Toulouse-Lautrec, of whom Arthur Symons said: "What is cruel in Lautrec is what is literally Latin in his race. He desires beauty with the rage of a lover; he hates ugliness with the hatred of a lover; and to him sex is the supreme beauty."

Henri Toulouse-Lautrec was born at Albi, a town in southwestern France. His father, a gentleman-follower of the sports, taught his son to love riding and hunting. But the young Lautrec was never able to indulge this inculcated taste because of his deformity. He struggled against it, finding what surcease he could in every known vice. His companions were women of the streets, and his drunken debauches sapped the strength from

his shriveled body and nearly destroyed the brilliant mind that inspired one of the most facile hands in the world of art.

Night after night he could be seen on his way to the cafés, wearing a derby hat on his enormous head, and attired in foppish clothes. There he would gaze at the performers, his extraordinary visual memory enabling him later to catch in superb flowing lines the eccentricity of each dancer. In 1899 he was forced to enter a sanatorium; his mind seemed to clear. At any rate, it was here that he made one of his finest series of drawings, "Le Cirque".

With Lautrec nothing is wasted—not a line. No one else has ever drawn with such telling economy and with such fierce understanding of human frailty. He had never found sympathy, and in return he never gave quarter. The worst traits of humanity, outlined with truth and diabolical insight, served him for subject matter. He chose to paint in the brothels where he was a frequent visitor, and his favorite models were harlots and panderers.

He loved animals and drew them with rare understanding, often from the most unusual and difficult angles. His drawings are always part of a linear scheme, partly influenced by Degas, but quite different in design. Like his contemporary, Beardsley, he borrowed from the Japanese print, then at the height of its popularity. In the "Le Cirque" series, the effect of the ring is indicated by two or three curving lines of empty circus seats, giving forceful emphasis to the figures in the center of the composition.

Toulouse-Lautrec died at the age of forty-six, after fifteen years of feverish, prodigious activity during which he painted and drew and lithographed. From his early trips to Spain he carried with him the impress of El Greco and of Goya's *los Caprichos*. Between the latter and Lautrec there was a close spiritual relation, for most of the Frenchman's work is distinguished by a beauty of line that can be compared only to Goya.

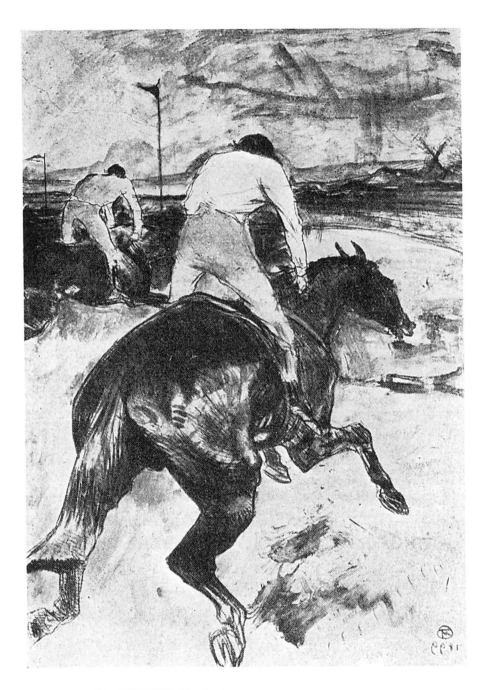

TOULOUSE-LAUTREC. *'Le Jockey'*

196

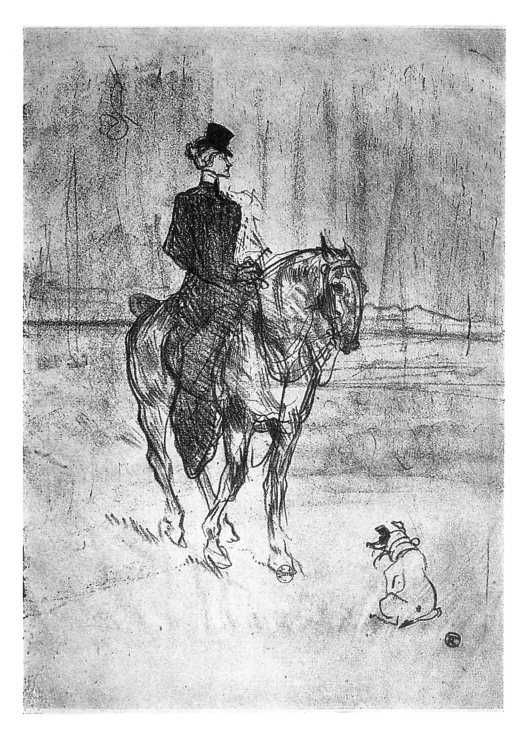

TOULOUSE-LAUTREC.

197

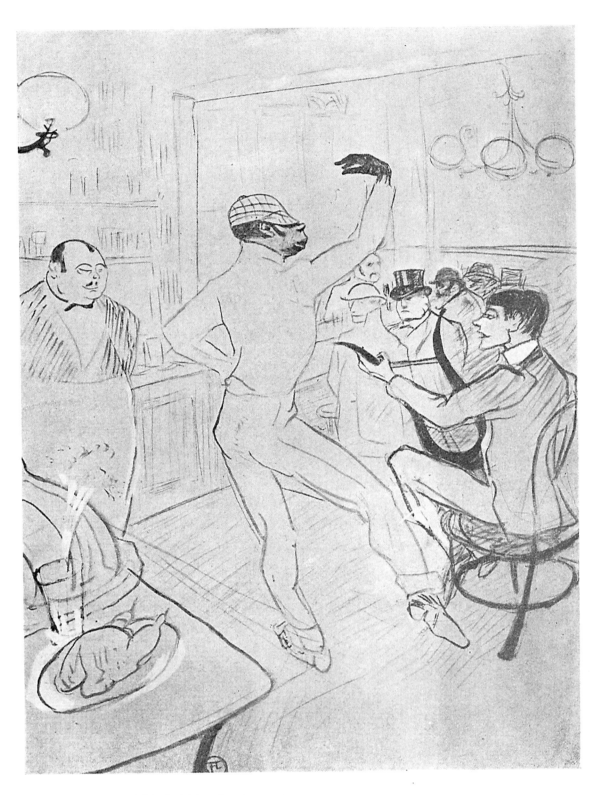

TOULOUSE-LAUTREC. *'Chocolat Dansant'*

198

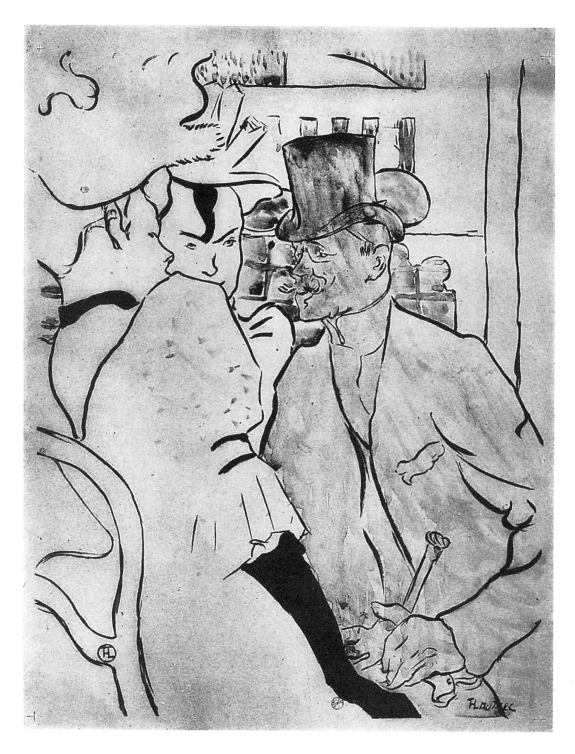

TOULOUSE-LAUTREC.

199

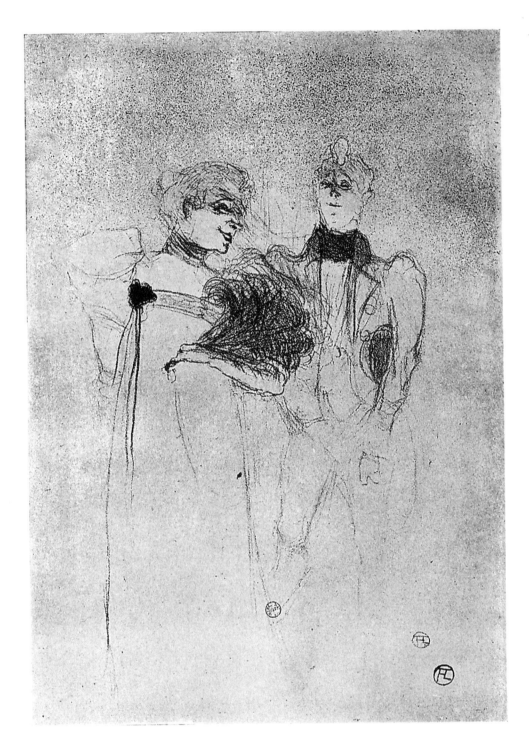

TOULOUSE-LAUTREC.

200

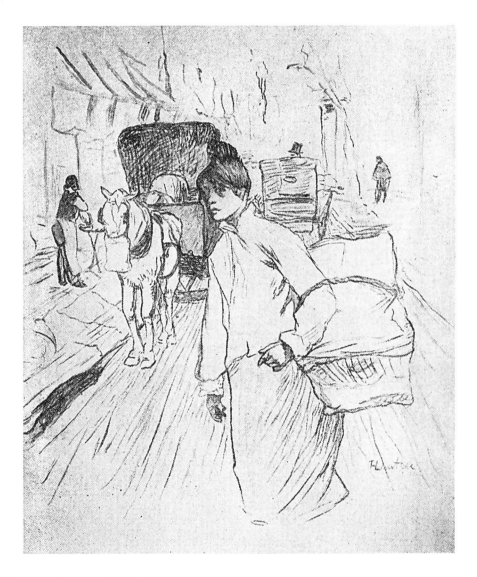

TOULOUSE-LAUTREC. *'La Blanchisseuse'*

TOULOUSE-LAUTREC.

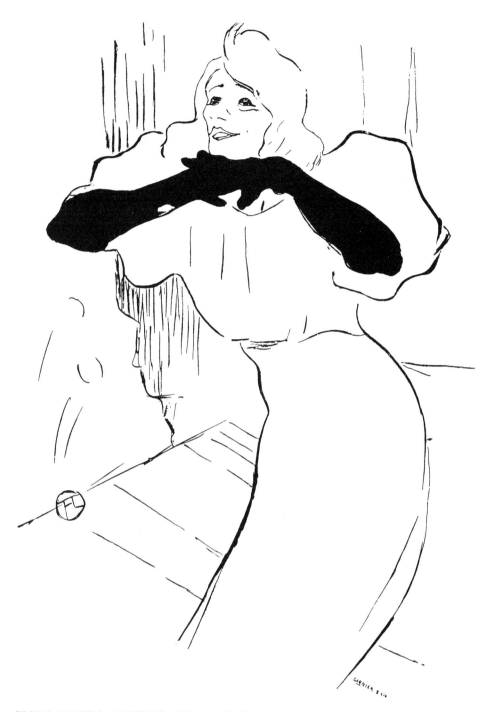

TOULOUSE-LAUTREC. *'Yvette Guilbert'*

TOULOUSE-LAUTREC.

204

GUSTAVE DORÉ 1832-1883

TODAY the name of Gustave Doré denotes little except that of a half-forgotten French illustrator who had a peculiarly involved style of drawing. Yet, not so very many years ago, Doré was extremely popular as an illustrator. "Genius", "the most original and variously gifted designer the world has ever known", "greatest of all living delineators"; were just a few of the superlatives showered upon Doré.

Doré was a prolific illustrator. The number and scope of his illustrations are difficult to estimate, even by a generous representation of his work. The Bible, *Don Quixote,* the works of Balzac and de la Fontaine, all have been lavishly decorated by him.

At fifteen Doré started upon his career by illustrating *The Labors of Hercules,* a travesty on Grecian Mythology. The little book was an immediate success and Doré at once took his place as a caricaturist of importance. Other books soon followed such as Rabelais immortal satire, *Pantagruel and Gargantua,* Balzac's *Droll Stories* and an interesting little book called *A Burlesque History of Holy Russia.* In these early books of his Doré showed a free, easy style, rich in imagination, that was often missing from his later work.

After Doré became conscious of his position as an important illustrator, he tried so hard to maintain it by improving and complicating his technique and in the end he succeeded in defeating his own purpose. His later drawings are in many instances carefully and painstakingly done with a considerable amount of detail, yet they lack the freedom and imagination so

206

apparent in his earlier work. However, Doré was a skilled and gifted draughtsman and when at his best there are few who can stand beside him. He was a past master in the creation of light and shadow, in perspective and in the composition of a mass of men such as upon a crowded battlefield.

During the last half of his life Doré was a bitter and disappointed man for, not content with his fame as an illustrator, he tried desperately hard to prove his ability as a painter and sculptor. He was repeatedly howled down by the critics and refused recognition by the academies. This derision had its effect on him for when he finally died it was with the feeling that he was as much a failure in the field of painting as he was a success as an illustrator.

GUSTAVE DORÉ. *Illustration from Cervantes' Don Quixote*

GUSTAVE DORÉ. *Illustration from Cervantes' Don Quixote*

209

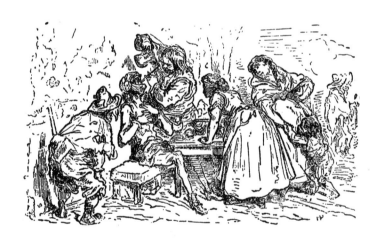

GUSTAVE DORÉ. *Two illustrations from Don Quixote*

GUSTAVE DORÉ. *Illustrations from Baron Mun-chausen*

GUSTAVE DORÉ. *Illustrations from Baron Munchausen*

GUSTAVE DORÉ. *Illustrations from the Labors of Hercules*

THE PRESENT

MODERN FRANCE

MODERN French book illustrators appear to have only one thing in common: their diversity. As we have seen, the different periods of the past each offered a distinct style, one that could not easily be confused with the creations of any other century. Especially did this hold true when the artistic productions were limited to a single country. But were future art historians to apply this rule to a study of Twentieth Century French illustrators, we fear that they would be sadly confounded. In some cases the work of one artist will represent several different methods of handling, from the medieval Germanic block to the most futuristic of modern conceptions.

It is Auguste Lepère who has been called the father of the modern book in France. A sensitive engraver on wood, he welded the older anecdotal style of illustration with a freedom of rendering that opened the way to a genuine renascence of the book. The four plates which represent him in this book bring out the delicacy and strength of his art.

Rather different are the talents of the four artists who owe so much of their success to the efforts of the publisher, Edouard Pelletan. It is because of him that the names of Daniel Vierge, Steinlen, Grasset, and Paul Émile Colin retain firm places in the annals of French art. It was Pelletan's idea to commission Vierge to illustrate Châteaubriand's work and *The Barber of Seville* of Beaumarchais. Vierge will also be remembered for his splendid illustrations to Victor Hugo, and for Michelet's *Histoire de France*.

Another of the group, Paul Émile Colin, gave up the medical profession in order to devote his entire time to art. He has since become the doyen of

French wood engravers. His warmly beautiful engravings of peasant life are broadly treated; they give the *feeling* of the text instead of attempting to depict any detail of the story. The solid masses of black are decorative and well-handled.

An example of diversified talent is shown by the work of Carlègle. In 1900 he was already well known for his illustrations of children's books. Then, in 1912 or thereabouts, he began to experiment on wood and soon after exhibited his first plates for *Daphnis and Chloe,* an exceedingly adult volume. Carlègle is a fine decorator; he is particularly successful in his rendering of the nude.

Compared to Carlègle, it would appear that Émile Bernard emanated from an entirely different place and time. Bernard shows very little of the modern influence. He is steeped in medieval lore and his work is reminiscent of Fifteenth Century Italy. His simple, thickly cut lines would be more at home opposite a page of German black letter than in a modern machine-made book.

Despite his long residence in Paris, Louis Jou has never lost the identity of his native Spain. He is a traditionalist who continues his individualistic work, willfully disregarding the trends about him. He loves typography for its own sake, and there is little about the books he illustrates that is not of his own choosing, from the type to the paper on which it is printed. Jou carefully engraves his woodcuts with a clear free line so that they will harmonize with the typeface. In order to gain a greater freedom in the making of books, he recently set up his own publishing house in his studio.

A return to uncluttered simplicity is André Deslignères' contribution to modern book illustrating. His direct, freely-cut blocks are animated with a sense of the open air. No complicated halftones obscure the healthy outlook of these bold illustrations. Each line conveys a meaning; together they form interesting designs.

It was Raoul Dufy who succeeded in breaking completely with the con-

ventional ideas and precepts of illustration. One of the most exciting and original of modern painters, he has devoted a great deal of time and labor to the art of the book. No thought of establishing the image created by the author enters into Dufy's design. For him the white sheet of paper is to be transformed into a pattern of decorative and vibrating lines. A daring and dynamic artist, humor and design are outstanding characteristics of his work.

The creations of Hermann Paul deserve a high place among his contemporaries. Paul's approach to the book is definitely his own, and with little technical variation in the use of the woodblock. In each of his one hundred and seven borders for the edition of the works of François Villon he interprets the spirit of the vagabond poet, and in no instance do the drawings lose their modern flavor. It would have been an easy task for Paul to have descended to a facile imitation of the early works in wood, but with his keen intuitive sense he has kept alive something of the eternal youth we find in Villon's poetry itself. Paul's illustrations for the *Danse Macabre* show vividly the modern point of view.

An admirer of J. F. Laboureur's ultra-modern conceptions would find it difficult to ascribe his early conservative efforts to the same artist. So well has Laboureur suited each style to the desired end, that his work has the effect of being done by several different men, none of them closely related in the artistic fraternity. And in each case he has chosen the reproductive medium best suited to the mood he is trying to instill. Laboureur never loses sight of the design, and his careful craftsmanship goes a long way toward securing his place among the ranking illustrators of the world.

Americans know Joseph Hémard chiefly through his illustrations to *Rabelais*. These drawings are filled with an overflowing sense of humor and are devoid of any trace of inhibition. They are pleasantly conceived in the roisterous spirit of the author.

D. Galanis is perhaps better known as a teacher of art than as an illustrator, but this should not in any way cast a reflection upon him in an

artistic sense. However, it is in his former capacity that he is able to exert such a strong influence over American and English schools of engraving as well as the French. Galanis is an exquisite craftsman and has done splendid decorative work. He is one of the very few who can really use a multiple burin in wood engraving.

Because their best work is done in color, two very fine French artists are not advantageously displayed in black-and-white. One is Sylvain Sauvage, whose line is both delicate and forceful. The other is Guy Arnoux, whose colored illustrations for children's books are delightfully humorous drawings.

A master in greatly varied fields is André Lhote. The archaic illustration to Paul Claudel's *Verlaine* is an excellent piece of work and very truthful; yet it was designed and executed by the painter-teacher who wields a wide influence in the field of modern art.

Edy Le Grand's fine drawings of the *Prize Ring* and the *Circus* are known to most lovers of the print, as are Ivan Lébédeff's appropriate woodcuts for *Les Vagabonds* of Gorki. The latter are in two colors, the second color being used judiciously and with restraint: it helps greatly to enhance the effect.

Despite his obviously Spanish name and birthplace, Pablo Picasso is thought by most Americans to be French. He is the leader of the French Modernist movement, and his strongly personal touch is carried into his work for books. Insofar as beauty of line is concerned, his illustrations approach perfection more nearly than do his paintings. Many of the great French modern painters have done drawings for books: Vlaminck's lithographs for Georges Duhamel's *Trois Journées de la Tribu;* André Derain's wood engravings for André Salmon's *Le Calumet;* and Marie Laurencin's etchings for *L'Eventail*.

Dunoyer de Ségonzac has influenced a great number of young illustrators. Long a modern of the extreme left in art, he has slowly developed a classic style of enduring substance. Ségonzac's drawings must be prized

for themselves. To the chagrin of some authors and publishers, his illustrations usually have little relation to the printed page. His vivacious line full of intense feeling decorates the text by masterly inference.

It is naturally quite impossible to include in this book every French artist who at some time illustrated a book. But those we have mentioned are today regarded as the leaders in their field; certainly they have won both public and critical acclaim. It is entirely possible that the greatest artists of each century are discovered only by the critics of the next, but we doubt that any contemporary genius of book illustration has escaped either our notice or our mention. These men, together with such others as Bernard Naudin and A. Roubille, have contributed a great deal toward maintaining France's high place in the world of the printed book.

It is also impossible to take account of the dispersal of French illustrators and the disruption of French bookmaking occasioned by the German occupation in 1940.

AUGUSTE LEPÈRE. *Self Portrait*

AUGUSTE LEPÈRE. '*Nude Dancing*'

AUGUSTE LEPÈRE. *Two Plates*

223

DANIEL VIERGE. *Wood Engraving from*
Beaumarchais' Le Barbier de Seville

STEINLEN. *Pencil Drawing from La*
Chanson des Gueux by Jean Richepin

EUGÈNE GRASSET. *Wood Engraving from Anatole France's Le Procurateur de Judée*

PAUL ÉMILE COLIN. *Wood Engravings from La Terre et L'Homme by Anatole France*

225

CARLÈGLE. *Two illustrations from La Fille d'Auberge by Virgil*

CARLÈGLE. *Woodcut from Daphnis et Chloé*

CARLÈGLE. *Woodcut from Les Plus
Jolies Roses de l'Anthologie Grecque*

226

ÉMILE BERNARD. *Woodcut from the Fioretti by Saint Francis of Assisi*

227

FORAIN. *Two pen drawings from Doux Pays*

FORAIN. *Two pen drawings from Doux Pays*

229

LOUIS JOU. *Woodcut from title page of Machia-*
velli's Le Prince

LOUIS JOU. *Woodcuts from* De la Servitude Volontaire, Ou le
Contr'un *by La Boétie*

230

DEUXIÈME STATION

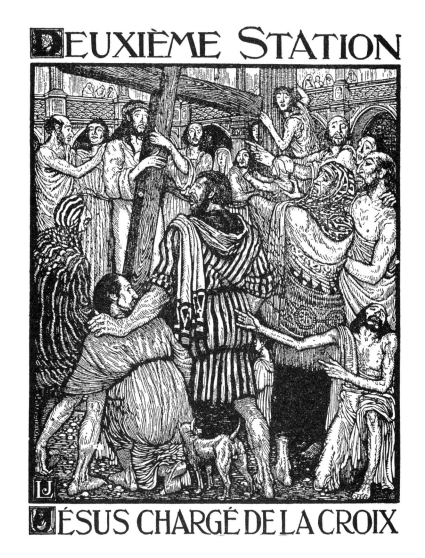

JÉSUS CHARGÉ DE LA CROIX

LOUIS JOU. *Woodcut from Le Chemin de la Croix*

ANDRÉ DESLIGNÈRES. *Woodcuts from Armor by Tristan Corbiere*

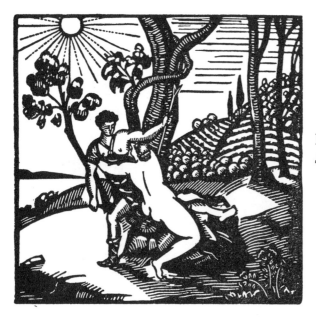

ROGER GRILLON. *Woodcut from Shakespeare's Venus and Adonis*

J. BOULLAIRE. *Woodcut from César Birotteau*

J. BOULLAIRE. *Woodcut from César Birotteau*

JEANNIOT. *Woodcut from Le Misanthrope by Molière*

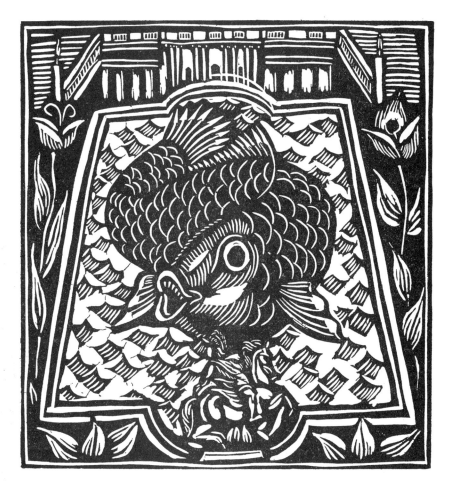

RAOUL DUFY. *Woodcut from Le Bestiaire by Guillaume Apollinaire*

ACHILLÉ OUVRE. *Woodcut from Crapotte by Henri Duvernois*

RAOUL DUFY. *Etching from Vollard's edition of La Belle Enfant*

PIERRE LAPRADE. *Pen drawing from Gustave Flaubert's Madame Bovary*

JEAN GABRIEL DARAGNÈS. *Woodcut from La Main Enchantée by Gérard de Nerval*

235

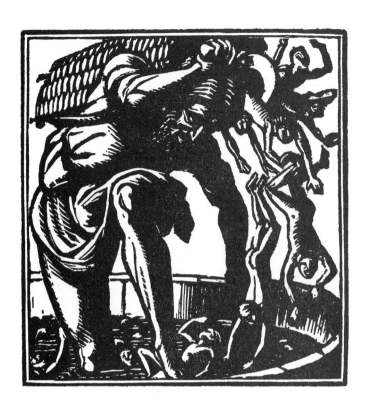

F. A. COSYNS. *Woodcut from L'Apocalypse*

ALFRED LATOUR. *Woodcut from L'Ile Oubliée by Henri Focillon*

J. B. VETTINER. *Woodcut from the Idylles of Theocritus*

CONSTANT LE BRETON. *Woodcut from*
Petits Poèmes en Prose by Charles Baudelaire

237

HERMANN PAUL. *Woodcut from La Danse Macabre*

MAXIMILIEN VOX. *Woodcut from*
Lucien Leuwen by Stendhal

HERMANN PAUL. *Page from Oeuvres de François Villon*
Woodcut

239

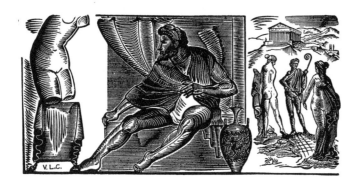

VALENTIN LE CAMPION. *Woodcuts from Les Poésies Priapiques*

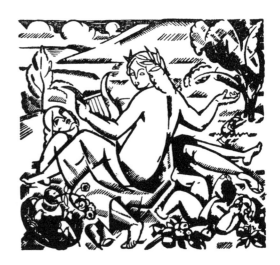

PAUL VERA. *Woodcut from Odes by Paul Valéry*

240

CHARLES LABORDE. *Two illustrations from Claudine en Ménage by Mme. Colette*

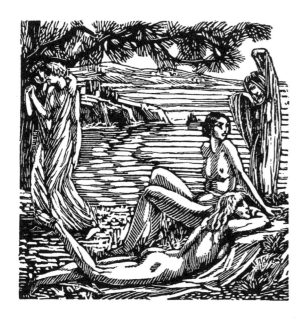

RAPHAËL DROUART. *Woodcut from Baudelaire's Les Fleurs du Mal*

241

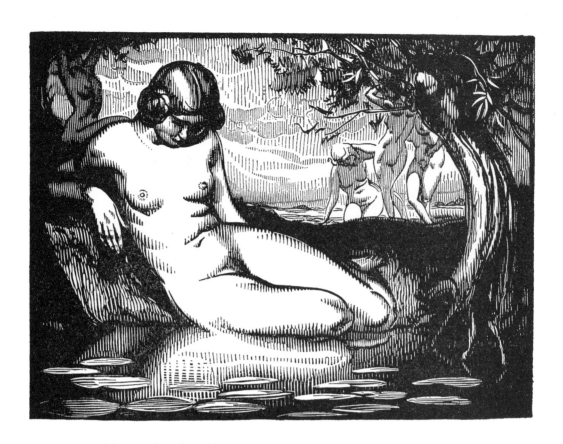

P. E. VIBERT. *Woodcut 'Nude'*

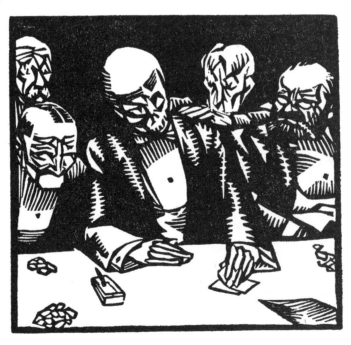

HERMANN PAUL. *Woodcut from La Danse Macabre*

242

P. E. VIBERT. *Woodcut illustration from Dix Paysages de l'Yveline*

J. F. LABOUREUR. *Woodcut from Florilège Gentil-Bernard*

243

D. GALANIS. *Woodcut from Bouclier du Zodiaque by André Suarès*

D. GALANIS. *Frontispiece for Œdipe by André Gide*

BERNARD NAUDIN. *Illustration from Bouvard et Pécuchet by Gustave Flaubert. Pencil Drawing*

BERNARD NAUDIN. *Opening chapter letter from Diderot's Le Neveu de Rameau*

HENRI BARTHÉLEMY. *Woodcut from Anatole France's Le Comte Morin, Député*

FERNAND SIMÉON. *Woodcut illustration from Nouvelles Histoires Extraordinaires*

FERNAND SIMÉON. *Two woodcuts from Marguerite by
Anatole France*

FERNAND SIMÉON. *Two woodcuts from Marguerite by Anatole France*

248

ROUALT. *Woodcut for Les Reincarnations du Père Ubu by Ambroise Vollard*

PABLO PICASSO. *Pen drawing from Balzac's Le Chef d'Oeuvre Inconnu*

PABLO PICASSO. *Woodcut from Hélène chez Archimède by André Suarès*

ANDRÉ LHOTE. *Woodcut from Verlaine by Paul Claudel*

PIERRE GANDON

A. ROUBILLE. *Woodcut from Le Cheval by Buffon*

IVAN LÉBÉDEFF. *Woodcut from Les Vaga-
bonds by Maxim Gorki*

DUNOYER DE SÉGONZAC. *Illustration from L'Education Sentimentale by Gustave Flaubert*

COCHET. *Two woodcuts from Voltaire's Candide*

254

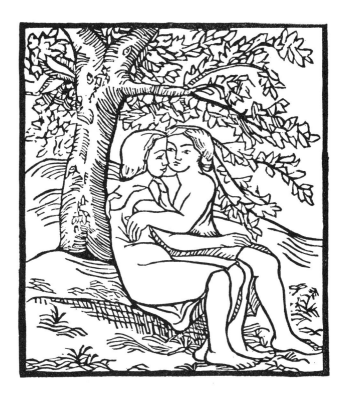

ARISTIDE MAILLOL. *Woodcut illustration for Daphnis et Chloé*

MODERN GERMANY

WHILE it may not be true that all art must carry political significance, it has been proved that political policies often affect the significance of a country's art. The most recent example of this has occurred in modern Germany. Since 1933 there has been a distinct let-down in German artistic activities; previous to that time, especially during the fifteen years between World Wars, experimentation had always been an outstanding characteristic of German book-making, and the German illustrator could always be depended upon for fresh ideas and new conceptions in the design of the book.

From Germany came new typefaces, new techniques, and it was there that the earliest use of impressionism in book illustration found its place. These illustrations did not sprawl across pages, heedless of decorative arrangement, but were carefully thought out and balanced with the type, in such a way as to open up an entirely new vista to the book artist. A whole group of painter-draftsmen gave their art to the subject of free line pen drawing in illustration. Because of their concentration on the design of the book itself, the German artists have never been so diversified as the French, but that in no way detracts from their achievements. Nor does it mean that all German artists have been cut from the same pattern.

Some of the most powerful work done for the German book is by Kathe Köllwitz, long an ardent foe of the Hitler regime. This humanitarian observer of the world about her, reveals in her striking drawings the misery and terror of her people. There is "Zwei Tote," one of the illustrations for

256

Romain Rolland, in which the awe-inspiring spectacle of two figures in death are drawn with economy and deep feeling. Again, in the fine tribute to Karl Liebknecht, death is the subject. In another place and at another time it might seem strange for an artist to become so preoccupied with the sister themes of Hunger, Poverty and Death to the complete exclusion of all other subject material. But in Kathe Köllwitz it is more than understandable: it is necessary.

Another artist of Germany between wars, whose work reflects the spirit of the times, is Alfred Kubin. His pen drawings seem filled with a nervous energy, well suited for the illustration of Poe's macabre tales.

Max Lieberman, a distinguished painter-draftsman, has drawn some beautifully free sketches which were transcribed upon wood. His line is strongly individual, and the drawings succeed in establishing a very definite atmosphere. Lieberman is one of the best known of German painters and he exhibits an original technique for the illustration of books.

Differing greatly from John Austen's illustrations for the same book, Max Slevogt's drawings for *Don Juan* are made with a rapid pen. In each of them the artist's sense of humor and cleverness is apparent. The illustrations were devised in the manner of notes, depicting and amplifying the text.

In a lesser hand the large blocks of Ernst Barlach might very well have lost all meaning and unity. The scattered patterns are never concise, but the racing freedom with which Barlach uses the knife on soft wood lends both cohesion and certainty to his woodcuts.

What appear to be woodcuts in books illustrated by Ernst Nückel are in reality plates fashioned from lead. He has discovered that he can use the metal medium in much the same manner as his contemporaries engrave on wood. No trace of hurry enters into these cuts. They are done with care and precision and are well designed. One of his books is done after the manner of Franz Masereel: in this the pictorial series tells a story in graphic form.

From the free, bold woodcuts of Richard Seewald it may be seen that the

257

artist has not allowed tradition to hamper his approach. His illustrations for the *Bucolica* of Virgil are both humorous and striking in their conception.

Rudolf Wirth has reached back several centuries for the inspiration to his woodcuts for *Die Heiligen in Holzchuhen*. Like those of the primitive German wood engravers, his cuts for this book are simple and fit well with the German black letter type.

Despite discouragement in their homeland, a great many German artists are today keeping alive the tradition which is their heritage. Some of them are working under unusual conditions or in foreign countries, but their productivity has not ceased, nor has the quality of their work suffered.

RICHARD SEEWALD. *Illustration from Höhenwind by Margarete Windthorst*

RICHARD SEEWALD. *Woodcut for Vergil's Bucolica*

RICHARD SEEWALD. *Woodcut for Vergil's Bucolica*

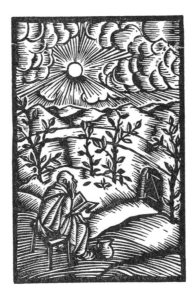

RUDOLPH WIRTH. *Woodcut from Die Heiligen in Holz-schuben by Heinrich Luhmann*

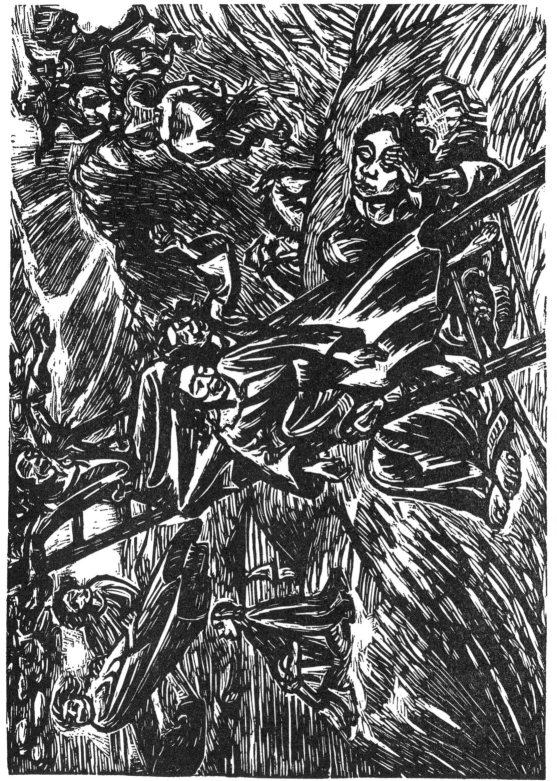

ERNST NÜCKEL. *Illustration cut in lead from Schicksal, A Story in Pictures*

ALFRED KUBIN. *Illustration from Tales of Edgar Allan Poe*

ALFRED KUBIN. *Illustration from Tales of Edgar Allan Poe*

ALFRED KUBIN. *Illustration from Tales of Edgar Allan Poe*

ALFRED KUBIN. *Illustration from Tales of Edgar Allan Poe*

266

ALFRED KUBIN. *Illustration from Tales of Edgar Allan Poe*

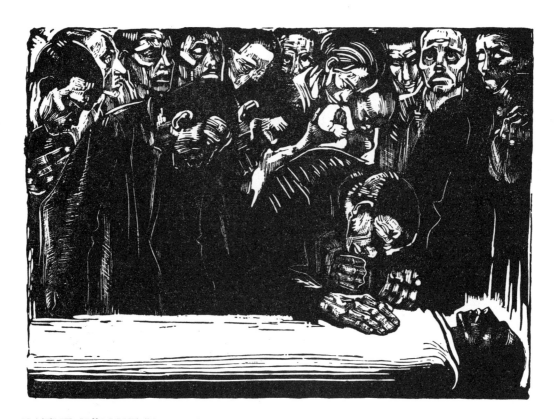

KATHE KÖLLWITZ. *Woodcut from Die Lebenden dem Toten*

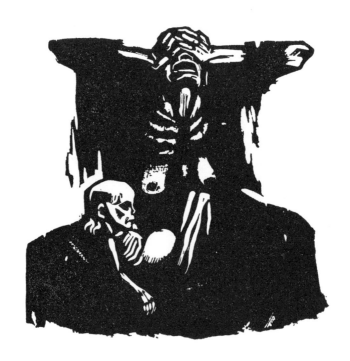

KATHE KÖLLWITZ

J. FRANKEN

MODERN POLAND

THE ART of the woodcut is traditional in Poland. In many villages and provincial towns the tales that were handed down from generation to generation were cut in wood, and under the guiding influence of the monasteries, wood engravings were made in replica of sacred paintings. Occasionally these were signed and dated. From those that remain we have been able to form a clear idea of the Eighteenth Century engravers in Poland.

The Polish sense of ordered pattern is at once apparent in these Biblical illustrations. They are highly conventionalized, and realism plays no part in their conception. The quaint imagery of the woodcuts is medieval in spirit, although in execution they were carefully and skillfully engraved. Their primary interest to us is to show the long tradition of work on wood behind the splendid modern engravings of Poland.

In 1926, at Warsaw, the *Ryt* was founded. It is an organization or union of wood engravers and it lent great impetus to the modern school of Polish craftsmen. One of the leaders at its inception was W. Skoczylas, whose woodcuts are in themselves of high quality. He preferred to work on large blocks, the subjects of which are usually the Polish mountain people he loved. He has made many fine representations of the rugged mountaineers who dwell in the high Tara. His technique strangely takes on the character of painting; line plays little part in his work. The solidity and realistic effect of Skoczylas's woodcuts are obtained by a careful attention to engraved planes.

270

The work of Bartlomiejczyk is graphic and is naturally suited to the medium of the wood block. He is very skillful in the use of the graver, and his white line is particularly effective. In the plate by which he is represented in this collection it will be seen that the relationship of the foreground to the background is exceedingly well handled.

St. Chrostowski is possessed of an unusually good sense of design. The clean glyptic quality of the print represented shows great economy of means. It might very well have been done with a single graver. St. Chrostowski's technique is reminiscent of the English group in general, and of Clifford Webb in particular.

The original and powerful engraving by Kulisiewicz is a fine technical achievement. The mood of the peasant subject is conveyed with startling realism, and the plate in its entirety is enhanced by a truly esthetic arrangement. The bold vertical lines are well emphasized, and the technical method of cutting is definitely original. An excellent piece of engraving may be seen in the gnarled hands of his peasant woman.

The Second World War interrupted a strongly creative period in the history of Polish book illustration. Up to the time that communication ceased we saw increasingly good work in wood and other media come from that country.

WLADYSLAW SKOCZYLAS. *'The Old Mountain Farmer'*

WLADYSLAW
SKOCZYLAS.
'The Potato Diggers'

WLADYSLAW
SKOCZYLAS

WLADYSLAW SKOCZYLAS

ST. O. CHROSTOWSKI

275

L. TYROWICZ

276

T. CIESLEWSKI

T. KULISIEWICZ

278

MODERN RUSSIA

ART THAT IS SPONSORED and commissioned by the State gives to modern Russia a new set of circumstances within which to evaluate book illustration in the U.S.S.R.

The Russian wood engravers are united by strong similarities of technical treatment although their subject matter varies widely. The woodcut, in particular, is a favorite medium for the illustrators of the U.S.S.R. They continue to experiment with the technique of the wood block and the results are endlessly lively and rewarding.

An exceedingly popular Russian artist is Edward Budogosky who illustrated a recent translation of Dickens' *Great Expectations*. Budogosky's use of the white line is interesting and varied. Although design plays a large part in most Russian illustration, in the case of these the obvious intention is character rather than design. They seem to incline toward the old English caricaturists such as Leech and Cruikshank.

In direct opposition to Budogosky are the illustrations to *Tales from the North,* drawn by Peter Staronossov. Staronossov is interested in pattern for its own sake. His handling is extremely original, and his drawings show skill and daring.

Alexis Kravchenko is one of the best equipped of the modern Russian engravers. His fine plate of the New York skyline is rich and varied. Kravchenko has made unusual use of the white line to produce blocks of gray in changing values. This procedure helps to suggest a city flung upward

instead of outward. This picture is, technically, one of the best engravings yet made of New York.

The plate by A. Kravtzov, "Propaganda at Odessa," is an excellent example of the original use to which the woodcut illustration may be put. It is an amusing device by which sailors are shown in the cellar of a structure, while flashbacks after the modern cinema manner depict people riding by in a carriage, battleships in the harbor, a forlorn person on a park bench, and a street scene; the whole of it organized into a pattern of refreshing design.

In the illustration for Gogol's *Sorstchinski Fair*, Nikolas Brummer crams a small plate full of action and fun. The simplest use is made of the graver, the artist obtaining his effect by characterization rather than by intricate design.

A considerable amount of experimentation and progress have been made by Russian artists in the field of colored lithographs for use in children's books. The quality of reproduction remains fairly high despite the huge editions which often run to several hundred thousand copies at one time.

EDWARD BUDOGOSKY. *Design from Charles Dickens' Great Expectations*

EDWARD BUDOGOSKY. *Illustration from Charles Dickens' Great Expectations*

ALEXIS KRAVCHENKO. *Illustration from Stefan Zweig's Short Stories*

A. KRAVCHENKO. *Illustrations from Maxim Gorky's Tales of Italy*

PETER STARONOSSOV. *Illustration from Tales From the North*

ALEXIS KRAVCHENKO. *View of New York*

PETER STARONOSSOV. *Illustrations from a children's book by Gurian Bessemer*

A. KRAVTZOFF. *Propaganda at Odessa*

286

GEORGES TCHERKESSOFF. *Illustration to Soledad*

GEORGES TCHERKESSOFF. *Illustration to Shakespeare's Hamlet*

288

SAKHNORSKAYA. *Woman in the 1905 Revolution*

N. PISKAREV. *Two woodcuts*

FAVORSKY. *Decorations from Stefan Zweig's Short Stories*

ЧАСТЬ II

MICHAEL POLIAKOV

NIKOLAS BRUMMER. *Woodcut from The Sorstchinski Fair by Gogol*

MICHAEL POLIAKOV

291

LEONID KHIZHINSKY. *Illustration for O. Forsch's Clad in Stone*

BORIS BLANCK. *Illustration for Sphorim's The Voyage of Benjamin III*

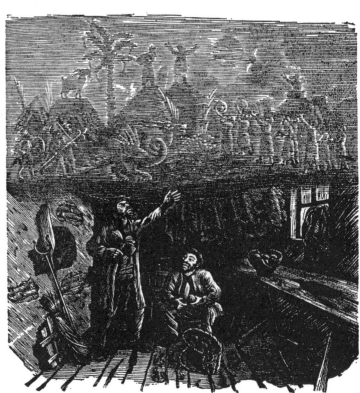

M. FRADKIN. *Illustration for Sholom Aleikhem, The German; Woodcut*

EUGENE BOURGOUNKER. *Illustration for Anatole Françe's The Crime of Sylvestre Bonnard*

293

CONSTANTINE KOZLOVSKY. 'Civil War in the
North Caucasus'

M. N. POLIAKOV. Illustration for
Heinrich Heine's Germania

294

CONSTANTINE KOZLOVSKY. *'Before the Attack'*

M. N. POLIAKOV. *Illustration for Heinrich Heine's*
Germania

E. CHARUSHIN. *'Gathering Dry Leaves for the Lair'*, illustration for Nina Smirnova's *How Misha the Teddy Grew up to Be a Big Bear*

SOLOMON YUDOVIN.
Illustrations for Feuchtwanger's Jew Süss

297

MODERN ITALY

ITALIAN book illustration is naturally traditional in style. The woodcut as opposed to the wood engraving appears a favorite medium. Perhaps as a result of this concentration upon the cut rather than the engraved block, a kind of heavy blackness, which adds to the difficulty in the design of the book, is often apparent. The use of full color also seems to be more general than in most countries although the quality of reproduction is rather uneven. The architecture of the page itself in some of the best books is reminiscent of the high excellence of Renaissance books.

Because this attempt is still in its early stages, some Italian illustrators have not yet learned to balance their drawings with the typeface. One of these is A. Baldini, whose fine woodcuts show definitely the painter's approach to the engraving art. Another is Gemma Pero, whose simple blocks possess a certain grace and charm despite their heavy blacks. And Remo Branca, who is represented here by a block of interesting pattern which is freely handled.

Adolfo de Carolis wisely has chosen a medieval style for his engravings of *St. Francis*. De Carolis shows the influence of Eric Gill, although the de Carolis blocks are not as technically perfect. There is a certain appropriate balance of style to subject. He is not limited to the archaic, however, and his skill as an engraver is demonstrated by the full page example.

Somewhat akin in technical approach, but more nearly like engraved pen drawing, is the work of Carlo Guarnieri. His black line is engraved carefully and at first glance seems to be following the forms, thickening as it becomes

a shadow and growing thinner in the light parts, a technique long familiar in the work of the steel engravers. Sometimes he deviates from this pattern in his desire to render realistic form.

Dario Neri's title page shows an interesting use of an ancient style, transformed by the freedom of the artist into a modern note. This may be contrasted to Aldo Patocchi's *Al Lavoro,* in which the block is used in a simple, entirely modern fashion. Another type of modernity is evidenced in the work of Felice Casorati. Here the artist's humor does not conceal his sense of design. The cuts, admirably fashioned, are interpreted with a high abstract quality.

War conditions in Italy after 1940 seriously interrupted development of book illustration.

BENVENUTO DISTERORI

A. BALDINI

300

A. BALDINI

GEMMA PERO

REMO BRANCA

303

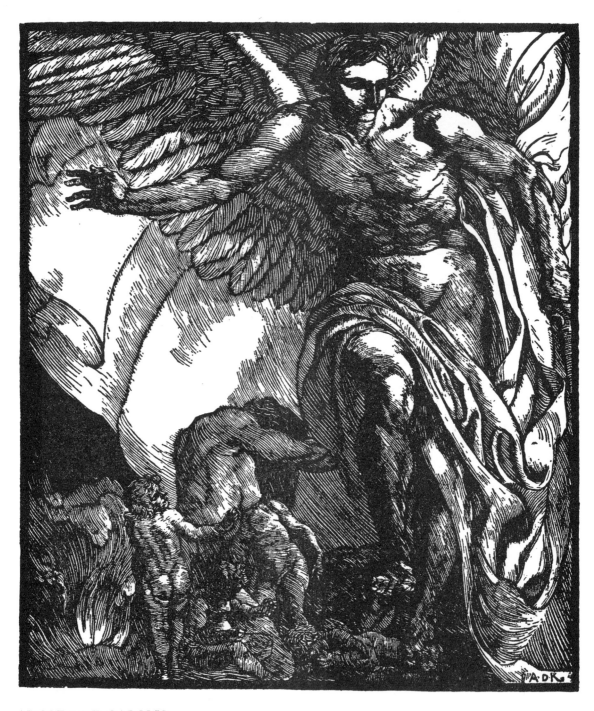

ADOLFO DE CAROLIS

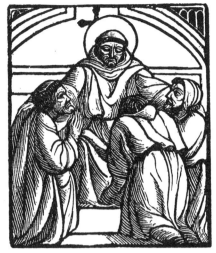 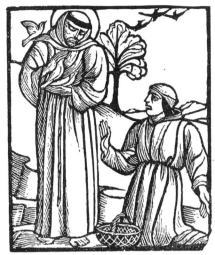

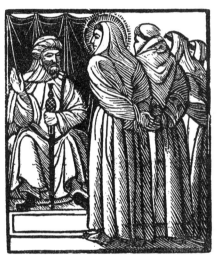

ADOLFO DE CAROLIS

305

ADOLFO DE CAROLIS

306

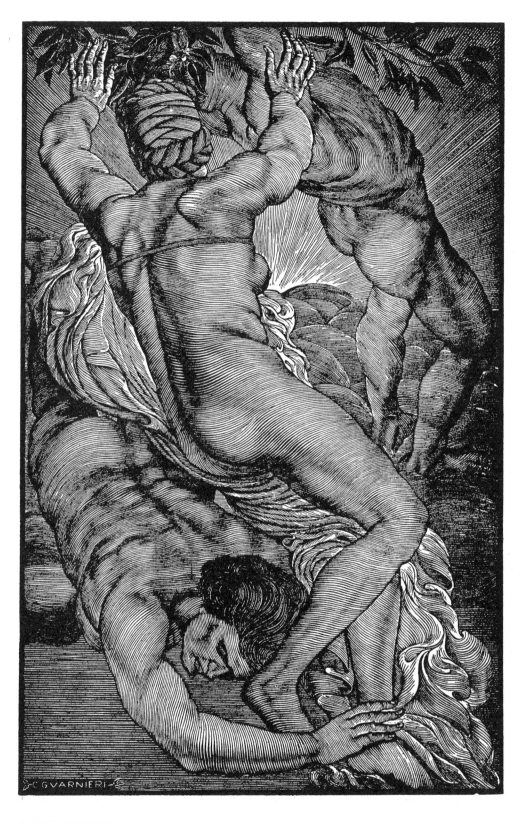

C. GUARNIERI

307

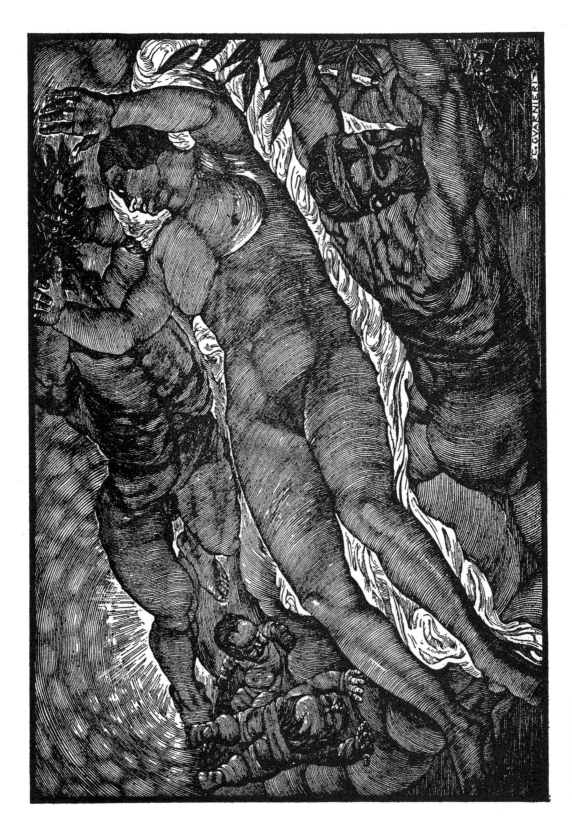

C. GUARNIERI

308

MARIO DELITALA

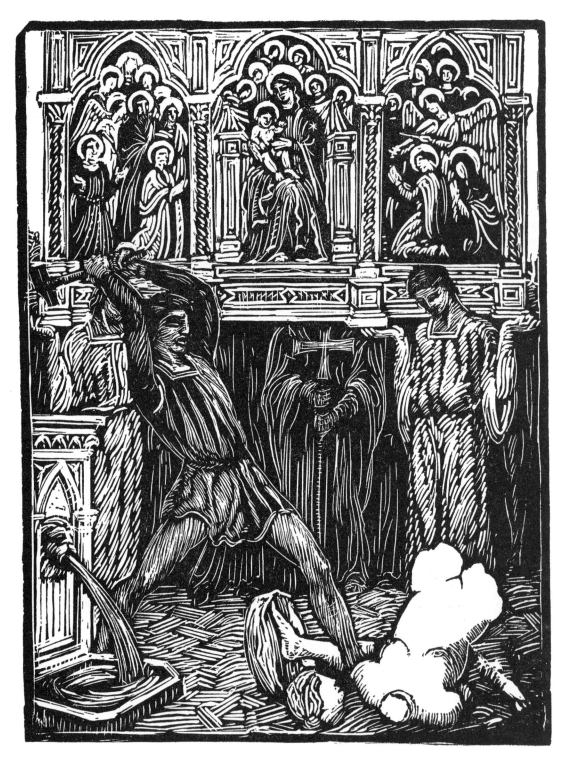

DARIO NERI

310

F. CUSIN

311

MODERN BELGIUM

DAVID ALADAR writes: "There can be no discussion of the modern woodcut in which Franz Masereel does not occupy the central place. He is so far above the ordinary run of artists that we have had to see him with unused eyes. In this case comparison is not only useless, it is absurd. Masereel stands alone."

Masereel is a Belgian by birth. He is without doubt one of the foremost wood engravers, certainly one of the most famous. The idea of books without words, in which a series of woodcuts tells the entire story in graphic form, was his conception. Two well known books, *Die Sonne* and *Mein Studenten Buch,* express his philosophy. The engravings are intensely personal in style, and the patterns are clearly brought out.

The landscape of Joris Minne achieves excellence through the artist's bold use of simple cutting with a knife. Another Belgian, Henri Van Straten, shows lively use of pattern, in which the influence of his countryman, Franz Masereel, can be traced directly.

Belgian bookmaking and book illustration may be expected to resume their vigor after the Second World War has been concluded.

FRANZ MASEREEL. *'Despair'*

343

JORIS MINNE HENRI VAN STRATEN

MODERN HOLLAND

IN NO OTHER LAND have the habits of the people so impressed themselves on their art. Hollanders have ever been neat and orderly, and many Dutch artists are noted for the compact designs of their work. Detail is usually carefully considered and as carefully reproduced.

A small country, Holland has nevertheless given more than its quota of artists to the world of the book. Of the moderns, Eekman, Van Cleemput and Rozendaal are the leaders. And of these three, O. Eekman is perhaps the best known. His plate, "The Pedlars," is an interesting design, freely cut on soft wood and of very large size, a new departure for the Netherlands artist. He has a personal style that is charged with feeling. "Society," by W. J. Rosendaal, is strikingly modern in concept and design.

The German occupation in 1940 interrupted the development of Netherlands illustrative art indefinitely.

JAN VAN CLEEMPUT

T. O. EEKMAN. *'The Fisherman'*

T. O. EEKMAN. 'The Pedlars'

W. J. ROSENDAAL. *'Society'*

MODERN MEXICO

THE splendid originality of Mexico's fresco painters is equaled by that of her graphic artists. Diego Rivera's illustrations for Carlton Beals' *Mexico* are an excellent example of this artist's versatility. He is as much at home drawing for the prescribed limits of a printed page as he is in decorating the large walls of a public building with his murals. His book illustrations are designed with the particular purpose of fitting the typeface, even though their wholly national character is always preserved. Rivera's rich, warm personality is everywhere reflected, and he is as popular in the United States as he is in his native Mexico.

Second only to Rivera in popularity is Miguel Covarrubias, who has spent most of his working years in the United States. Like Rivera's, the work of Covarrubias has lost little of its native flavor. His subject material changes. He has drawn Harlem negroes, a great many caricatures—an excellent collection is, *The Prince of Wales and other Famous Americans*—and there is his latest book, *Bali,* supplemented by photographs taken by his wife. Rhythmic design and harmonious color always play a major part in his work.

A great deal of interesting work in wood engraving has been done by Leopoldo Mendez, whose plates are characterized by their free bold cutting. Its ultimate effect is to underline his revolutionary ideas.

Jose Guadalupe Posada was one of the first Mexicans to use the material of revolution for his subject matter. There is a concrete forcefulness in his work which dominates the naïve eccentricity of his drawing. Posada's surfaces appear flat, a point that serves to emphasize the solidity of his forms.

DIEGO RIVERA. *'Vegetable Carrier'*

MIGUEL COVARRUBIAS. *Two illustrations from his Island of Bali (copyright Knopf, 1936, 1937)*

322

LEOPOLDO MENDEZ. 'Beggars'.
Woodcut (Courtesy Agustín Veláz-
quez Chávez, Mexico City)

LEOPOLDO MENDEZ. 'Spree'.
Woodcut (Courtesy Mexican Art
Editions, Mexico City)

323

LEOPOLDO MENDEZ. 'Francisco Madero'.
Woodcut (Courtesy of Celestino Herrera, Pa-
chuca, Mexico)

JOSE GUADALUPE POSADA. *'Zepata Halloween'*. *Wood-cut (Courtesy of Agustín Velázquez Chávez, Mexico City)*

MODERN GREAT BRITAIN

BRITISH ARTISTS have illustrated so many American books that the more prominent of them need very little introduction to the American reading public. They are many in number and their technique is varied, but the quality of British book illustration rarely descends below a surprisingly high level of excellence.

Perhaps best known in this country is the work of Clare Leighton. The superb craftsmanship of her wood engravings, coupled with a powerful sense of design, has earned her a high place in the art of the book. Some of her finest engravings are strikingly conceived, their play of delicately tooled white lines picking out the essentials of the composition. Neither haste nor crudity marks her woodblocks, yet the finished proof carries with it a sense of power through its dynamic organization. *The Farmer's Year* is a beautifully conceived work, and some of its plates are among Clare Leighton's best.

Robert Gibbings has made some splendid wood engravings that for sheer skill and technique are in a class by themselves but his great influence upon contemporary artists in both America and England is perhaps derived from another source. As the coordinator who presides over the destinies of The Golden Cockerel Press, he employs the talents of the best illustrators at work in England today. The *Phaedo of Plato,* beautiful in its simplicity, is an excellent example of modern book production.

Agnes Miller Parker is a splendid craftsman whose work in wood is characterized by excellent design and intelligent variety in the use of the graver. Her engravings are carefully studied in relation to the type.

The initial letters and ornaments for the *Phaedo* were designed and executed by Eric Gill, whose place in modern art is an anomaly. He is considered a leader in the new movement, yet his work harks back to the early Germans. For sheer skill in the use of the black line in engraving, it would be difficult to find his equal. His familiarity with all the phases of hand printing is demonstrated again and again by the ease with which his engravings adapt themselves to their type-surroundings.

The precision of Gill's work contrasts oddly with the freedom and dash of Frank Brangwyn's woodcuts. Brangwyn is primarily a painter of murals, but he has never neglected the illustrative art. For most of his best work in books he drew his designs directly upon the blocks, turning them over to his sympathetic collaborator, Ushibara, for skillful cutting. The woodcut from Emile Verhaeren's *Les Campagnes Hallucinées,* published in France, illustrates well the technique of this distinguished painter.

Some of the first modern woodcuts to be published in America, the illustrations for the poetry of James Branch Cabell, were engraved by the English artist, Leon Underwood. His splendid and unusual use of the white line influenced the work of many contemporary engravers. Underwood's work is distinguished by a sense of design which approaches abstract art. Nevertheless, subject matter plays an important part in his illustrations.

Clifford Webb's forthright handling of his scenes of the English countryside are rich and warm, and his compositions show a great deal of forethought in their design. The least that can be said of Webb's wood engravings is that they are not too original in technique.

A lack of originality is a fault of which Iain MacNab will never be accused. His work is spontaneous and striking in its handling. MacNab loves the contrast of strong light and shadow on the walls of buildings, and one can follow clearly the creative and varied marks of the graver on the highly conventionalized trees and sky. All the devices of the graver's art are apparent, yet they are well subordinated to the final effect.

Blair Hughes-Stanton and John Farleigh, both expert engravers on

327

wood, desert tradition and work toward a synthesis of form carried through to abstraction, a quality exemplified in Farleigh's *Melancholia*. Hughes-Stanton makes striking use of the engraver's tool in his plate taken from *Comus*. The contrast of the figure against the carefully engraved design of the dress shows a very high degree of technical skill.

Design plays an important part in the work of another British artist, this time the very popular John Austen. His work is characterized by its simple, graceful use of line. He does not permit realism to hamper his approach, and his drawings are composed in a conventional though vivacious pattern. Austen understands how to fit weight and color to balance the page, and in most of his earlier work a great deal of imagination is displayed.

The mantle of Aubrey Beardsley has descended upon the shoulders of Harry Clarke. Clarke has gone to the Savoy for his inspiration, consciously avoiding every other influence. With patience and insistence upon much elaborate detail, he enters into the highly imaginative form of book illustration. Some of his drawings for *Faust* deserve special mention.

Two more English illustrators have arrived at prominence through highly divergent paths. Claughton Pellew, with great originality in the technique of his craft and a judicious use of the graver, has managed to produce striking plates from rather mediocre material. And Ernest Shepherd's free and charming illustration to *Christopher Robin* and other children's stories by A. A. Milne must have a place in the world of the English book.

Eric Fitch Dagleish is primarily a naturalist. His beautifully engraved birds and animals show his painstaking concern with the texture of feathers and fur. His illustrations may be categorized as realistic, but some of the plates transcend his first purpose and by reason of their excellent pattern become fine decorations for the book.

Keith Henderson's line has been called rigid, but he consciously uses this form to obtain a forceful simplicity. To him, balance and rhythm are more important than mere plasticity. His carefully authenticated illustra-

tions to Prescott's *Mexico* and to Hudson's *The Purple Land* show his strongly stylized decorations to good advantage.

The Lindsay brothers, Norman and Jack, have nothing in common except the accident of their birth. Jack Lindsay is a serious and careful worker whose art is somewhat in the manner of Austen and Clarke. Norman Lindsay prefers to illustrate humorous writings. He uses a sketchy and facile pen in a style admirably suited to Aristophanes' comedy *Lysistrata*.

Rex Whistler, an excellent illustrator, is a fine imaginative draftsman whose sense of humor is immediately apparent. His designs for Walter de la Mare show that a good sense of design and humorous material may be welded without loss to either quality.

Gwendolyn Raverat's woodcuts are distinguished by the artist's originality of design and her sense of fitness in her craft. Whether she uses the knife or the graver, the instrument is sympathetically and skillfully handled. The intrinsic merit of a Raverat woodcut is so apt that the observer feels that any other medium would be out of place. The blocks have a certain quiet beauty, a sense of peace and a fine atmospheric effect.

Edmund Sullivan's illustrations to the *Rubaiyat of Omar Khayyam* have a beauty and quality of their own. The charm of Sullivan's plates lies in his tender and imaginative interpretation of the text. He has a splendid sense of design, and his drawings transmit a definite feeling of spaciousness that cannot easily be duplicated.

The beautiful imaginative drawings of Arthur Rackham seem to belong to an earlier time. The playful spirit of his gnomes and fairies does not, however, disguise his able draftsmanship. His most fearsome and grotesque images are somehow touched with delicate charm. His admirable feeling for form and his exquisite line work are perhaps more readily discernible in his illustrations to *The Nibelüngen*.

British illustrators continued at work even during the wartime difficulties following 1940, in some cases with the government's encouragement.

CLARE LEIGHTON. *Woodcut from the Farmer's Year Written and Engraved by the artist (Longmans, Green and Co., N.Y.)*

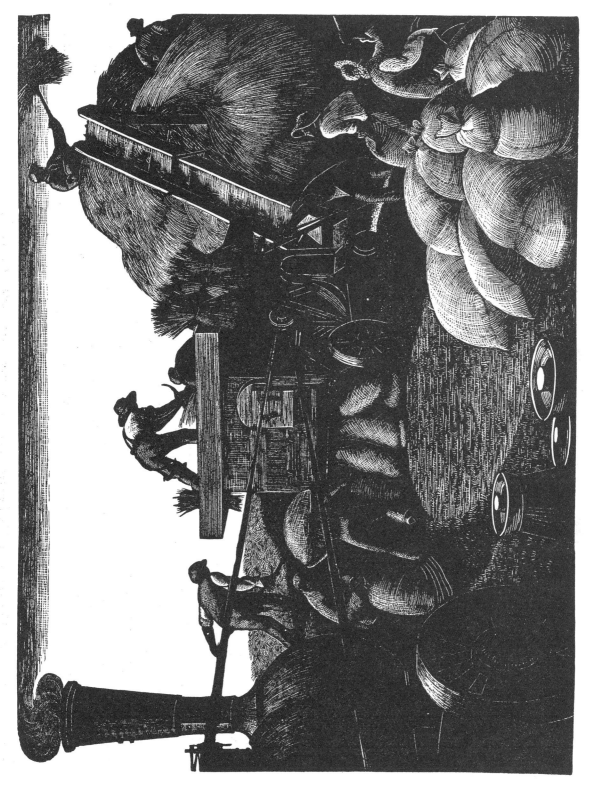

CLARE LEIGHTON. *Woodcut from The Farmer's Year (Longmans, Green and Co., N.Y.)*

CLARE LEIGHTON. *Woodcut from* The Farmer's Year *(Longmans, Green and Co., N. Y.)*

332

ROBERT GIBBINGS. *Woodcut from Gustave Flaubert's Salammbo*

ROBERT GIBBINGS. *Woodcut from Gustave Flaubert's Salammbo*

ROBERT GIBBINGS. *Woodcut from Gustave Flaubert's Salammbo*

334

FRANK BRANGWYN. *Illustration from Les Campagnes Hallucinées*
by Emile Verhaeren (Helleu et Sergent, Paris)

335

LEON UNDERWOOD. 'The Dream of Mardocheus' from the Apocrypha
(The Cresset Press, London)

336

CLIFFORD WEBB. *'Loading' Woodcut (English Wood Engraving Society)*

CLIFFORD WEBB. 'Building the Rick' Woodcut (Redfern Gallery, London)

IAIN MACNAB. *'Majorcan Village'*
(English Wood Engraving Society)

IAIN MACNAB. *'Corsican Landscape' (Redfern Gallery, London)*

IAIN MACNAB. 'Saint Paul' (English Wood Engraving Society)

340

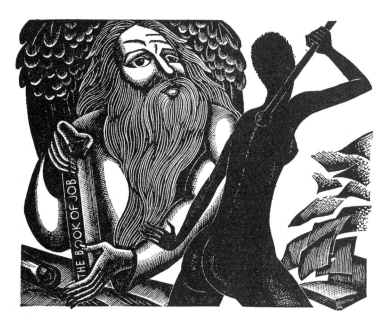

JOHN FARLEIGH. *Illustration from The Black Girl in Her Search for God*

JOHN FARLEIGH. *Chapter initial from The Black Girl in Her Search for God*

JOHN FARLEIGH. *Illustration from Chapman's Homer (Shakespeare Head Press)*

343

JOHN FARLEIGH. *Illustration from The Black Girl in Her Search for God*

BLAIR HUGHES-STANTON. *Illustration from*
Comus (Gregynog Press)

345

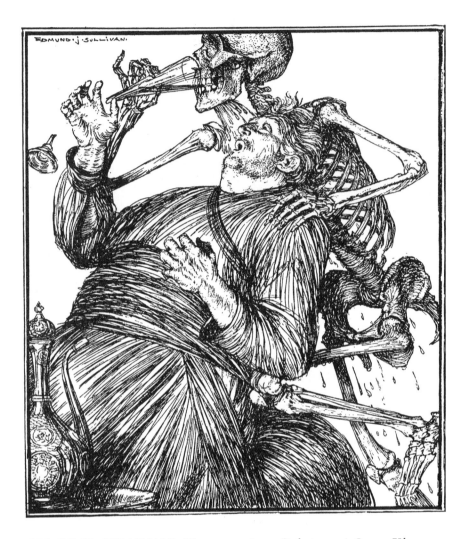

EDMUND SULLIVAN. *Illustration from Rubaiyat of Omar Khayyam*

346

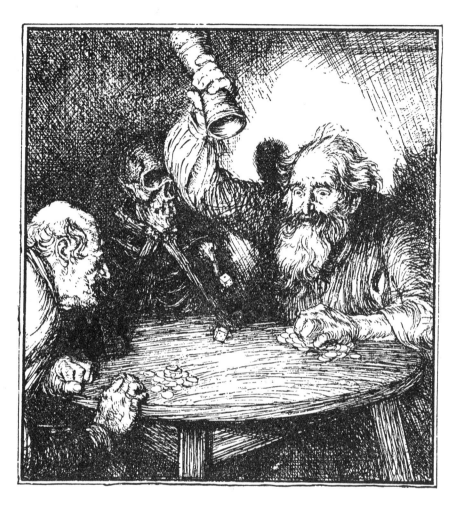

EDMUND SULLIVAN. *Illustration from Rubaiyat of Omar Khayyam*

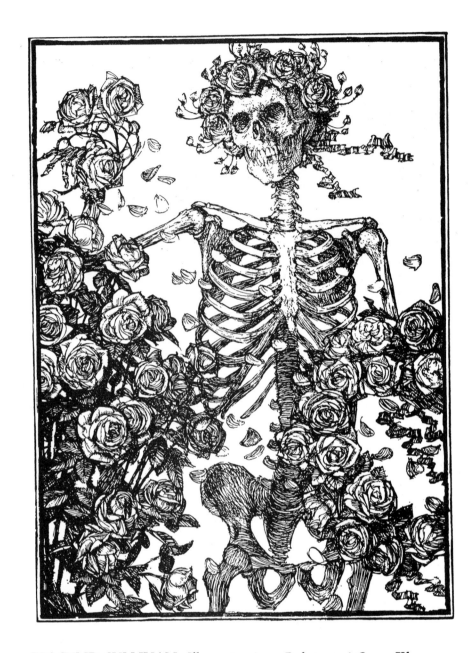

EDMUND SULLIVAN. *Illustration from Rubaiyat of Omar Khayyam*

348

JOHN AUSTEN. *Two illustrations from Byron's Don Juan*

JOHN AUSTEN. *Illustration
from Byron's Don Juan*

JOHN AUSTEN. *Decorations for E. C. Lefroy's Echoes from
Theocritus (Selwyn and Blount)*

350

JOHN AUSTEN. *Illustration from Byron's Don Juan*

JOHN AUSTEN. *Illustration from Byron's Don Juan*

JOHN AUSTEN. *Illustration from Byron's Don Juan*

JOHN AUSTEN. *Illustration from Shakespeare's As You Like It (William Jackson Books Ltd.)*

352

JOHN AUSTEN. *Illustration from Moll Flanders by Daniel Defoe (John Lane, The Bodley Head)*

JOHN AUSTEN. *Illustration from Shakespeare's As You Like It (William Jackson Books Ltd.)*

JOHN AUSTEN. *Illustration from Shakespeare's As You Like It (William Jackson Books Ltd.)*

354

JOHN AUSTEN. *'Scheherezade'. Pen Drawing*

355

EDMUND DULAC. *Two illustrations from Edgar Allan Poe's The Bells and other Poems (Hodder & Stoughton)*

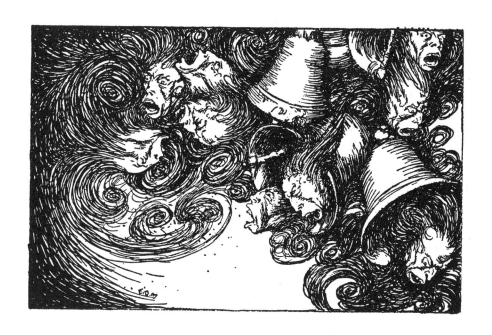

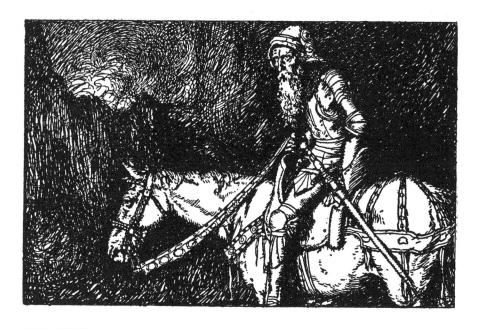

EDMUND DULAC. *Two illustrations from Edgar Allan Poe's The Bells and other Poems (Hodder & Stoughton)*

357

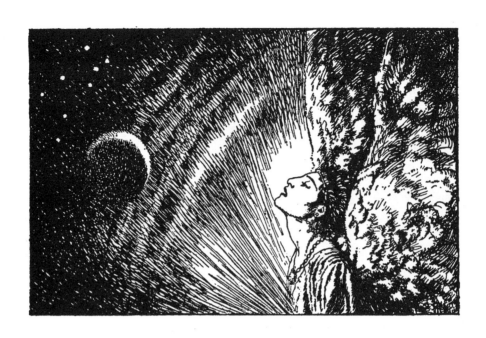

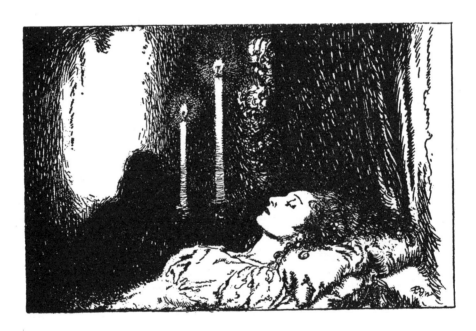

EDMUND DULAC. *Two illustrations from Edgar Allan Poe's The Bells and other Poems (Hodder & Stoughton)*

HARRY CLARKE. *Two illustrations from Andersen's Fairy Tales*

HARRY CLARKE. *Illustration from Andersen's Fairy Tales*

HARRY CLARKE. *Illustration from Goethe's Faust*

361

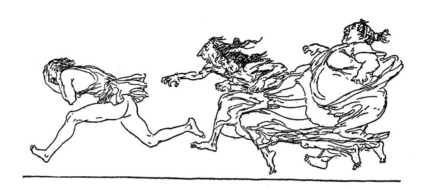

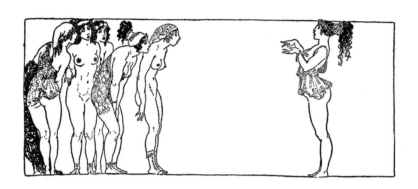

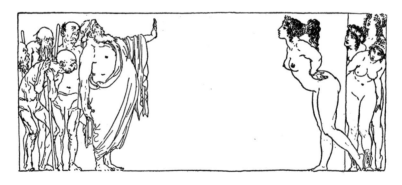

NORMAN LINDSAY. *Three pen drawings from Aristophanes'*
Lysistrata

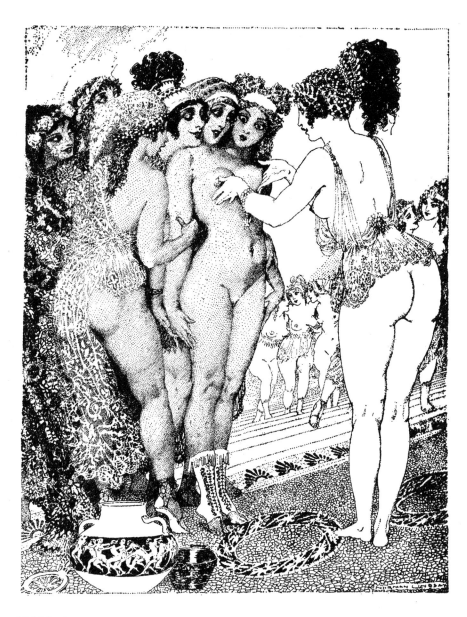

NORMAN LINDSAY. *Pen drawing from Aristophanes' Lysistrata*

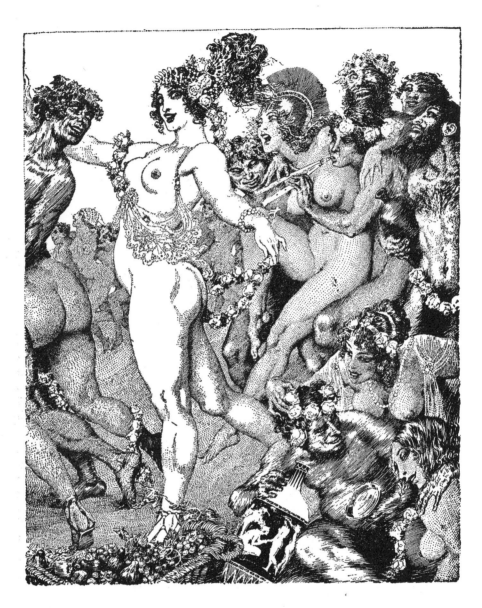

NORMAN LINDSAY. *Pen drawing from Aristophanes' Lysistrata*

364

CLAUGHTON PELLEW. *Woodcut 'The Squirrel' (The English Wood Engraving Society)*

365

CLAUGHTON PELLEW. *Woodcut 'The Entombment' (St. George's Gallery)*

366

ERIC FITCH DAGLEISH. *Woodcut from* The Natural History of Selborne *by Gilbert White (Thornton Butterworth)*

ERIC GILL. *Woodcut from Shakespeare's King Richard III (E. P. Dutton, New York)*

ERIC GILL. *Woodcut from Shakespeare's Julius Caesar (E. P. Dutton, New York)*

368

ERIC GILL. *Title page design for Hamlet (Goupil Gallery, London)*

KEITH HENDERSON. *Two illustrations from The Purple Land by W. H. Hudson*

KEITH HENDERSON. *Frontispiece design from Green Mansions by*
W. H. Hudson

KEITH HENDERSON. *Illustrations from Green Mansions by W. H. Hudson*

KEITH HENDERSON. *Illustration from The Purple Land by W. H. Hudson*

372

REX WHISTLER. *Illustration from* The Lord Fish *by Walter de la Mare (Faber & Faber, London)*

REX WHISTLER. *Illustration from* Dick and the Beanstalk *by Walter de la Mare (Faber & Faber, London)*

373

GWEN RAVERAT. *Illustrations from The Runaway (Macmillan & Co. Ltd.)*

GWEN RAVERAT. *Illustrations from The Runaway (Macmillan & Co. Ltd.)*

375

ARTHUR RACKHAM. *Illustration from Grimms' Fairy Tales (Constable & Co., London)*

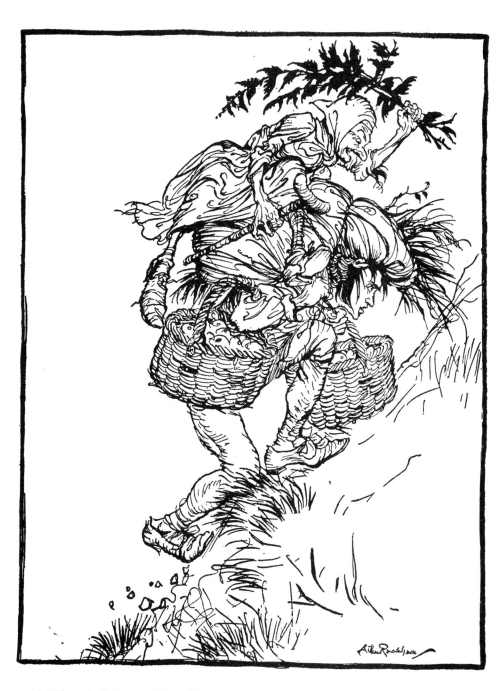

ARTHUR RACKHAM. *Illustration from Grimms' Fairy Tales (Constable
& Co., London)*

377

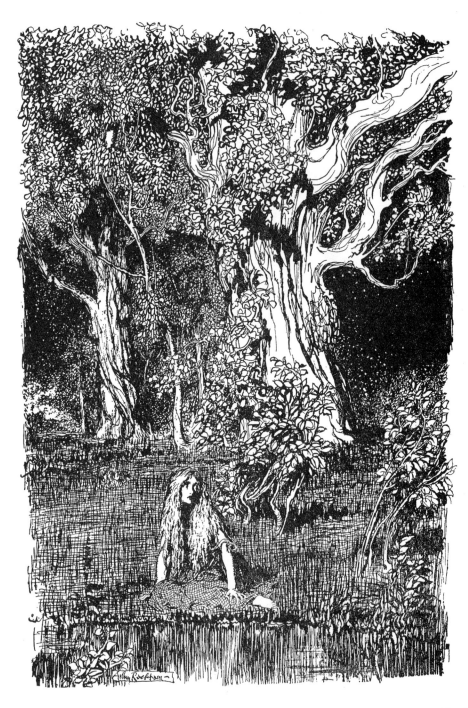

ARTHUR. RACKHAM. *Illustration from Grimms' Fairy Tales (Constable & Co., London)*

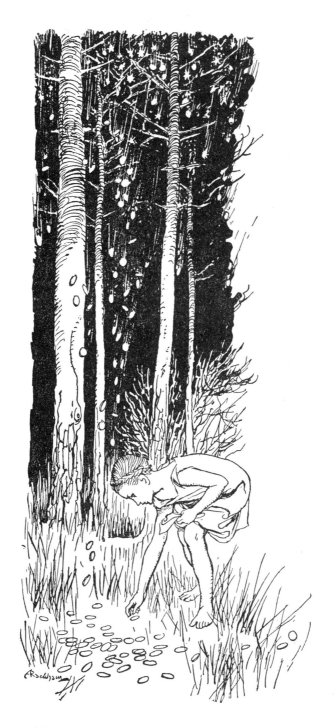

ARTHUR RACKHAM. *Illustration from Grimms'*
Fairy Tales (Constable & Co., London)

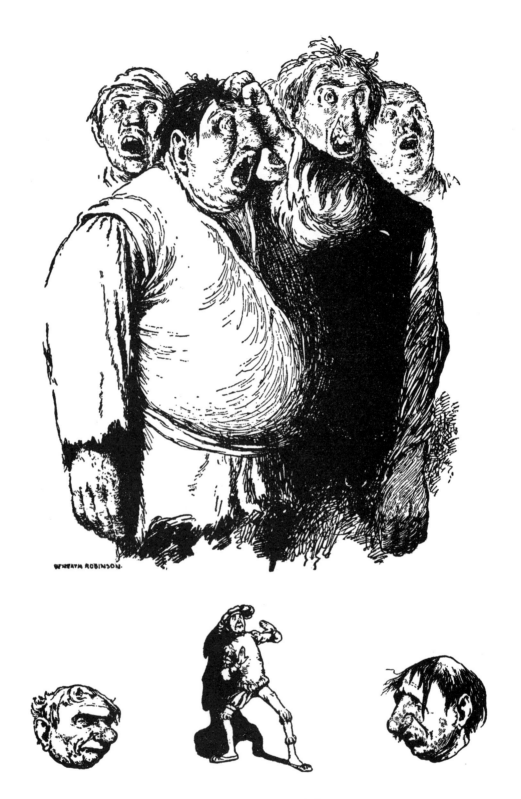

W. HEATH ROBINSON. *Illustrations from Rabelais*

380

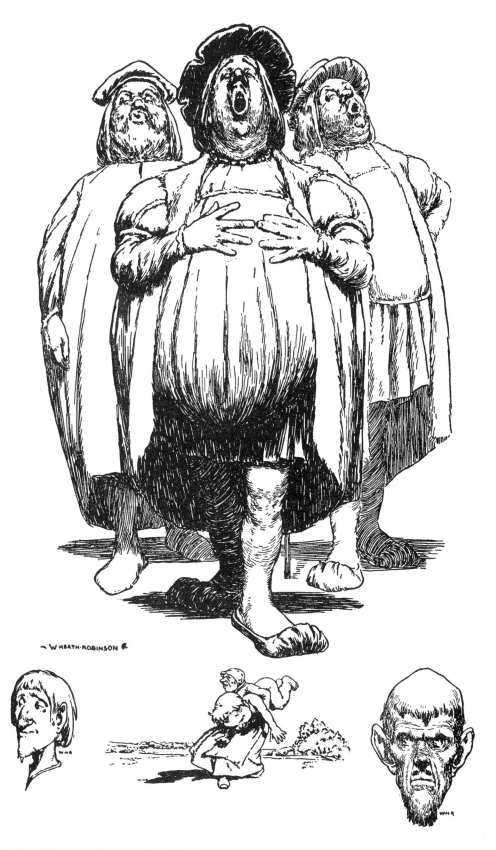

W. HEATH ROBINSON. *Illustrations from Rabelais*

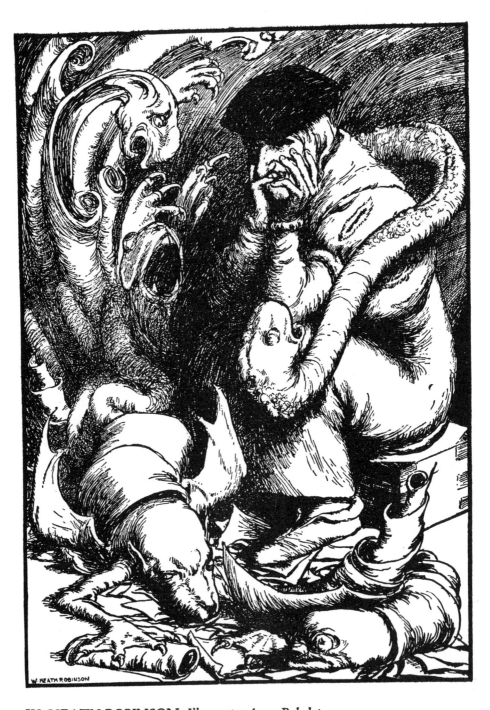

W. HEATH ROBINSON. *Illustration from Rabelais*

382

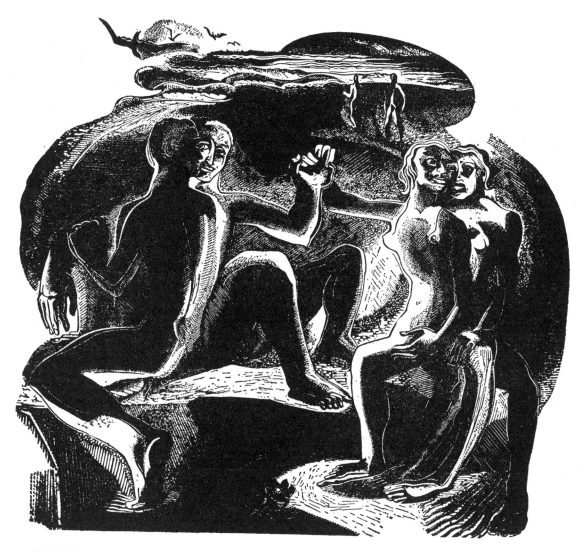

GERTRUDE HERMES

R. A. MAYNARD. *Woodcut from Vision of Judgment (Raven Press, London)*

384

AGNES MILLER PARKER. *Illustration from Through the Woods*

AGNES MILLER PARKER. *Illustration from Through the Woods*

386

AGNES MILLER PARKER. *Illustration from Through the Woods*

J. F. GREENWOOD. *Woodcut from The Book of Clare (Clare College, Cambridge)*

LIONEL ELLIS. *Woodcut from The Complete Works of Catullus (Fanfrolico Press, London)*

BARBARA GREGG. *Illustration from Mysteries of Natural History (Stokes)*

BARBARA GREGG. *Illustration from Mysteries of Natural History (Stokes)*

389

BARBARA GREGG. *Illustration from Mysteries of Natural History (Stokes)*

NORMAN JAMES. *'Factory' (Redfern Gallery, London)*

THE UNITED STATES

ILLUSTRATION in the United States today varies in technique and in styles. Although some well marked directions may already be discerned, none yet approaches a national point of view. The artists themselves, many of whom were born in other countries, have by the freshness of their approach contributed to the heterogeneous effect. As a consequence, American illustration is particularly alive and vigorous. Surprisingly little influence of the French modern school has found its way into our books, at least as far as literal rendition is concerned. The most successful of the men working today have given their attention to the sort of decorative pattern which does not lean too heavily upon realism.

Rockwell Kent is the foremost of these. Kent has lived and worked hard to carve out his decidedly interesting career. When he is not adventuring in Greenland, or other far-flung places, he makes his home at Ausable Chasm, New York. The beauty of the country surrounding his home is often reflected in his highly stylized drawings.

By his fine inventiveness and sense of design, as well as by the dynamic quality of his personality, Kent has assumed leadership in the field of American illustration. The romantic appeal engendered by his voyages to the Far North has helped to popularize his strikingly individual designs. He has illustrated many of the classics, his plates for *Chaucer* being splendid examples of his ability to adapt himself to his material. *Moby Dick*, too, has inspired some of his best pen drawings. Of recent years he has taken to writing and illustrating his own books, among which are *Salamina* and *N by E*, journals of adventure and good examples of his style.

Lynd Ward, beginning with a novel in woodcut, *God's Man,* in which he displayed a great deal of ingenuity and interesting use of the graver, has progressed rapidly. He has developed a style which is at once dynamic and imaginative. Ward has thoroughly mastered the tools of his craft, and, for excellence in engraving, some of his cuts for recent books are among the best that this country has produced.

One of the few first-rate artists of the American South, J. J. Lankes has for many years given us fine and tender engravings of local American scenes. His cuts of his southern homeland are designed with care and precision, and give proof of his strong originality. *A Woodcut Manual,* his book on the technique of wood engraving and wood cutting, is filled with charming examples of his own work.

After having shown a great deal of promise in her illustrations for a number of children's books, Helen Sewell steps into the front rank of American illustrators with her work in a collection of Biblical stories, *First Bible.* The drawings are vital and original in design, and the fine insistence on decorative arrangement in these plates in no way interferes with their illustrative quality.

Boris Artzybasheff displays a dazzling array of techniques. In his illustrations for Henriette Celaire's *Behind Moroccan Walls,* he makes unusual use of the pen line. In *The Seven Simeons* he has recourse to the most delicate decorative illustration, the pen line being used in two colors with telling effect. His sense of humor is apparent in most of his work, and his style is so adaptable that he is able to render the spirit of the text in books whose subject matter is widely varied.

Paul Landacre's reputation grows greater each year. This is not unnatural, as he is one of the most skillful wood engravers in America. His ability to make the graver reveal a mood is nothing short of remarkable, and he has been very successful in some of his experiments with art in its abstract form.

It is a far step from nature drawings to the exotic flavor of Mahlon Blaine.

Blaine belongs among those illustrators who find the grotesque best suited to their temperaments. His intensely personal style is well adapted to fantasy, of which his illustrations for *Sindbad* are excellent examples.

American history is the chief concern of James Daugherty. His drawings are filled with vitality. After the prissy and stilted engravings and the quaint vagaries of Currier and Ives lithographs, Daugherty's naturalness is a happy change. His free approach to the problems of the book is lively and bold.

H. L. Glintenkamp is one of the pioneer wood-engravers in the United States. He has a bold and individual manner which may be seen to excellent advantage in his travel book of woodcuts, *Wanderer in Woodcuts*. He is fond of striking oppositions in black and white, and he achieves original effects in design. Wilfred Jones also uses black and white with telling decorative effect. He has a great deal of strength and originality of design.

The illustrations for Phil Stong's *The Young Settler* are good examples of Kurt Wiese's work. Wiese has traveled extensively in the Orient and in South Africa, and he has been a close observer of the native life. There is a certain authenticity in his pictures that catches the spirit and mood of far-away places. He has done much fine work for children's books, especially in his animal series.

The standard Palgrave's *Golden Treasury* contains the workmanlike illustrations of Lawrence W. Chaves. His drawings show his perfected and intricate pen technique. They are done with care and precision and are eminently suited to the spirit of the book.

Peggy Bacon is a shrewd observer of what goes on about her. Her satiric, amusing pen is predominantly concerned with the less serious aspects of living. Not the least of her books is *Off With Their Heads,* a collection of caricatures in which she has spared no one, not even herself. Carl Sandburg's *Rutabaga Stories* brought an excellent opportunity to her hand. Her recent work includes the illustrations for Margaret Halsey's *With Malice*

Toward Some, in which the text is not followed too closely, and her collaboration with Tom Robinson for the children's book, *Buttons.*

Gordon Grant is famous for his drawings of ships and the sea. His free pen line skillfully depicts activities aboard ship and on the shore. His sailors are genuine and rollicking. Lyle Justis' drawings for *Treasure Island* introduce more nautical pictures. Almost every page of the book is decorated with drunken, swearing, fighting pirates. Justis has a bounding sense of exaggeration that fulfills perfectly the demands of this perennial favorite.

Henry C. Pitz, besides the illustration shown in this book, has also made many dashing drawings of adventure.

Old Houses in Virginia is illustrated by a fine series of woodcuts by Charles R. Smith. These plates are direct, simple, and beautiful in design. They display a nice feeling and a deep sympathy for this type of southern architecture.

Another who uses the woodcut in individual fashion is Ilse Bischoff. Her illustrations for children's books are extremely well designed and possess a nice quality of humor. Her plates for *The Temptation of St. Anthony* are of a rather different order, but they too are ably executed.

Grace Paull is one of the most successful illustrators of children's books. Her provoking sense of humor and her talent for character delineation are expressed notably in the drawings for *Mr. Bumps and His Monkey* by Walter de la Mare.

Wanda Gág is one of the most personal and original of American illustrators. Her unusual style is characterized by a short stabbing line which follows the form. In *Millions of Cats,* a book for children, she is at her best. The drawings are ebullient with understanding and good humor.

395

ROCKWELL KENT. *Full page illustration from Memoirs of Jacques Casanova (Aventuros, New York)*

396

ROCKWELL KENT. *Two illustrations from N. by E. (Harcourt, Brace and Co., New York)*

ROCKWELL KENT. *Illustration from Memoirs of Jacques Casanova (Aventuros, New York)*

398

ROCKWELL KENT. *Illustration from Moby Dick by Herman Melville (The Lakeside Press, Chicago)*

LYND WARD. *Two wood-cuts from Vertigo. A Novel in woodcuts*
(Random House, New York)

LYND WARD. *Two woodcuts from Vertigo. A Novel in woodcuts*
(*Random House, New York*)

J. J. LANKES. 'Aspens' from Woodcut Manual

402

J. J. LANKES. *'Farmyard' from Woodcut Manual*

J. J. LANKES. *Woodcut from Marbacka by Selma Lagerlof (Doubleday, Doran & Co., New York)*

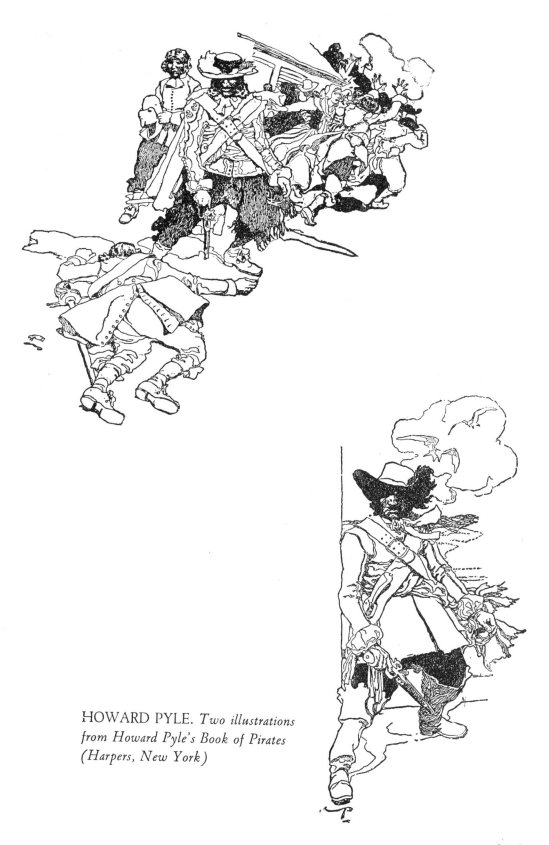

HOWARD PYLE. *Two illustrations from Howard Pyle's Book of Pirates (Harpers, New York)*

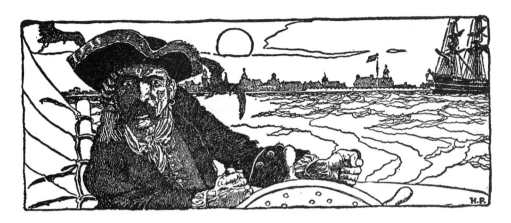

HOWARD PYLE. *Illustration from Howard Pyle's Book of Pirates (Harpers, New York)*

JAMES REID. *Illustration from The Lapp Mystery by S. S. Smith (Harcourt, Brace and Co., New York)*

JAMES REID. *Illustration from* The Lapp Mystery *by S. S. Smith (Harcourt, Brace and Co., New York)*

HELEN SEWELL. *Illustration from* The First Bible *(Oxford University Press, New York)*

408

HELEN SEWELL. *Illustration from The First Bible (Oxford University Press, New York)*

HELEN SEWELL. *Illustration from* The First Bible *(Oxford University Press, New York)*

410

BORIS ARTZYBASHEFF. *Two illustrations from Seven Simeons (Story Parade, New York)*

BORIS ARTZYBASHEFF. *Illustration from Seven Simeons (Story Parade, New York)*

BORIS ARTZYBASHEFF. *Illustration from Seven Simeons (Story Parade, New York)*

BORIS ARTZYBASHEFF. *Woodcut from Behind Moroccan Walls by Henriette Celaire (Macmillan, New York)*

BORIS ARTZYBASHEFF. *Woodcut from Behind Moroccan Walls by Henriette Celaire (Mac-millan, New York)*

415

PAUL LANDACRE. *Woodcut 'Storm' (Weyhe Gallery, New York)*

PAUL LANDACRE. *Woodcut 'The Press' (Weyhe Gallery, New York)*

JAMES DAUGHERTY. *Two illustrations from Courageous Companions by Charles J. Finger (Longmans, Green and Co., New York)*

418

JAMES DAUGHERTY. *Two illustrations from Courageous Companions by Charles J. Finger (Longmans, Green and Co., New York)*

HOWARD SIMON. *Woodcut from the Plays of Anton Chekhov (Illustrated Editions Co., New York)*

HOWARD SIMON. *Illustration from Old Hell by Emmet Gowan (Modern Age, New York)*

HOWARD SIMON. *Illustration from Old Hell by Emmet Gowan (Modern Age, New York)*

HOWARD SIMON. *Woodcut from the Plays of Anton Chekhov (Illustrated Editions Co., New York)*

HOWARD SIMON. *Illustration from Old Hell by Emmet Gowan (Modern Age, New York)*

HOWARD SIMON. *Woodcut from* The Plays of Anton Chekhov
(Illustrated Editions Co., New York)

423

HOWARD SIMON. *Woodcut from* The Plays of Anton Chekhov
(Illustrated Editions Co., New York)

424

HOWARD SIMON. *Woodcut from The Plays of Anton Chekhov (Illustrated Editions Co., New York)*

HOWARD SIMON. *Illustration from Rabelais (Ives Washburn, New York)*

426

KURT WIESE. *Two illustrations from Young Fu of the Upper Yangtze by Elizabeth Foreman Lewis (John C. Winston Co.)*

VALENTI ANGELO. *Two pen drawings from Chinese Love Tales (Illustrated Editions Co., New York)*

VALENTI ANGELO. *Two pen drawings from Dumas' The Three Musketeers (Illustrated Editions Co., New York)*

VALENTI ANGELO. *Illustration from Chinese Love Tales*

ALEXANDER KING. *Two pen drawings from The Romance of the Queen Pédauque by Anatole France (Illustrated Editions Co., New York)*

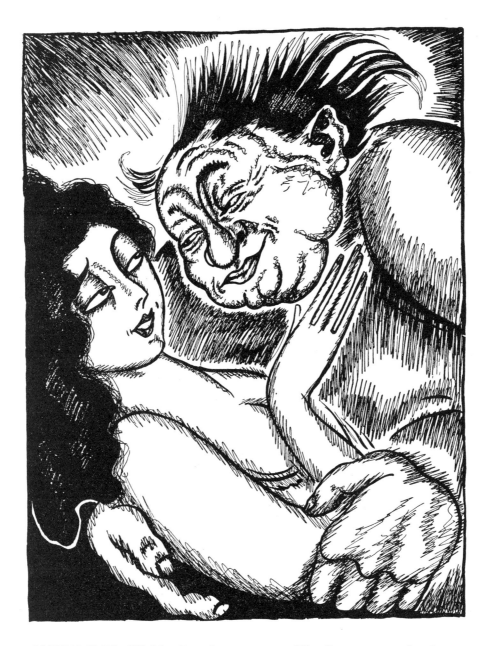

ALEXANDER KING. *Pen drawing from* The Romance of the Queen
Pédauque *by Anatole France*

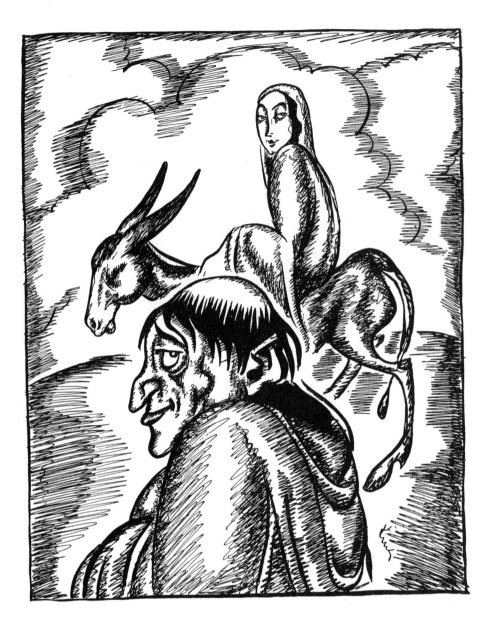

ALEXANDER KING. *Illustration from The Romance of the Queen Pédauque*

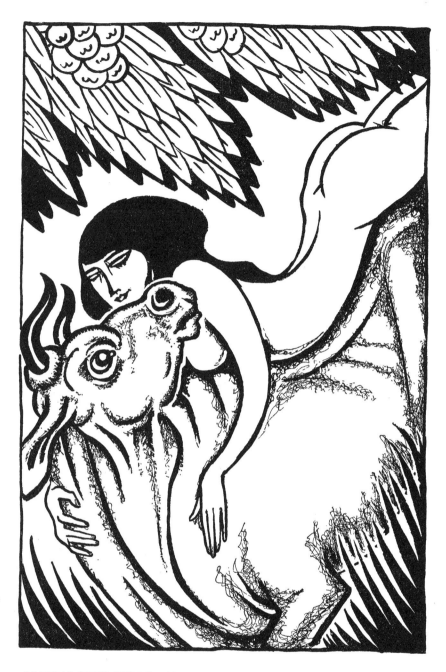

ALEXANDER KING. *Illustration from Giovanni Boccaccio's Pleasant Questions of Love*

433

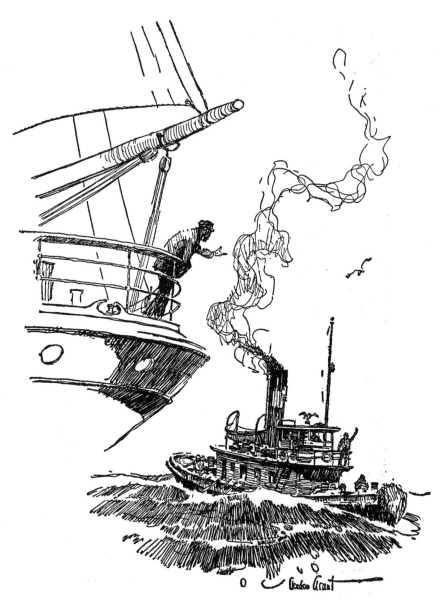

GORDON GRANT. *Illustration from Sail Ho! (W. F. Payson)*

434

GORDON GRANT. *Illustration from Sail Ho! (W. F. Payson)*

435

GORDON GRANT. *Illustration from Sail Ho! (W. F. Payson)*

LYLE JUSTIS. *Two drawings from Treasure Island by Robert Louis Stevenson*

436

LYLE JUSTIS. *Two pen drawings from Treasure Island*

LYLE JUSTIS. *Two illustrations from Treasure Island*

438

PEGGY BACON. *Illustration from Rootabaga Country by Carl Sandburg (Harcourt, Brace & Co., New York)*

439

LAWRENCE CHAVES. *Illustration from Palgrave's Golden Treasury*

LAWRENCE CHAVES. *Illustration from Palgrave's Golden Treasury (Illustrated Editions, New York)*

LAWRENCE CHAVES. *Ornamental illustrations from Palgrave's Golden Treasury*

LAWRENCE CHAVES. *Full page illustration from Confessions of an English Opium Eater by Thomas de Quincey*

443

ELINORE BLAISDELL. *Illustration from A Shropshire Lad by A. E. Housman (Illustrated Editions Co., New York)*

ELINORE BLAISDELL. *Illustration from* A Shropshire Lad *by A. E. Housman*

HENRY GLINTENKAMP

446

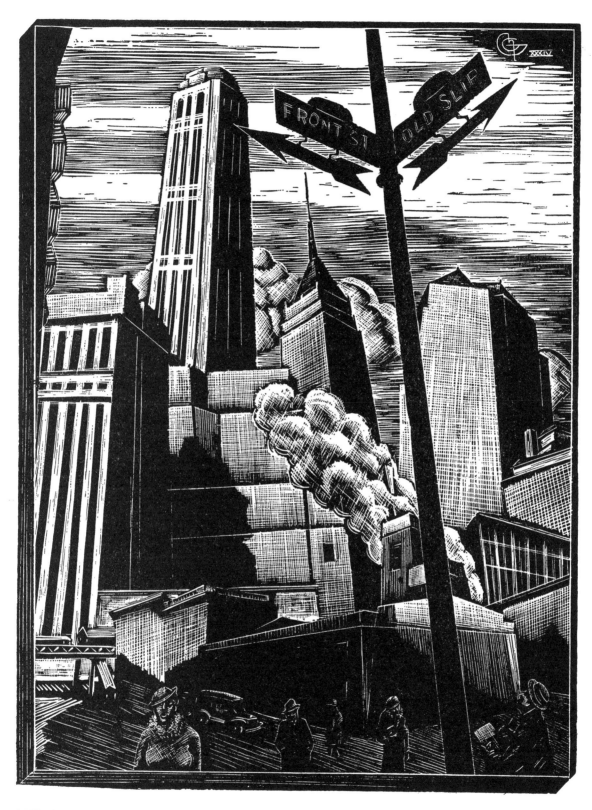

HENRY GLINTENKAMP

447

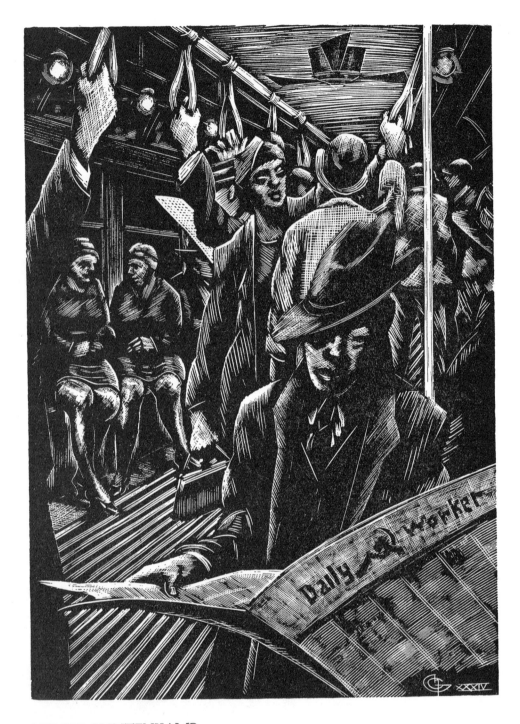

HENRY GLINTENKAMP

448

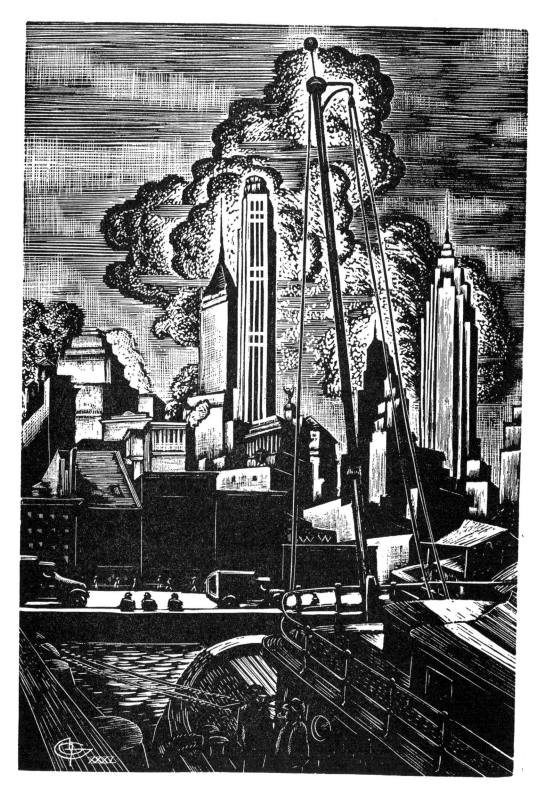

HENRY GLINTENKAMP

449

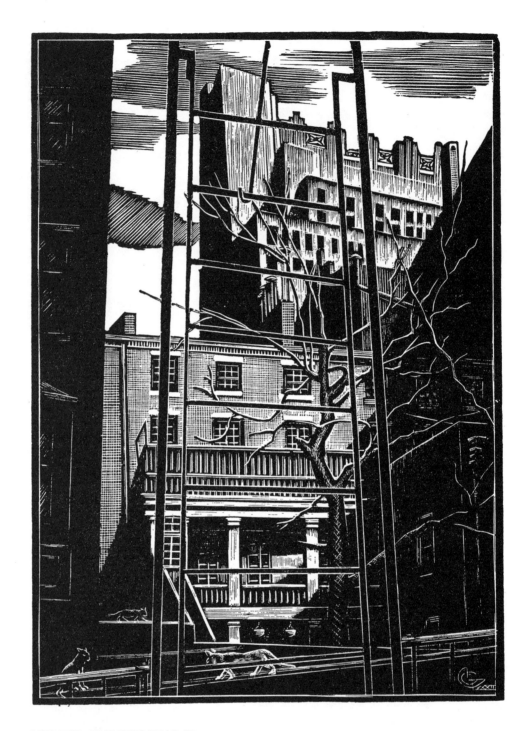

HENRY GLINTENKAMP

450

WM. WOLFSON. '*The Wreckers*'

WM. WOLFSON. 'The Road Builders'

452

WM. WOLFSON. *'Six A.M.'*

453

WILFRED JONES. *Two illustrations from Rise of American Civilization by Charles and Mary Beard (Macmillan, New York)*

WILFRED JONES. *Two illustrations from Rise of American Civilization by Charles and Mary Beard (Macmillan, New York)*

454

MAHLON BLAINE. *Illustration for Voltaire's Candide*

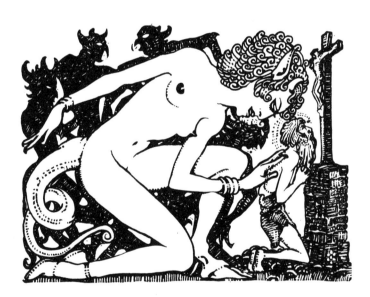

MAHLON BLAINE. *Illustration for Flaubert's Temptation of St. Anthony*

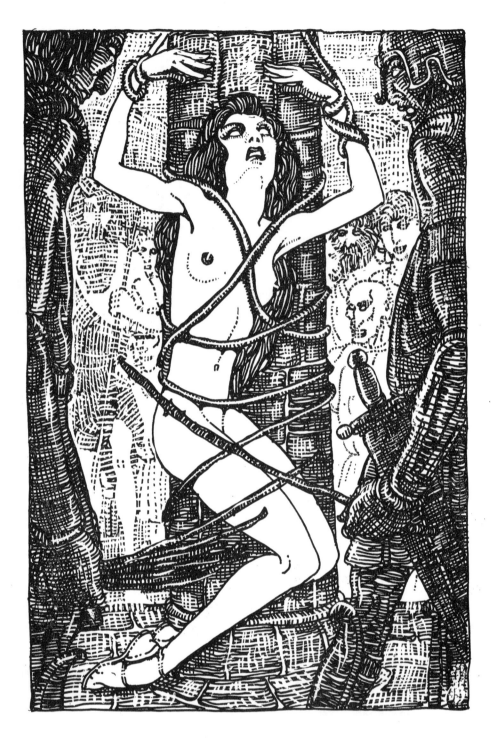

MAHLON BLAINE. *Illustration for Flaubert's Temptation of St. Anthony*

456

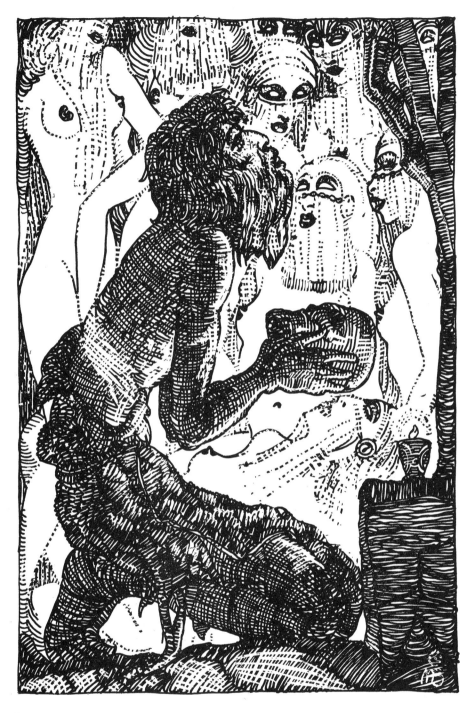

MAHLON BLAINE. *Illustration for Flaubert's Temptation of St. Anthony*

457

MAHLON BLAINE.
*Illustration for Sterne's
Sentimental Journey*

MAHLON BLAINE.
*Illustration for Voltaire's
Candide*

458

GRACE PAULL. *Two illustrations from Mr. Bumps and His Monkey by Walter de la Mare (Story Parade, New York)*

GRACE PAULL. *Two illustrations from Mr. Bumps and His Monkey by Walter de la Mare (Story Parade, New York)*

GRACE PAULL. *Illustration from Mr. Bumps and His Monkey by Walter de la Mare (Story Parade, New York)*

ILSE BISCHOFF. *Illustration from In Calico and Crinoline by Eleanor M. Sickels (The Viking Press, New York)*

461

ILSE BISCHOFF. *Illustration from In Calico and Crinoline by Eleanor M. Sickels (The Viking Press, New York)*

WANDA GAG. *Two illustrations from Millions of Cats (Coward-McCann, New York)*

463

HENRY C. PITZ. *Pen drawing from Lumberjack by Stephen W. Meader (Harcourt, Brace & Co., New York)*

464

HENRY C. PITZ. *Pen drawing from Lumberjack by Stephen
W. Meader (Harcourt, Brace & Co., New York)*

465

INDEX

468

A CATALOG OF SELECTED
DOVER BOOKS
IN ALL FIELDS OF INTEREST

A CATALOG OF SELECTED DOVER
BOOKS IN ALL FIELDS OF INTEREST

100 BEST-LOVED POEMS, Edited by Philip Smith. "The Passionate Shepherd to His Love," "Shall I compare thee to a summer's day?" "Death, be not proud," "The Raven," "The Road Not Taken," plus works by Blake, Wordsworth, Byron, Shelley, Keats, many others. 96pp. 5¾₁₆ x 8¼. 0-486-28553-7

100 SMALL HOUSES OF THE THIRTIES, Brown-Blodgett Company. Exterior photographs and floor plans for 100 charming structures. Illustrations of models accompanied by descriptions of interiors, color schemes, closet space, and other amenities. 200 illustrations. 112pp. 8⅜ x 11. 0-486-44131-8

1000 TURN-OF-THE-CENTURY HOUSES: With Illustrations and Floor Plans, Herbert C. Chivers. Reproduced from a rare edition, this showcase of homes ranges from cottages and bungalows to sprawling mansions. Each house is meticulously illustrated and accompanied by complete floor plans. 256pp. 9⅜ x 12¼.
0-486-45596-3

101 GREAT AMERICAN POEMS, Edited by The American Poetry & Literacy Project. Rich treasury of verse from the 19th and 20th centuries includes works by Edgar Allan Poe, Robert Frost, Walt Whitman, Langston Hughes, Emily Dickinson, T. S. Eliot, other notables. 96pp. 5¾₁₆ x 8¼. 0-486-40158-8

101 GREAT SAMURAI PRINTS, Utagawa Kuniyoshi. Kuniyoshi was a master of the warrior woodblock print — and these 18th-century illustrations represent the pinnacle of his craft. Full-color portraits of renowned Japanese samurais pulse with movement, passion, and remarkably fine detail. 112pp. 8⅜ x 11. 0-486-46523-3

ABC OF BALLET, Janet Grosser. Clearly worded, abundantly illustrated little guide defines basic ballet-related terms: arabesque, battement, pas de chat, relevé, sissonne, many others. Pronunciation guide included. Excellent primer. 48pp. 4¾₁₆ x 5¾.
0-486-40871-X

ACCESSORIES OF DRESS: An Illustrated Encyclopedia, Katherine Lester and Bess Viola Oerke. Illustrations of hats, veils, wigs, cravats, shawls, shoes, gloves, and other accessories enhance an engaging commentary that reveals the humor and charm of the many-sided story of accessorized apparel. 644 figures and 59 plates. 608pp. 6 ⅛ x 9¼.
0-486-43378-1

ADVENTURES OF HUCKLEBERRY FINN, Mark Twain. Join Huck and Jim as their boyhood adventures along the Mississippi River lead them into a world of excitement, danger, and self-discovery. Humorous narrative, lyrical descriptions of the Mississippi valley, and memorable characters. 224pp. 5¾₁₆ x 8¼. 0-486-28061-6

ALICE STARMORE'S BOOK OF FAIR ISLE KNITTING, Alice Starmore. A noted designer from the region of Scotland's Fair Isle explores the history and techniques of this distinctive, stranded-color knitting style and provides copious illustrated instructions for 14 original knitwear designs. 208pp. 8⅜ x 10⅞. 0-486-47218-3

Browse over 9,000 books at www.doverpublications.com

ALICE'S ADVENTURES IN WONDERLAND, Lewis Carroll. Beloved classic about a little girl lost in a topsy-turvy land and her encounters with the White Rabbit, March Hare, Mad Hatter, Cheshire Cat, and other delightfully improbable characters. 42 illustrations by Sir John Tenniel. 96pp. 5³⁄₁₆ x 8¼. 0-486-27543-4

AMERICA'S LIGHTHOUSES: An Illustrated History, Francis Ross Holland. Profusely illustrated fact-filled survey of American lighthouses since 1716. Over 200 stations — East, Gulf, and West coasts, Great Lakes, Hawaii, Alaska, Puerto Rico, the Virgin Islands, and the Mississippi and St. Lawrence Rivers. 240pp. 8 x 10¾.
0-486-25576-X

AN ENCYCLOPEDIA OF THE VIOLIN, Alberto Bachmann. Translated by Frederick H. Martens. Introduction by Eugene Ysaye. First published in 1925, this renowned reference remains unsurpassed as a source of essential information, from construction and evolution to repertoire and technique. Includes a glossary and 73 illustrations. 496pp. 6⅛ x 9¼. 0-486-46618-3

ANIMALS: 1,419 Copyright-Free Illustrations of Mammals, Birds, Fish, Insects, etc., Selected by Jim Harter. Selected for its visual impact and ease of use, this outstanding collection of wood engravings presents over 1,000 species of animals in extremely lifelike poses. Includes mammals, birds, reptiles, amphibians, fish, insects, and other invertebrates. 284pp. 9 x 12. 0-486-23766-4

THE ANNALS, Tacitus. Translated by Alfred John Church and William Jackson Brodribb. This vital chronicle of Imperial Rome, written by the era's great historian, spans A.D. 14-68 and paints incisive psychological portraits of major figures, from Tiberius to Nero. 416pp. 5³⁄₁₆ x 8¼. 0-486-45236-0

ANTIGONE, Sophocles. Filled with passionate speeches and sensitive probing of moral and philosophical issues, this powerful and often-performed Greek drama reveals the grim fate that befalls the children of Oedipus. Footnotes. 64pp. 5³⁄₁₆ x 8 ¼. 0-486-27804-2

ART DECO DECORATIVE PATTERNS IN FULL COLOR, Christian Stoll. Reprinted from a rare 1910 portfolio, 160 sensuous and exotic images depict a breathtaking array of florals, geometrics, and abstracts — all elegant in their stark simplicity. 64pp. 8⅜ x 11. 0-486-44862-2

THE ARTHUR RACKHAM TREASURY: 86 Full-Color Illustrations, Arthur Rackham. Selected and Edited by Jeff A. Menges. A stunning treasury of 86 full-page plates span the famed English artist's career, from *Rip Van Winkle* (1905) to masterworks such as *Undine, A Midsummer Night's Dream,* and *Wind in the Willows* (1939). 96pp. 8⅜ x 11.
0-486-44685-9

THE AUTHENTIC GILBERT & SULLIVAN SONGBOOK, W. S. Gilbert and A. S. Sullivan. The most comprehensive collection available, this songbook includes selections from every one of Gilbert and Sullivan's light operas. Ninety-two numbers are presented uncut and unedited, and in their original keys. 410pp. 9 x 12.
0-486-23482-7

THE AWAKENING, Kate Chopin. First published in 1899, this controversial novel of a New Orleans wife's search for love outside a stifling marriage shocked readers. Today, it remains a first-rate narrative with superb characterization. New introductory Note. 128pp. 5³⁄₁₆ x 8¼. 0-486-27786-0

BASIC DRAWING, Louis Priscilla. Beginning with perspective, this commonsense manual progresses to the figure in movement, light and shade, anatomy, drapery, composition, trees and landscape, and outdoor sketching. Black-and-white illustrations throughout. 128pp. 8⅜ x 11. 0-486-45815-6

Browse over 9,000 books at www.doverpublications.com

THE BATTLES THAT CHANGED HISTORY, Fletcher Pratt. Historian profiles 16 crucial conflicts, ancient to modern, that changed the course of Western civilization. Gripping accounts of battles led by Alexander the Great, Joan of Arc, Ulysses S. Grant, other commanders. 27 maps. 352pp. 5⅜ x 8½.　　　0-486-41129-X

BEETHOVEN'S LETTERS, Ludwig van Beethoven. Edited by Dr. A. C. Kalischer. Features 457 letters to fellow musicians, friends, greats, patrons, and literary men. Reveals musical thoughts, quirks of personality, insights, and daily events. Includes 15 plates. 410pp. 5⅜ x 8½.　　　0-486-22769-3

BERNICE BOBS HER HAIR AND OTHER STORIES, F. Scott Fitzgerald. This brilliant anthology includes 6 of Fitzgerald's most popular stories: "The Diamond as Big as the Ritz," the title tale, "The Offshore Pirate," "The Ice Palace," "The Jelly Bean," and "May Day." 176pp. 5⅜ x 8½.　　　0-486-47049-0

BESLER'S BOOK OF FLOWERS AND PLANTS: 73 Full-Color Plates from Hortus Eystettensis, 1613, Basilius Besler. Here is a selection of magnificent plates from the *Hortus Eystettensis,* which vividly illustrated and identified the plants, flowers, and trees that thrived in the legendary German garden at Eichstätt. 80pp. 8⅜ x 11.
　　　0-486-46005-3

THE BOOK OF KELLS, Edited by Blanche Cirker. Painstakingly reproduced from a rare facsimile edition, this volume contains full-page decorations, portraits, illustrations, plus a sampling of textual leaves with exquisite calligraphy and ornamentation. 32 full-color illustrations. 32pp. 9⅜ x 12¼.　　　0-486-24345-1

THE BOOK OF THE CROSSBOW: With an Additional Section on Catapults and Other Siege Engines, Ralph Payne-Gallwey. Fascinating study traces history and use of crossbow as military and sporting weapon, from Middle Ages to modern times. Also covers related weapons: balistas, catapults, Turkish bows, more. Over 240 illustrations. 400pp. 7¼ x 10⅛.　　　0-486-28720-3

THE BUNGALOW BOOK: Floor Plans and Photos of 112 Houses, 1910, Henry L. Wilson. Here are 112 of the most popular and economic blueprints of the early 20th century — plus an illustration or photograph of each completed house. A wonderful time capsule that still offers a wealth of valuable insights. 160pp. 8⅜ x 11.
　　　0-486-45104-6

THE CALL OF THE WILD, Jack London. A classic novel of adventure, drawn from London's own experiences as a Klondike adventurer, relating the story of a heroic dog caught in the brutal life of the Alaska Gold Rush. Note. 64pp. 5³⁄₁₆ x 8¼.
　　　0-486-26472-6

CANDIDE, Voltaire. Edited by Francois-Marie Arouet. One of the world's great satires since its first publication in 1759. Witty, caustic skewering of romance, science, philosophy, religion, government — nearly all human ideals and institutions. 112pp. 5³⁄₁₆ x 8¼.　　　0-486-26689-3

CELEBRATED IN THEIR TIME: Photographic Portraits from the George Grantham Bain Collection, Edited by Amy Pastan. With an Introduction by Michael Carlebach. Remarkable portrait gallery features 112 rare images of Albert Einstein, Charlie Chaplin, the Wright Brothers, Henry Ford, and other luminaries from the worlds of politics, art, entertainment, and industry. 128pp. 8⅜ x 11.　　　0-486-46754-6

CHARIOTS FOR APOLLO: The NASA History of Manned Lunar Spacecraft to 1969, Courtney G. Brooks, James M. Grimwood, and Loyd S. Swenson, Jr. This illustrated history by a trio of experts is the definitive reference on the Apollo spacecraft and lunar modules. It traces the vehicles' design, development, and operation in space. More than 100 photographs and illustrations. 576pp. 6¾ x 9¼.　　　0-486-46756-2

Browse over 9,000 books at www.doverpublications.com

A CHRISTMAS CAROL, Charles Dickens. This engrossing tale relates Ebenezer Scrooge's ghostly journeys through Christmases past, present, and future and his ultimate transformation from a harsh and grasping old miser to a charitable and compassionate human being. 80pp. 5³⁄₁₆ x 8¼. 0-486-26865-9

COMMON SENSE, Thomas Paine. First published in January of 1776, this highly influential landmark document clearly and persuasively argued for American separation from Great Britain and paved the way for the Declaration of Independence. 64pp. 5³⁄₁₆ x 8¼. 0-486-29602-4

THE COMPLETE SHORT STORIES OF OSCAR WILDE, Oscar Wilde. Complete texts of "The Happy Prince and Other Tales," "A House of Pomegranates," "Lord Arthur Savile's Crime and Other Stories," "Poems in Prose," and "The Portrait of Mr. W. H." 208pp. 5³⁄₁₆ x 8¼. 0-486-45216-6

COMPLETE SONNETS, William Shakespeare. Over 150 exquisite poems deal with love, friendship, the tyranny of time, beauty's evanescence, death, and other themes in language of remarkable power, precision, and beauty. Glossary of archaic terms. 80pp. 5³⁄₁₆ x 8¼. 0-486-26686-9

THE COUNT OF MONTE CRISTO: Abridged Edition, Alexandre Dumas. Falsely accused of treason, Edmond Dantès is imprisoned in the bleak Chateau d'If. After a hair-raising escape, he launches an elaborate plot to extract a bitter revenge against those who betrayed him. 448pp. 5³⁄₁₆ x 8¼. 0-486-45643-9

CRAFTSMAN BUNGALOWS: Designs from the Pacific Northwest, Yoho & Merritt. This reprint of a rare catalog, showcasing the charming simplicity and cozy style of Craftsman bungalows, is filled with photos of completed homes, plus floor plans and estimated costs. An indispensable resource for architects, historians, and illustrators. 112pp. 10 x 7. 0-486-46875-5

CRAFTSMAN BUNGALOWS: 59 Homes from "The Craftsman," Edited by Gustav Stickley. Best and most attractive designs from Arts and Crafts Movement publication — 1903–1916 — includes sketches, photographs of homes, floor plans, descriptive text. 128pp. 8¼ x 11. 0-486-25829-7

CRIME AND PUNISHMENT, Fyodor Dostoyevsky. Translated by Constance Garnett. Supreme masterpiece tells the story of Raskolnikov, a student tormented by his own thoughts after he murders an old woman. Overwhelmed by guilt and terror, he confesses and goes to prison. 480pp. 5³⁄₁₆ x 8¼. 0-486-41587-2

THE DECLARATION OF INDEPENDENCE AND OTHER GREAT DOCUMENTS OF AMERICAN HISTORY: 1775-1865, Edited by John Grafton. Thirteen compelling and influential documents: Henry's "Give Me Liberty or Give Me Death," Declaration of Independence, The Constitution, Washington's First Inaugural Address, The Monroe Doctrine, The Emancipation Proclamation, Gettysburg Address, more. 64pp. 5³⁄₁₆ x 8¼. 0-486-41124-9

THE DESERT AND THE SOWN: Travels in Palestine and Syria, Gertrude Bell. "The female Lawrence of Arabia," Gertrude Bell wrote captivating, perceptive accounts of her travels in the Middle East. This intriguing narrative, accompanied by 160 photos, traces her 1905 sojourn in Lebanon, Syria, and Palestine. 368pp. 5⅜ x 8½.
 0-486-46876-3

A DOLL'S HOUSE, Henrik Ibsen. Ibsen's best-known play displays his genius for realistic prose drama. An expression of women's rights, the play climaxes when the central character, Nora, rejects a smothering marriage and life in "a doll's house." 80pp. 5³⁄₁₆ x 8¼. 0-486-27062-9

Browse over 9,000 books at www.doverpublications.com

DOOMED SHIPS: Great Ocean Liner Disasters, William H. Miller, Jr. Nearly 200 photographs, many from private collections, highlight tales of some of the vessels whose pleasure cruises ended in catastrophe: the *Morro Castle, Normandie, Andrea Doria, Europa,* and many others. 128pp. 8⅞ x 11¾. 0-486-45366-9

THE DORÉ BIBLE ILLUSTRATIONS, Gustave Doré. Detailed plates from the Bible: the Creation scenes, Adam and Eve, horrifying visions of the Flood, the battle sequences with their monumental crowds, depictions of the life of Jesus, 241 plates in all. 241pp. 9 x 12. 0-486-23004-X

DRAWING DRAPERY FROM HEAD TO TOE, Cliff Young. Expert guidance on how to draw shirts, pants, skirts, gloves, hats, and coats on the human figure, including folds in relation to the body, pull and crush, action folds, creases, more. Over 200 drawings. 48pp. 8¼ x 11. 0-486-45591-2

DUBLINERS, James Joyce. A fine and accessible introduction to the work of one of the 20th century's most influential writers, this collection features 15 tales, including a masterpiece of the short-story genre, "The Dead." 160pp. 5³⁄₁₆ x 8¼. 0-486-26870-5

EASY-TO-MAKE POP-UPS, Joan Irvine. Illustrated by Barbara Reid. Dozens of wonderful ideas for three-dimensional paper fun — from holiday greeting cards with moving parts to a pop-up menagerie. Easy-to-follow, illustrated instructions for more than 30 projects. 299 black-and-white illustrations. 96pp. 8⅜ x 11. 0-486-44622-0

EASY-TO-MAKE STORYBOOK DOLLS: A "Novel" Approach to Cloth Dollmaking, Sherralyn St. Clair. Favorite fictional characters come alive in this unique beginner's dollmaking guide. Includes patterns for Pollyanna, Dorothy from *The Wonderful Wizard of Oz,* Mary of *The Secret Garden,* plus easy-to-follow instructions, 263 black-and-white illustrations, and an 8-page color insert. 112pp. 8¼ x 11. 0-486-47360-0

EINSTEIN'S ESSAYS IN SCIENCE, Albert Einstein. Speeches and essays in accessible, everyday language profile influential physicists such as Niels Bohr and Isaac Newton. They also explore areas of physics to which the author made major contributions. 128pp. 5 x 8. 0-486-47011-3

EL DORADO: Further Adventures of the Scarlet Pimpernel, Baroness Orczy. A popular sequel to *The Scarlet Pimpernel,* this suspenseful story recounts the Pimpernel's attempts to rescue the Dauphin from imprisonment during the French Revolution. An irresistible blend of intrigue, period detail, and vibrant characterizations. 352pp. 5³⁄₁₆ x 8¼. 0-486-44026-5

ELEGANT SMALL HOMES OF THE TWENTIES: 99 Designs from a Competition, Chicago Tribune. Nearly 100 designs for five- and six-room houses feature New England and Southern colonials, Normandy cottages, stately Italianate dwellings, and other fascinating snapshots of American domestic architecture of the 1920s. 112pp. 9 x 12. 0-486-46910-7

THE ELEMENTS OF STYLE: The Original Edition, William Strunk, Jr. This is the book that generations of writers have relied upon for timeless advice on grammar, diction, syntax, and other essentials. In concise terms, it identifies the principal requirements of proper style and common errors. 64pp. 5⅜ x 8½. 0-486-44798-7

THE ELUSIVE PIMPERNEL, Baroness Orczy. Robespierre's revolutionaries find their wicked schemes thwarted by the heroic Pimpernel — Sir Percival Blakeney. In this thrilling sequel, Chauvelin devises a plot to eliminate the Pimpernel and his wife. 272pp. 5³⁄₁₆ x 8¼. 0-486-45464-9

Browse over 9,000 books at www.doverpublications.com